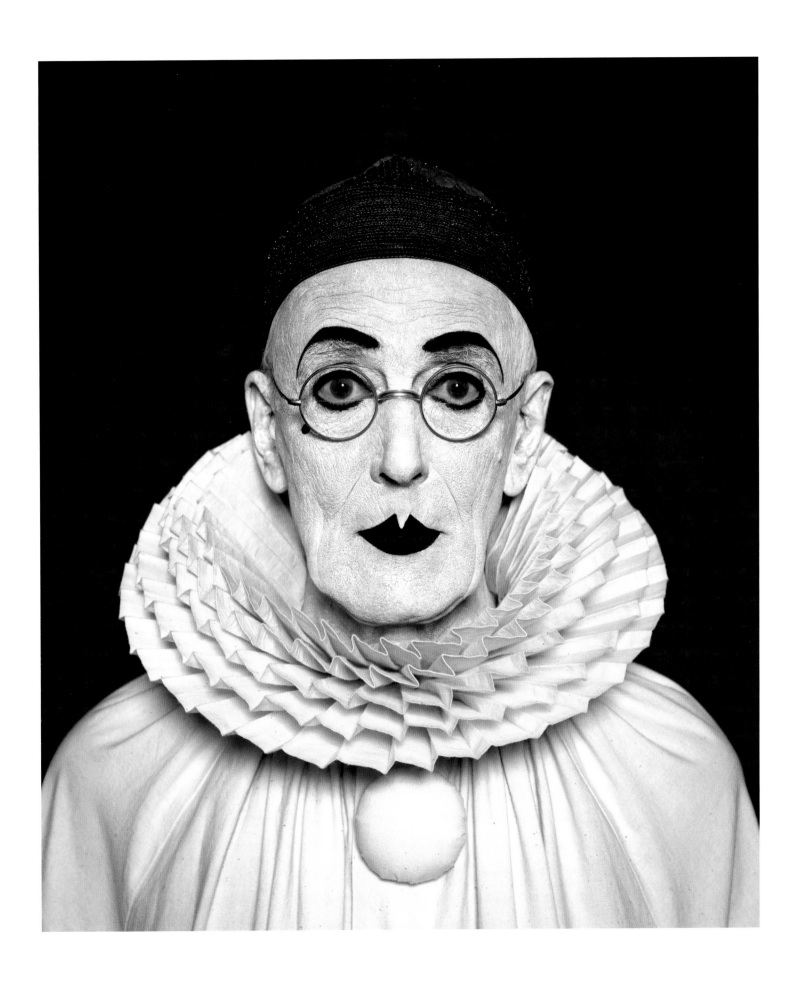

After Nadar: Pierrot Turning (detail), 2012

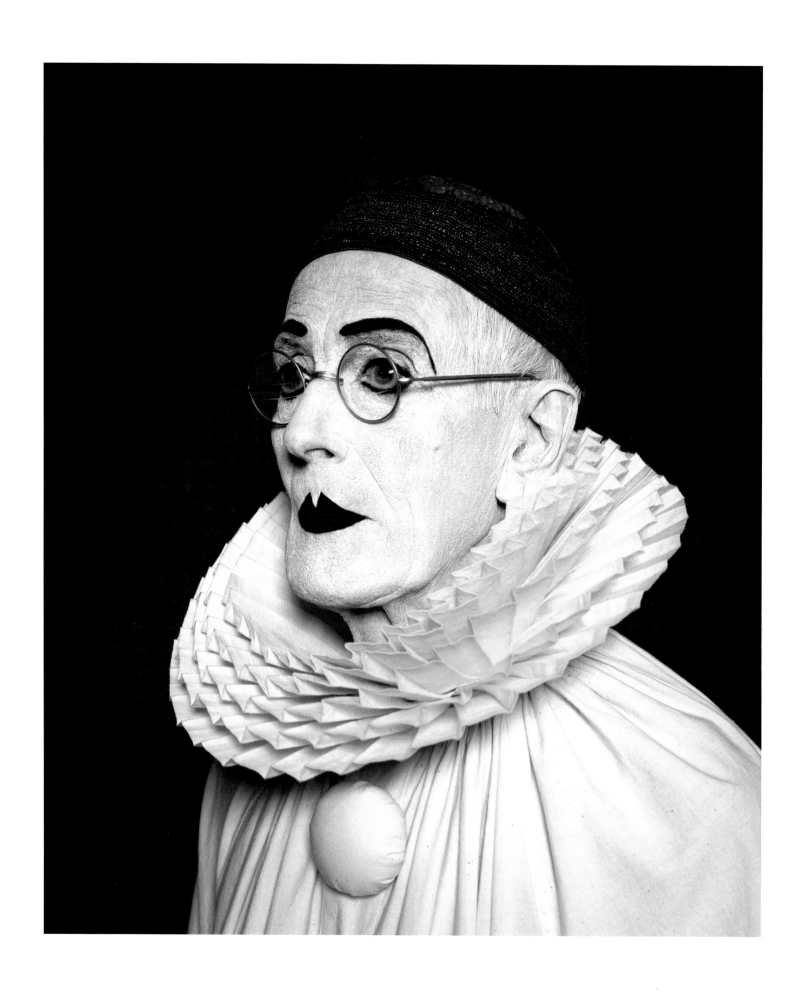

After Nadar: Pierrot Turning (detail), 2012

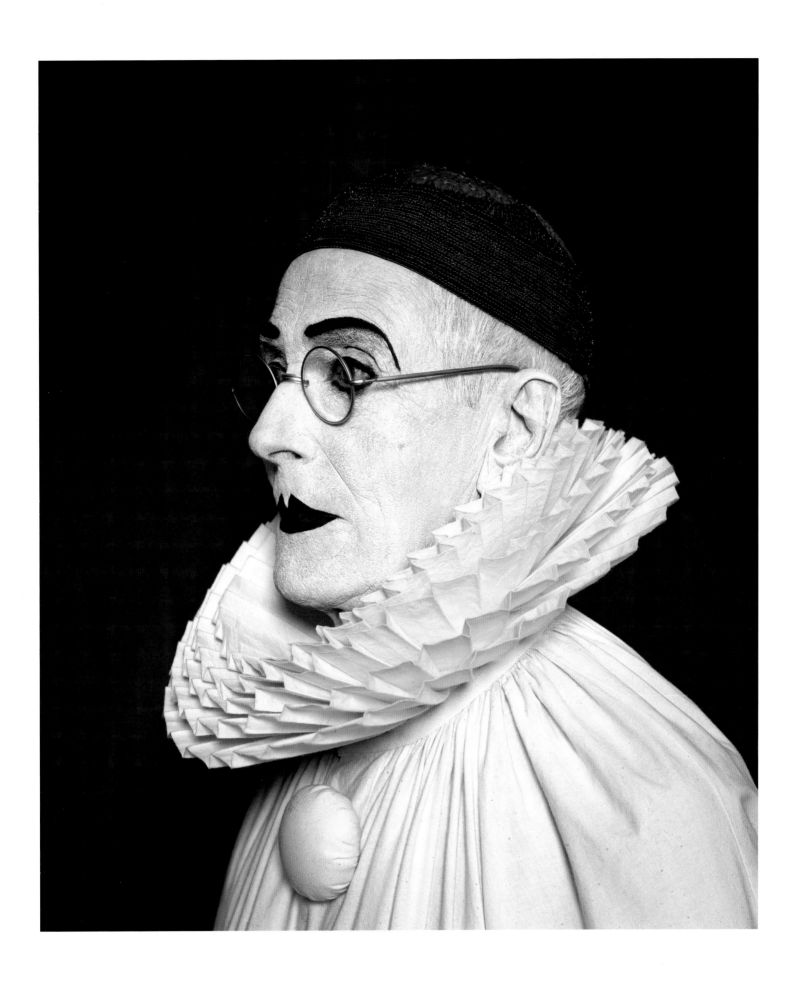

After Nadar: Pierrot Turning (detail), 2012

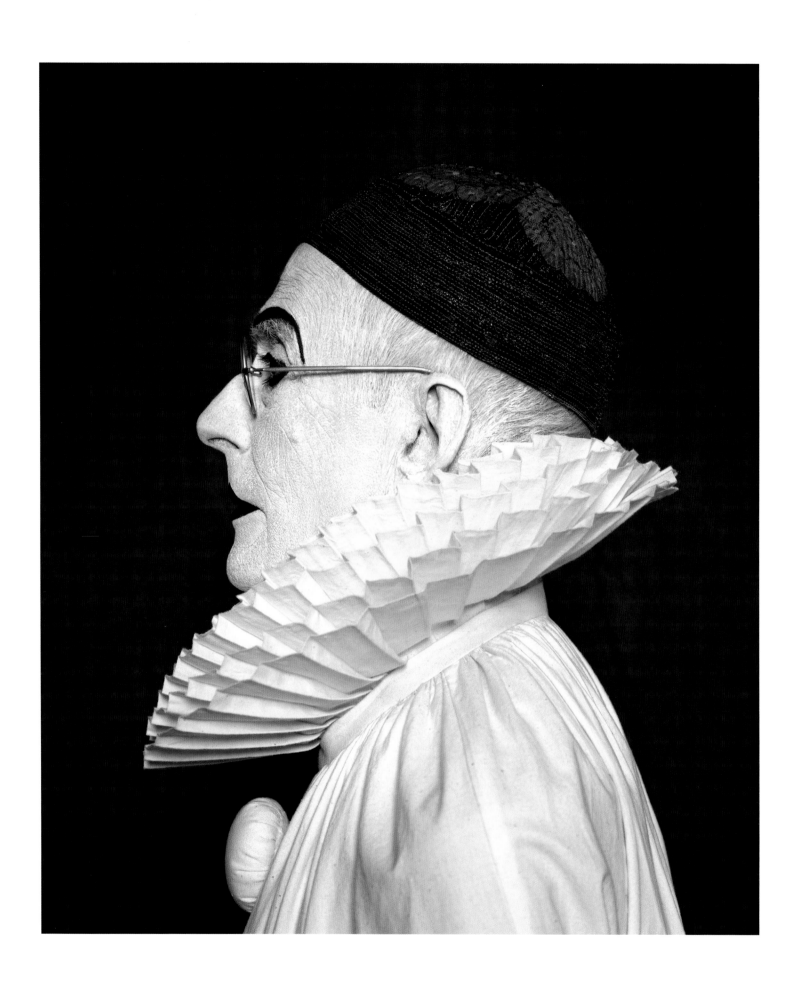

After Nadar: Pierrot Turning (detail), 2012

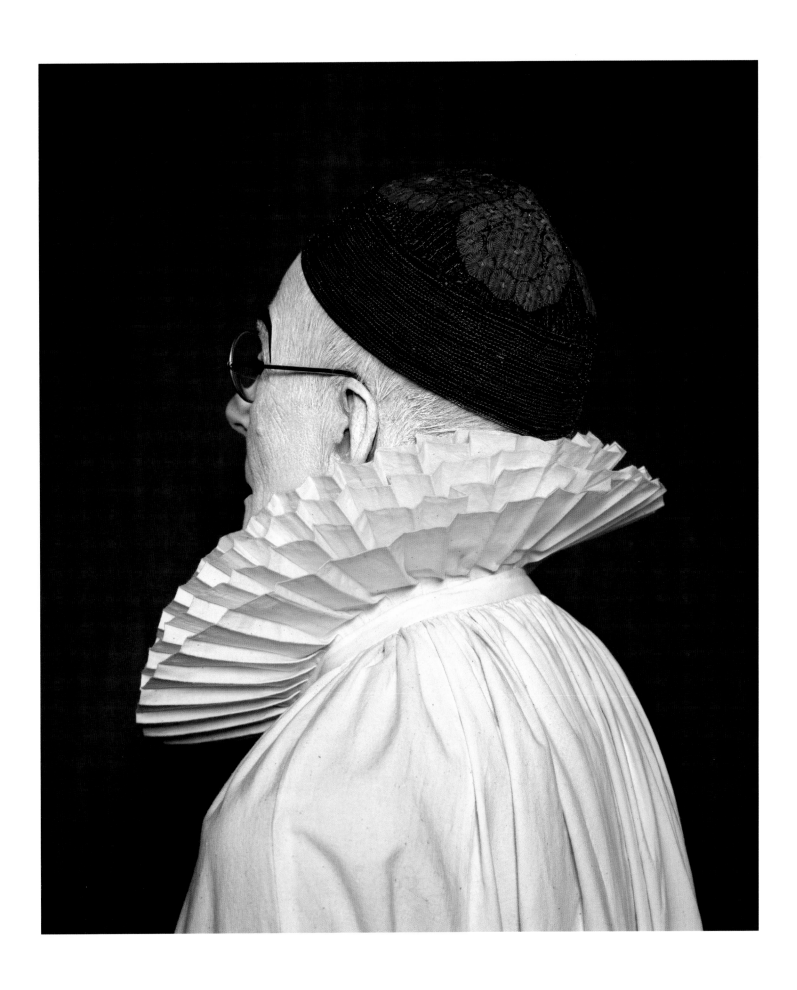

After Nadar: Pierrot Turning (detail), 2012

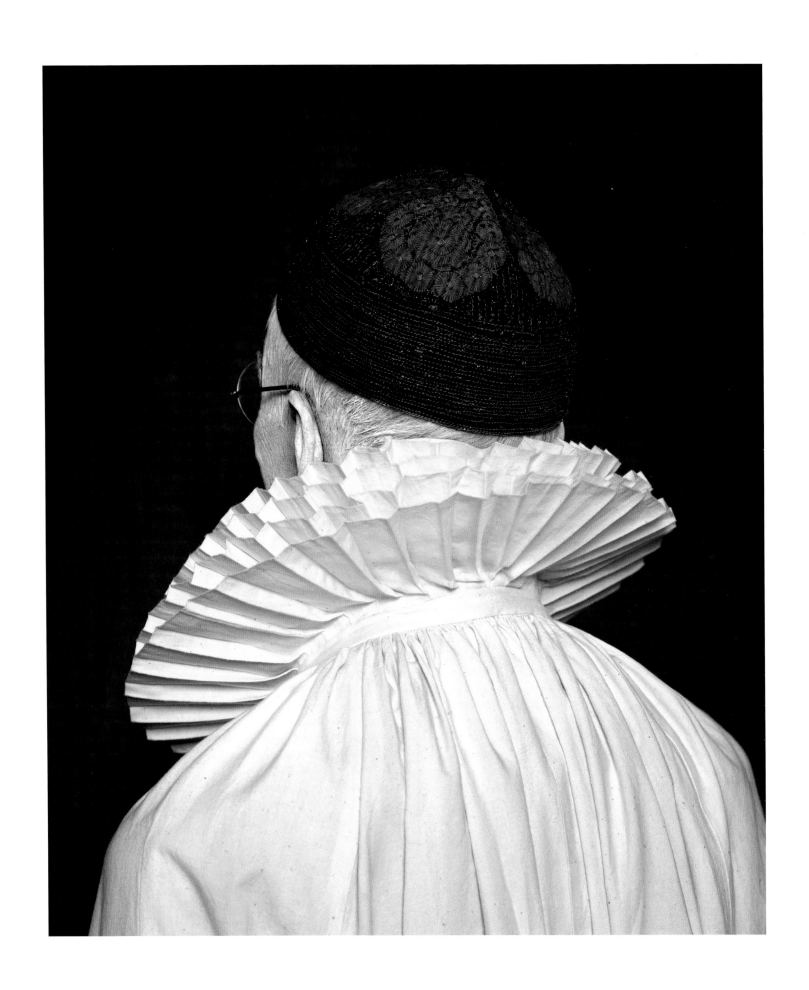

After Nadar: Pierrot Turning (detail), 2012

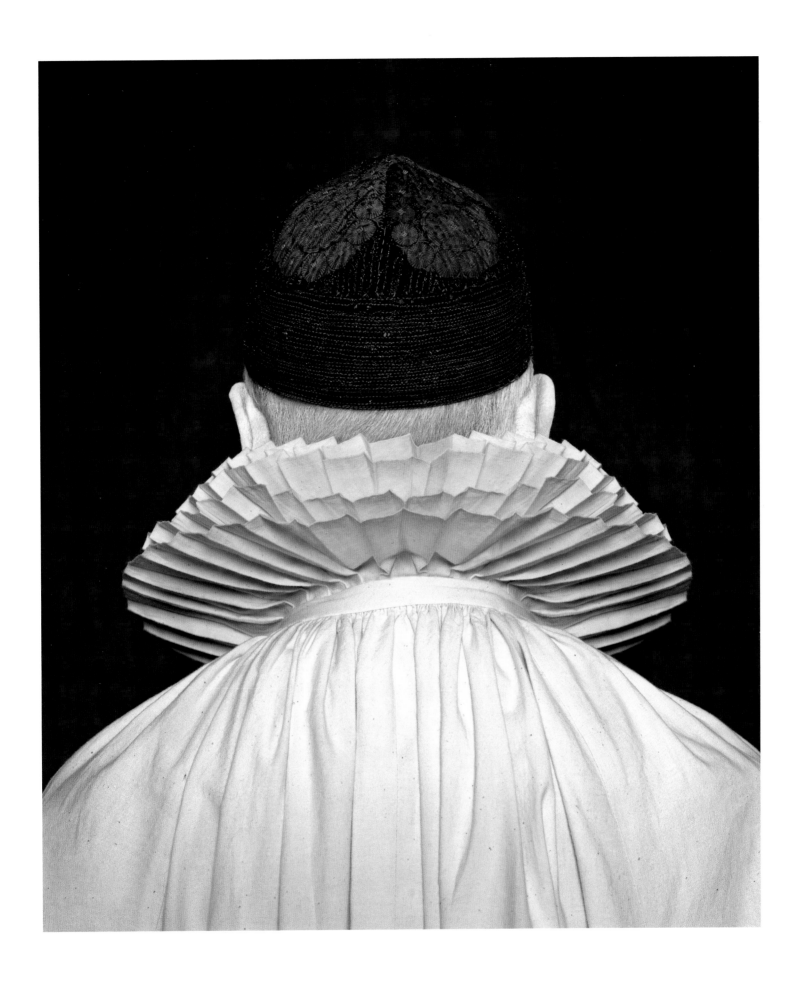

After Nadar: Pierrot Turning (detail), 2012

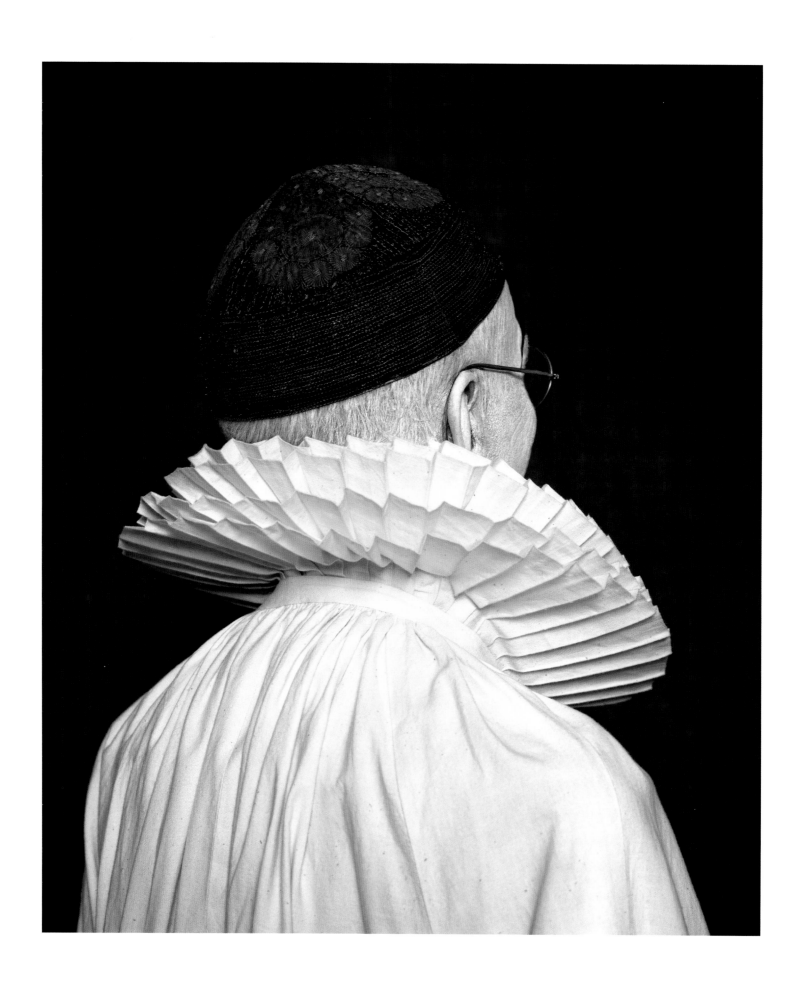

After Nadar: Pierrot Turning (detail), 2012

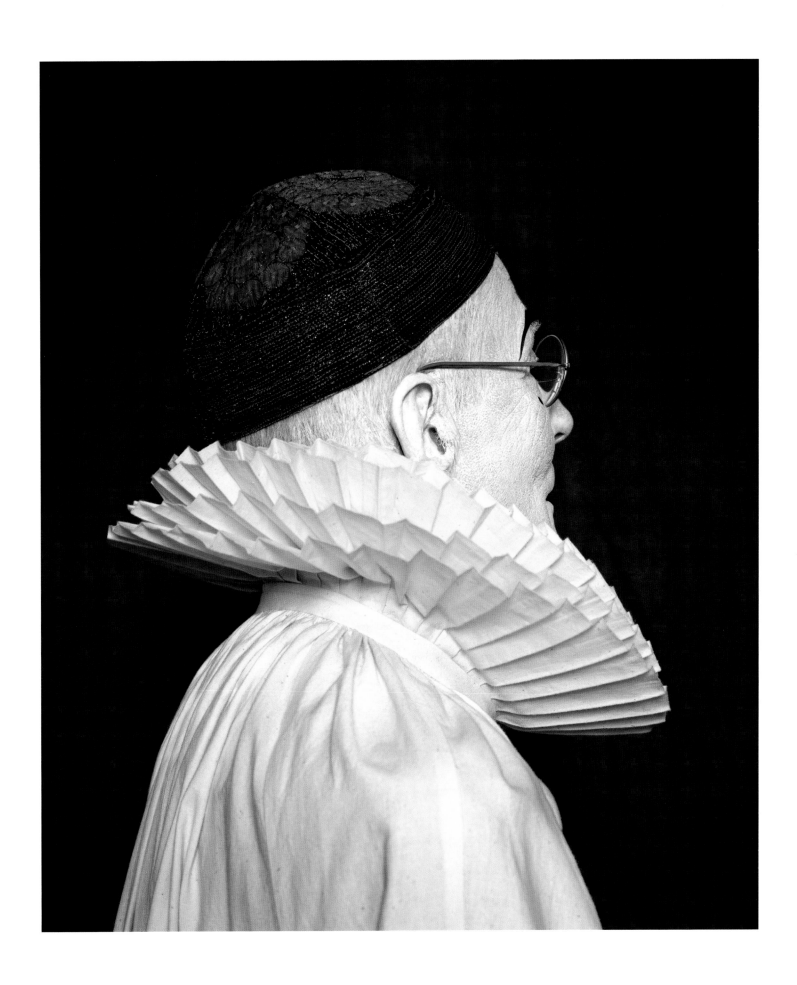

After Nadar: Pierrot Turning (detail), 2012

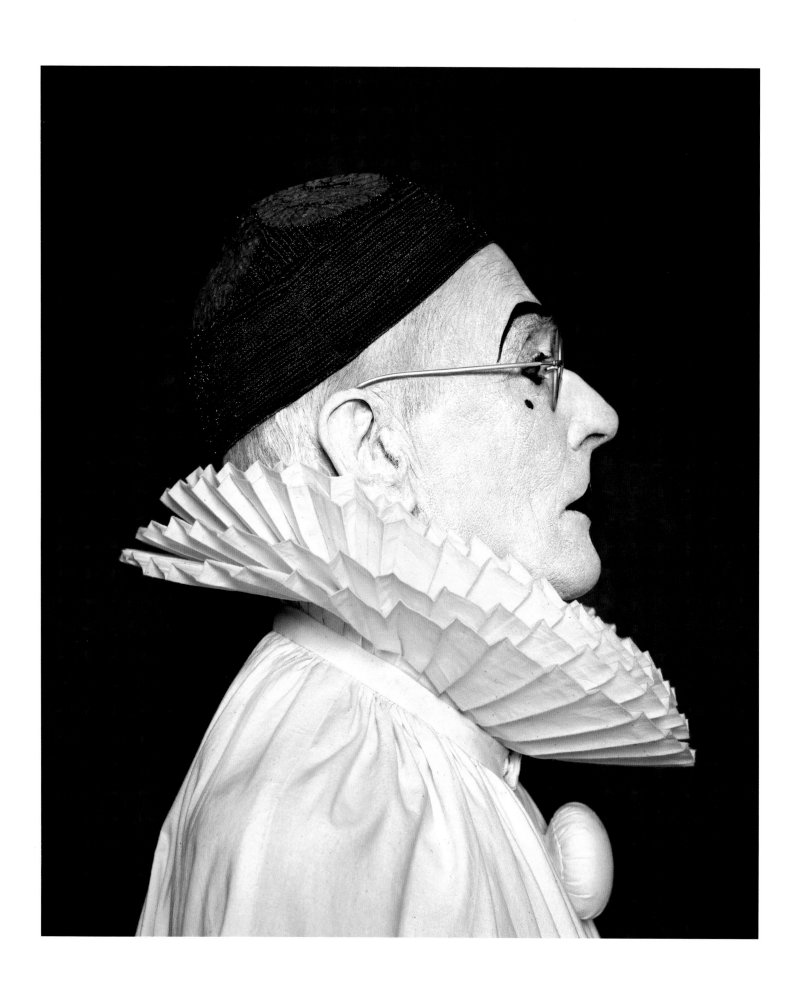

After Nadar: Pierrot Turning (detail), 2012

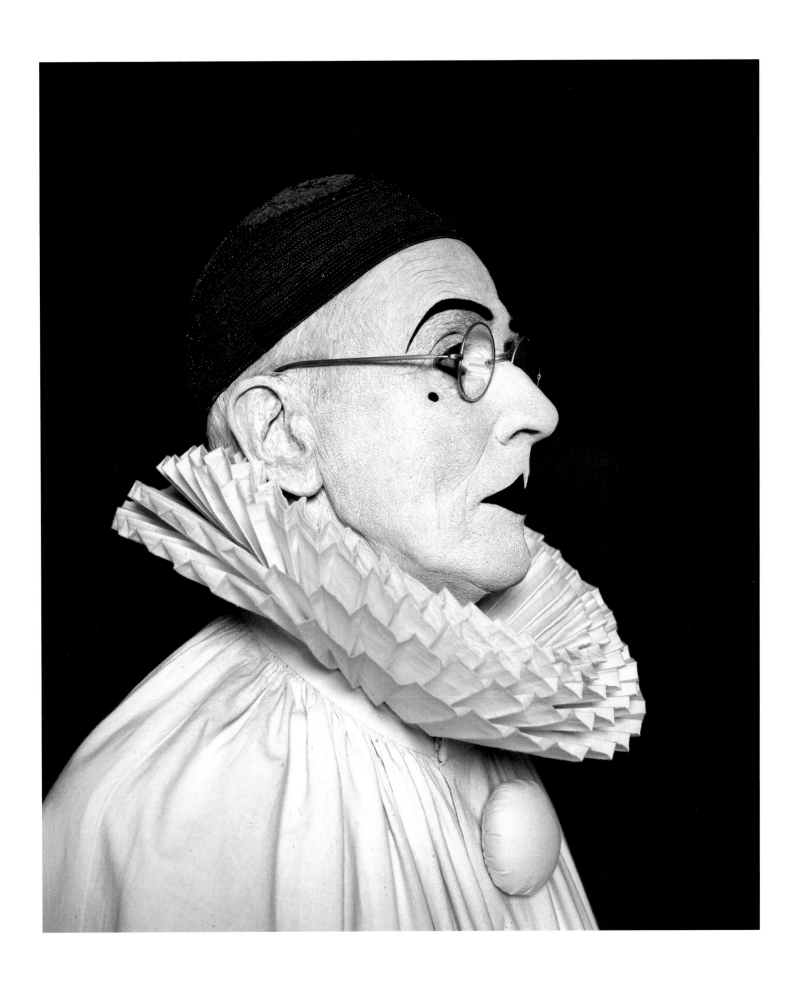

After Nadar: Pierrot Turning (detail), 2012

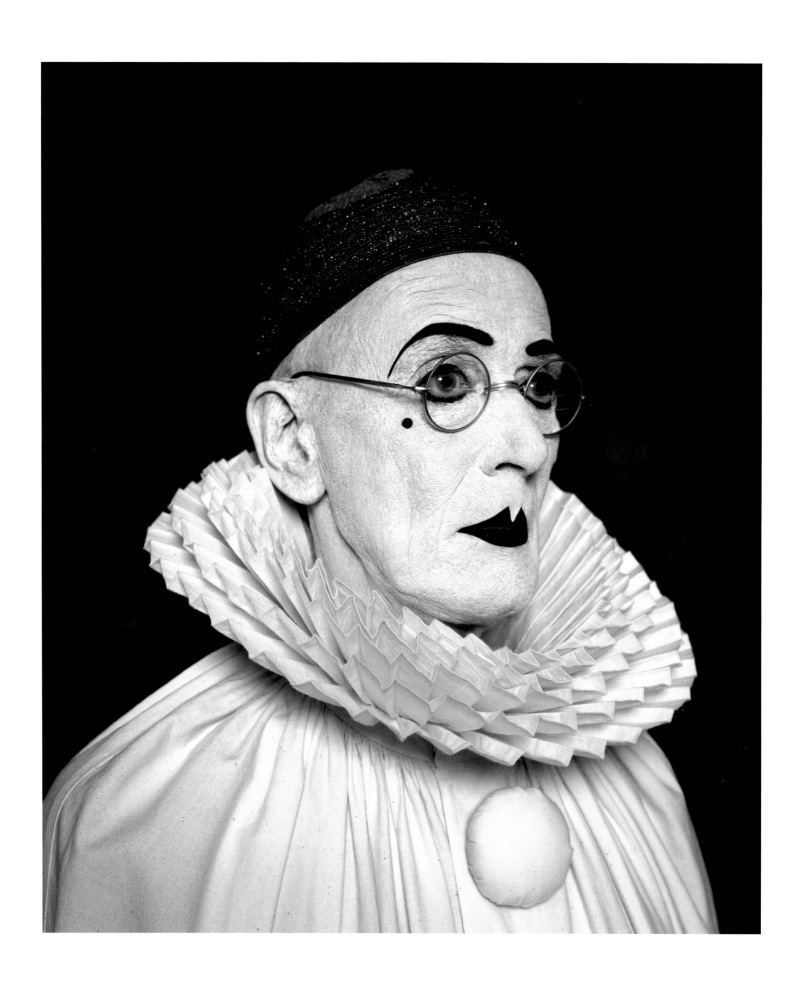

After Nadar: Pierrot Turning (detail), 2012

ARNAUD MAGGS

SCOTIABANK
PHOTOGRAPHY
AWARD
2012

STEIDL | Scotiabank™

First edition published in 2013 on the occasion of the awarding of the
2012 Scotiabank Photography Award to Arnaud Maggs

Book design by Barr Gilmore
Photographic production and management by Katyuska Doleatto
Project management by Amanda Sebris
Copy editing by Kate Pocock

All photography by Arnaud Maggs, unless otherwise noted
All digital colour work by Daniel Ebert and Stephen Brookbank, Toronto Image Works, Toronto
Additional colour work by Steidl's digital darkroom
Production and printing by Steidl, Göttingen

Cover image: Arnaud Maggs, *Joseph Beuys, 100 Frontal Views* (detail 17), 1980
Back cover image: Arnaud Maggs, *Joseph Beuys, 100 Profile Views* (detail 60), 1980

Steidl
Düstere Str. 4 / 37073 Göttingen, Germany
Phone +49 551 49 60 60 / Fax +49 551 49 60 649
mail@steidl.de
www.steidlville.com / www.steidl.de

ISBN 978-3-86930-591-2
Printed in Germany by Steidl

This catalogue was generously sponsored by Scotiabank.

Library and Archives Canada Cataloguing in Publication

Arnaud Maggs, 1926-2012
Arnaud Maggs
Contributing authors: Doina Popescu; Maia-Mari Sutnik; Sophie Hackett [et al.]

The estate of Arnaud Maggs is represented by Susan Hobbs Gallery, Toronto.
www.susanhobbs.com

CONTENTS

SPONSOR'S FOREWORD

RICK WAUGH, CHIEF EXECUTIVE OFFICER OF SCOTIABANK

At the 2012 Scotiabank CONTACT Photography Festival, Scotiabank was delighted that Arnaud Maggs had been chosen as the second recipient of the Scotiabank Photography Award. Arnaud is an extraordinary artist whose unique portraits have earned him international recognition. With this publication and feature exhibition at the 2012 Scotiabank CONTACT Photography Festival, we hope to share his compelling work with a broader worldwide audience.

Through our Scotiabank Bright Future program, our goal is to make a difference by supporting organizations and projects that have a direct, immediate impact on communities where we live and work around the world. This includes a strong focus on arts, culture and heritage programs, as well as making art more accessible to the public. Our Scotiabank Fine Art Collection, established in 1976, has helped us achieve this with an impressive portfolio, which is on display to the public in our offices and branches.

The Scotiabank CONTACT Photography Festival and Scotiabank Photography Award celebrate the creative vision and accomplishments of Canada's most gifted photographers. We hope that, together, our projects will continue to enrich our cultural life and raise the profile of our country's best photographic talent.

SCOTIABANK PHOTOGRAPHY AWARD

E D W A R D B U R T Y N S K Y & J A N E E . N O K E S

On behalf of Scotiabank, we are pleased to introduce *Arnaud Maggs*, the second in a series of publications distributed worldwide by Gerhard Steidl celebrating the winner of the annual Scotiabank Photography Award (SPA) and the art of photography in Canada.

This book and the Award create a testament to the power of photography to tell us the stories of who we were and who we have become. Arnaud Maggs was chosen for his particular ability to bring the past into the present in a meaningful way. *Arnaud Maggs* demonstrates the range and consistency of the artist's vision comprising pristine, technically brilliant images.

The Scotiabank Photography Award is the largest peer-reviewed photographic art award in Canada recognizing a mature and accomplished body of work by an established Canadian artist working in the medium of photography—both in the extended scope and the monetary value of the prize. The winning artist is selected on the basis of an arc of work. This body of work is celebrated in this book that presents a coherent overview of the artist's vision and excellence in execution over a period of time and in a feature exhibition at the following year's Scotiabank CONTACT Photography Festival in Toronto.

Scotiabank is Canada's most international bank and the Scotiabank Photography Award reinforces its mission to support the best Canadian visual art talent and to raise the artist's profile to a worldwide audience. The Award's three components, the $50,000 cash to the winning artist (and $5,000 to each of the other two short-listed artists), the book deal with Gerhard Steidl and the feature exhibition at Scotiabank CONTACT Photography Festival combine to reward the winning artist in the most positive, tangible and meaningful way.

The Scotiabank Photography Award is made possible by an extraordinary and committed team. Individuals throughout Scotiabank and in organizations and institutions across Canada and around the world have made the award assured of a sustainable and dynamic future.

We wish to thank every member of the team, especially Rick Waugh, Brian Porter and Sabi Marwah for their belief in us and our vision. Barbara Mason, Sue Graham-Parker, and John Doig have provided policy and procedural support at key moments in the launch of SPA.

We are indebted to Gerhard Steidl and designer Barr Gilmore for this strikingly beautiful publication.

Thanks as well to many other Scotiabankers whose support has been unwavering and critical to the success of this unique award program.

Darcy Killeen and the Scotiabank CONTACT Photography Festival staff, and Todd Sharman, Chair of the Scotiabank CONTACT Photography Festival, and the rest of our fellow CONTACT Board members have been solidly behind us and committed to making the Award work.

We want to express our gratitude to Nicholas Metivier of Nicholas Metivier Gallery, our longtime friend, strategic advisor, and constant collaborator, to Karen Machtinger, Marcus Schubert and the team at the Edward Burtynsky Studio, to Corrado Santoro, Audrey Raymond and the team at Scotiabank Archives, Corporate Records and Fine Art, and to Doina Popescu and Sara Angelucci at the Ryerson Image Centre.

Thanks to Amanda Sebris, Scotiabank Photography Award Administrator, for her patience, dedication and commitment to excellence.

Our Nominators for the 2012 Scotiabank Photography Award were: Stephane Aquin (Montreal), Robert Enright (Winnipeg), Shirley Madill (Kitchener), Anne-Marie Ninacs (Montreal), Lori Pauli (Ottawa), Sheila Perry (St John's), Doina Popescu (Toronto), Bernie Riordan (Fredericton), Reid Shier (Vancouver), Jeffrey Spalding (Calgary), Vincent Varga (Saskatoon), and Liz Wylie (Kelowna). Our thanks to each Nominator who produced a thoughtful and extensive nomination package, on time and to the exacting specifications of the Award. Our pre-eminent Jury—William A. Ewing, Karen Love and Ann Thomas—contributed professionalism, expertise and exacting eyes for excellence. We are very grateful for their commitment and enthusiasm in supporting the evolution of the award.

We would also like to acknowledge the insightful and knowledgeable Sophie Hackett and Maia-Mari Sutnik who have contributed essays highlighting important series in Arnaud Maggs's œuvre, and commend Doina Popescu for nominating the artist and for her passionate nominator's introduction.

Congratulations as well to the 2012 shortlisted artists Fred Herzog and Alain Paiement and we thank them for their time and participation in the Award.

Special thanks to Kate Pocock, Daniel Ebert, Stephen Brookbank and to Arnaud's team of Katyuska Doleatto, Susan Hobbs and the gracious and courageous Spring Hurlbut.

Finally, we welcome the second winner of the Scotiabank Photography Award, Arnaud Maggs. With *Arnaud Maggs* we are honoured to present the range of Maggs's œuvre, his fascination and extended interaction with the archival image, his imagination and his technical expertise, his commitment to excellence and his use of both the ordinary and the extraordinary to illustrate the history of the world.

Arnaud Maggs reinforces our commitment to making the Scotiabank Photography Award an annual search for excellence, to move it forward as one of Scotiabank's major art, culture and heritage initiatives, and to help it take its place as one of Canada's richest showcases for contemporary photographic art.

With this and subsequent annual publications, we invite you to explore the vision, imagination and achievement of Canada's leading contemporary photographers.

As the Chair of the Scotiabank Photography Award Jury and the Executive Director of the Award program, we are pleased and proud to re-dedicate ourselves to the Award's goals.

EDWARD BURTYNSKY, CHAIR JANE E. NOKES, EXECUTIVE DIRECTOR

INTRODUCTION

DOINA POPESCU WITH RACHEL VERBIN

It was a great pleasure to nominate Toronto-based artist Arnaud Maggs (b. Montreal, 1926) for the 2012 Scotiabank Photography Award (SPA). Having followed the development of his artistic production with keen interest for many years, I feel strongly that his work remains as relevant today as ever, and I am pleased, together with my colleagues at the Ryerson Image Centre, to congratulate Arnaud Maggs as the 2012 SPA Award winner.

In 1973, at the age of 47, Maggs left behind a successful career as a commercial illustrator and fashion photographer to dedicate himself to the fine arts.[1] He has since worked emphatically as a photographic artist for more than three decades. The production of his first major work in 1976-1978, *64 Portrait Studies*—thirty-two anonymous models, photographed frontally and in profile from the shoulders up, arranged in a grid to a total of 64 black and white, gelatin silver photographs[2]—laid the groundwork for an artistic vision that Maggs has carried through to the present, with continuous development and innovation, with remarkable technical expertise and with utmost attention to detail. Since 1994, Maggs's interest in archival practice has led him to photograph objects and books of extreme beauty, rarity and historical importance. These pristine, technically brilliant images are, moreover, at the forefront of a current trend within contemporary art: the archive.[3]

Maggs uses photography to delicately explore and document people and objects. His work speaks as much about the history of the photographic medium and about archival research and practice as it does about his subject matter, which over the years has transitioned from the human head and face to historic materials, from black and white to colour and from analogue to digital. As noted by former Power Plant curator Philip Monk in the 1999 catalogue *Arnaud Maggs: Works, 1976-1999*, Maggs's artistic production was (at that time) divided into three stages: "portraits" (1976 to 1984), "transitional" (1988 to 1991) and "archival works" (beginning in 1994).[4] To coincide with Maggs's most recent projects—which see him returning to portraiture—the pieces featured in the 2013 SPA exhibition and catalogue primarily focus on portrait work.

Maggs's early "portraits" were characterized by his photographic explorations of the human head and face, captured in black and white as frontal and profile views, installed as enlargements compiled into large-format grids, or as grids constructed from contact prints of his medium-format negative strips. From the anonymous sitters featured in *64 Portrait Studies,* Maggs's focus turned to artistic and cultural producers, aficionados and icons, including German conceptual artist Joseph Beuys, French photographer André Kertész, chefs from the Ledoyen restaurant in Paris and students attending the Kunstakademie in Düsseldorf. He also photographed himself. Northrop Frye, Ydessa Hendeles, Jane Jacobs, John Max and Paul Wong were just a handful of the 162 Canadians captured by Maggs in *48 Views* (1981-1983). Together these portraits form an archival document of the Canadian artistic scene at the time.[5]

Maggs's transitioning from photographs of people to objects began with *The Complete Prestige 12" Jazz Catalogue* (1988) and *Hotel* (1991). His interest shifted to the numerical cataloguing of jazz records and the graphic design of Parisian hotel signs. His "archival" photographs made their debut in 1994 with *Travail des enfants dans l'industrie,* a series of 198 colour photographs of nineteenth-century child worker tags from a French

garment factory, which Maggs rescued for posterity from a flea market. Maggs's archival work then grew to include photographic documentations of nineteenth-century death notices (*Notification*, 1996) and the clientele book of Eugène Atget (*Répertoire*, 1997)—*the* photographer made famous for his late-nineteenth and early-twentieth century images of Paris.

These detailed, repetitious, photographic explorations, which Maggs formulates into series and grids, sometimes capturing both recto and verso (as in the case of *Les factures de Lupé*), lifts left-behind objects from historic obscurity, "elevating them photographically into art" according to Monk: "Having purchased this material first found by accident and then sought out, Maggs became its unofficial archivist: he collected, preserved, and then documented the 'collection' photographically."[6]

With *The Dada Portraits* (2010) and *After Nadar* (2012), Maggs revives his interest in portraiture, all the while retaining a love for found objects and history, linking the past with the present and the photographer with his influences. Once architectural drawings from 1850 (another remarkable French flea market find), *The Dada Portraits* are now graphically rich representations of artists Marcel Duchamp, Hannah Höch and Max Ernst, among others.[7] *After Nadar*, a series of self-portraits recalling Gaspard-Félix Tournachon's (otherwise known as Nadar) mid-1850s photographs of the mime Charles Deburau, also features many of the objects photographed and collected by Maggs over the years.

Photographic modernism demanded that fine art photographs be faithful to the medium and its specific characteristics; essentially, photographs were to be about the formal qualities of photography.[8] In comparison, conceptual art practices of the 1960s and 1970s were more reflective and exploratory, putting ideas before aesthetics.[9] Fittingly, Art Gallery of Ontario curator Maia-Mari Sutnik contextualizes Maggs's work as interplay between these two movements: Maggs's art is embedded in the modernist tradition of formalism that still involves pictorial problem solving, an issue that is richly resolved in his photographic work. However, Maggs's artistic building blocks have programmatically evolved and taken on a different conceptual vocabulary.[10]

The large scale of Maggs's photographic production—inspired by minimalist sculptor Carl Andre[11]—and his interest in archival practice, give his work a growing importance within the art world. David Campany's *Art and Photography* examines themes prevalent in photographic art in recent decades, including "Memories and Archives" and "Objective Objects." It is here that we can situate Maggs's œuvre, from the 1970s to the present: building bridges between modernism and conceptual art, while using photography to create dialogues between memories, archives, objects and people.

Maggs's work can be appreciated on various levels: from the beauty of a nineteenth-century mould-ridden journal doused in soft jewel tones (*Contamination*, 2007) to the serial documentation of people, both famous and unknown, formulated in a mug-shot style that references that of nineteenth-century criminologist Alphonse Bertillon.[12] Maggs's photographs also convey current theories related to the study of the history of photography, which stress the importance of using first generation objects as research tools to re-examine history.[13] With his "archival" work and latest portrait pieces, Maggs brings viewers face to face with books and ephemera, skillfully photographed, re-presented and gracefully shared with us as works of fine art.

Since his 1978 showing of *64 Portrait Studies* in Toronto and Halifax, Maggs has had solo exhibitions in Toronto, Montreal, Vancouver, New York and Paris. He has participated in group exhibitions at The Photographers' Gallery, London; the International Center of Photography, New York; the Musée de l'Elysée, Lausanne; and the Fondation Cartier, Paris, among others. His work is held in more than thirty public and private collections in Canada and France. In 2006, he received the Governor General's Award in Visual and Media Arts.

In 2012, the National Gallery of Canada honoured Maggs's thirty-five-year career with the survey exhibition *Arnaud Maggs: Identification*. The exhibition and its accompanying catalogue displayed Maggs's mastery as a conceptual artist, photographic producer and astute collector, from *64 Portrait Studies*, to *Hotel*, *Notification*, *The Dada Portraits*, and vitrines showcasing his collectables and journals.

By focusing on his portraits some three decades after he created his "first work,"[14] the SPA exhibition and catalogue celebrates Maggs's artistic development and achievements, awarding his momentous, continuously evolving career while highlighting his most current artistic pursuits. •

1. Josée Drouin-Brisebois, "Arnaud Maggs: Portrait of a Working Artist," in *Arnaud Maggs: Identification*, ed. Carolyn Wetherilt (Ottawa: National Gallery of Canada, 2012), 26; Ben Portis, "Evidence of Existence: A Conversation with Toronto-based Photographer Arnaud Maggs," Art on Paper, May/June 2008, 64.

2. Philip Monk, ed., *Arnaud Maggs: Works, 1976-1999* (Toronto: The Power Plant Contemporary Art Gallery, 1999), 34; Blake Gopnik, "Turning Repetition into Artistic Virtue; Art Review, Arnaud Maggs: Works," *The Globe and Mail*, April 17, 1999, C.11.

3. See for example: "Collecter. Recycler. Usages de l'archive photographique dans la création contemporaine," Centre photographique d'Île-de-France, 2010; "La revanche de l'archive photographique," Centre de la Photographie—Genève, 2010; "Order and Disorder: Archives in Photography," National Gallery of Victoria, Australia, 2008; "Archive Fever," International Center of Photography, New York, 2008; "Deep Storage: Collecting, Storing, and Archiving in Art," P.S.1, New York, 1998.

4. Philip Monk, "Life's Traces," in *Arnaud Maggs: Works, 1976-1999*, ed. Philip Monk (Toronto: The Power Plant Contemporary Art Gallery, 199), 19-20.

5. Gopnik, "Turning Repetition into Artistic Virtue," C.11.

6. Monk, "Life's Traces," 25-26.

7. Robert Enright, "Designs on Life: An Interview With Arnaud Maggs," *Border Crossings*, vol. 31, no. 2 (2012): 43-53.

8. Gilles Mora, *The Last Photographic Heroes: American Photographers of the Sixties and Seventies* (New York: Abrams, 2007), 127.

9. David Campany, *Art and Photography* (London/New York: Phaidon, 2003), 17.

10. Maia-Mari Sutnik, "Portraits by Arnaud Maggs," in *Arnaud Maggs: Works, 1976-1999*, ed. Philip Monk (Toronto: The Power Plant Contemporary Art Gallery, 199), 17.

11. Robert Enright, "Designs on Life: An Interview With Arnaud Maggs," *Border Crossings*, vol. 31, no. 2 (2012): 50.

12. "At this point I was still asking myself: 'How am I going to present these pictures?' And my mind went back to Alphonse Bertillon, the Paris police official who set up the systems of identifying people [...]." Charles A. Stainback, "Q and A: November 2011 Arnaud Maggs and Charles A. Stainback, in *Arnaud Maggs: Identification*, ed. Carolyn Wetherilt (Ottawa: National Gallery of Canada, 2012), 112.

13. Ilsen About and Clément Chéroux, "L'histoire par la photographie," *Études photographiques 10* (November 2001): 8-33.

14. "It was titled 64 Portrait Studies. It was my first work and I was excited about it at the time." Charles A. Stainback, "Q and A: November 2011 Arnaud Maggs and Charles A. Stainback, in *Arnaud Maggs: Identification*, ed. Carolyn Wetherilt (Ottawa: National Gallery of Canada, 2012), 112.

Doina Popescu is the Director, and Rachel Verbin the Project Research Fellow, at the Ryerson Image Centre in Toronto.

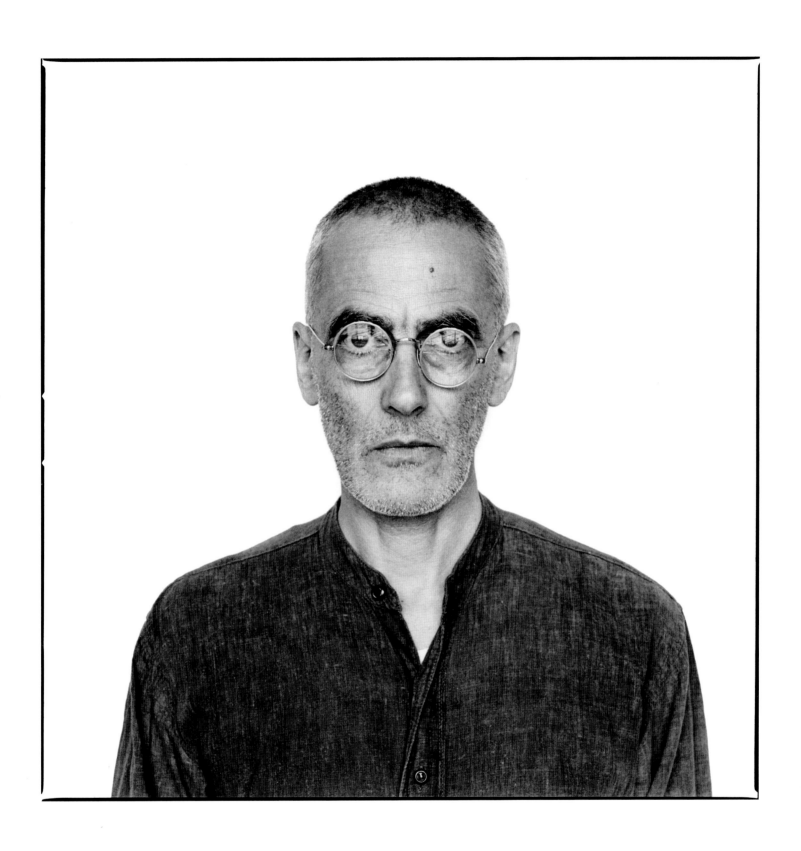

Self-Portrait (detail), 1983

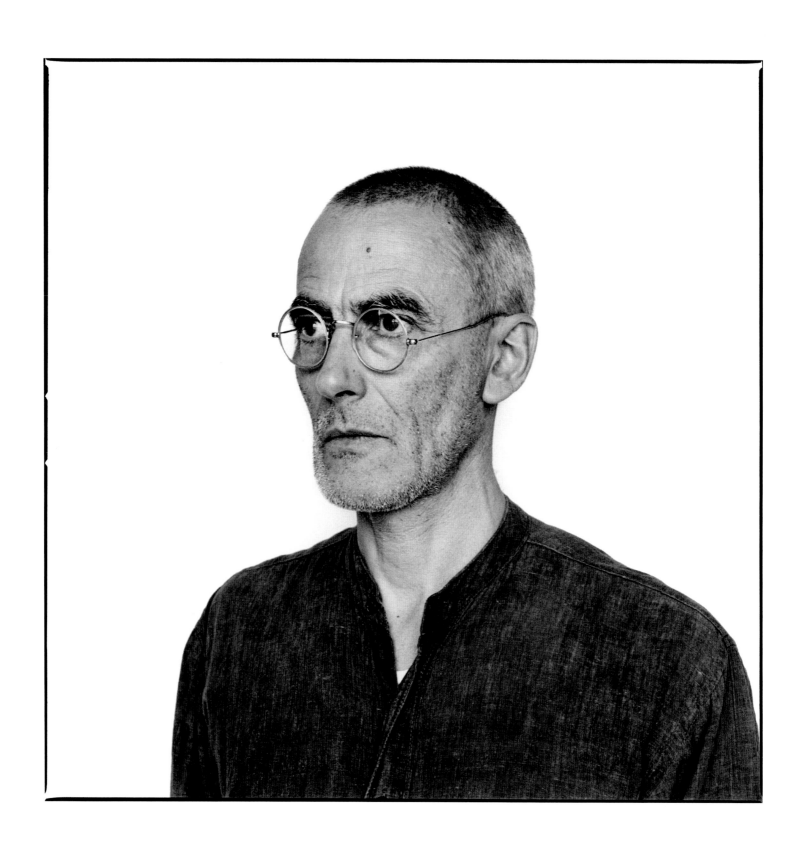

Self-Portrait (detail), 1983

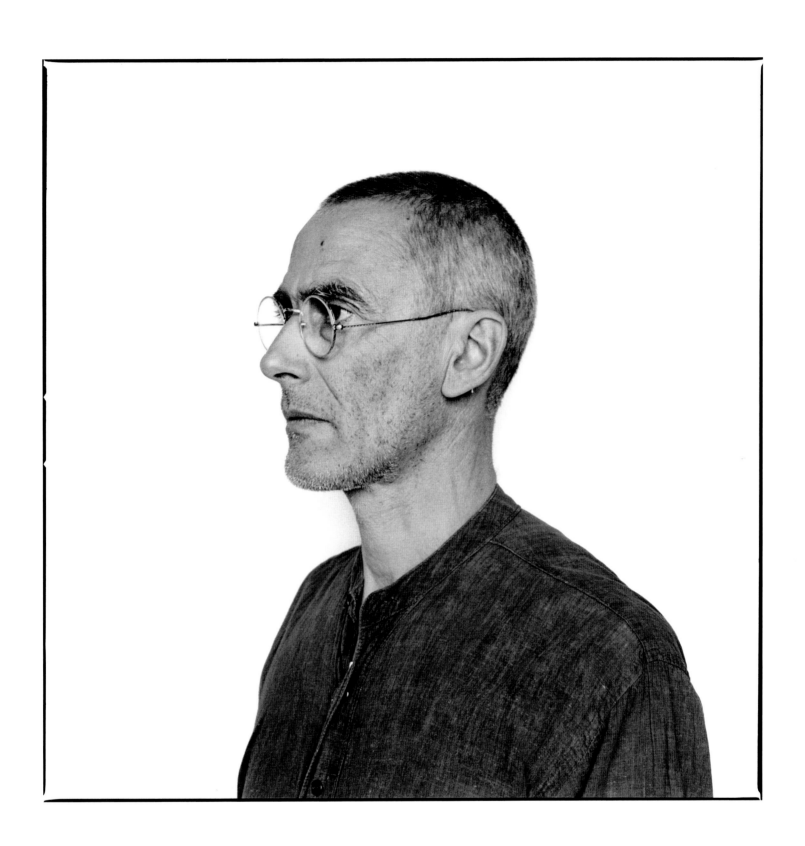

Self-Portrait (detail), 1983

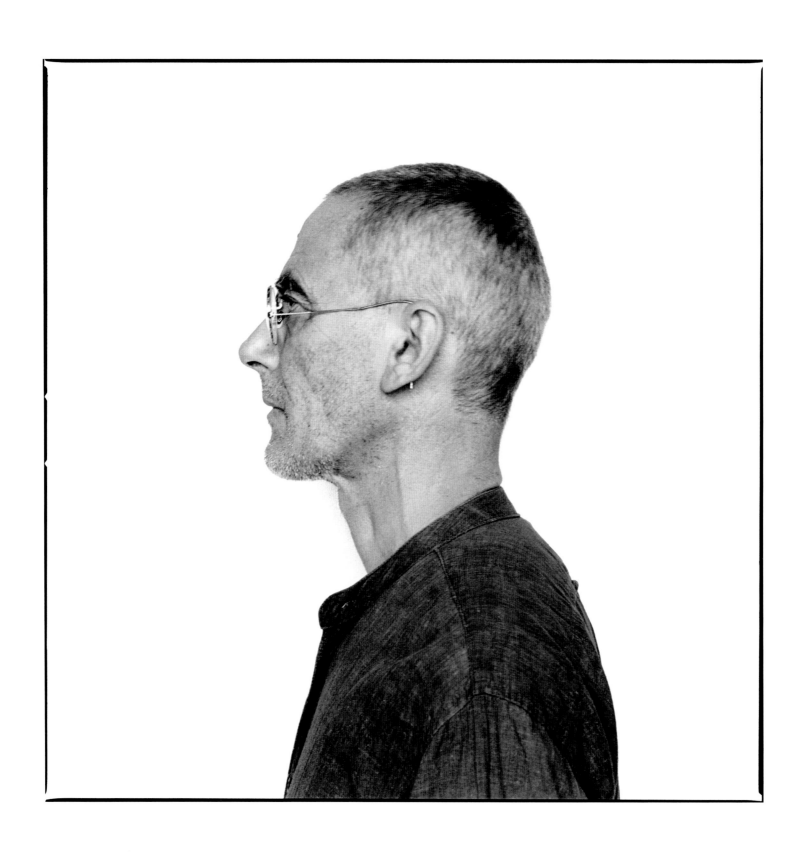

Self-Portrait (detail), 1983

Self-Portrait (detail), 1983

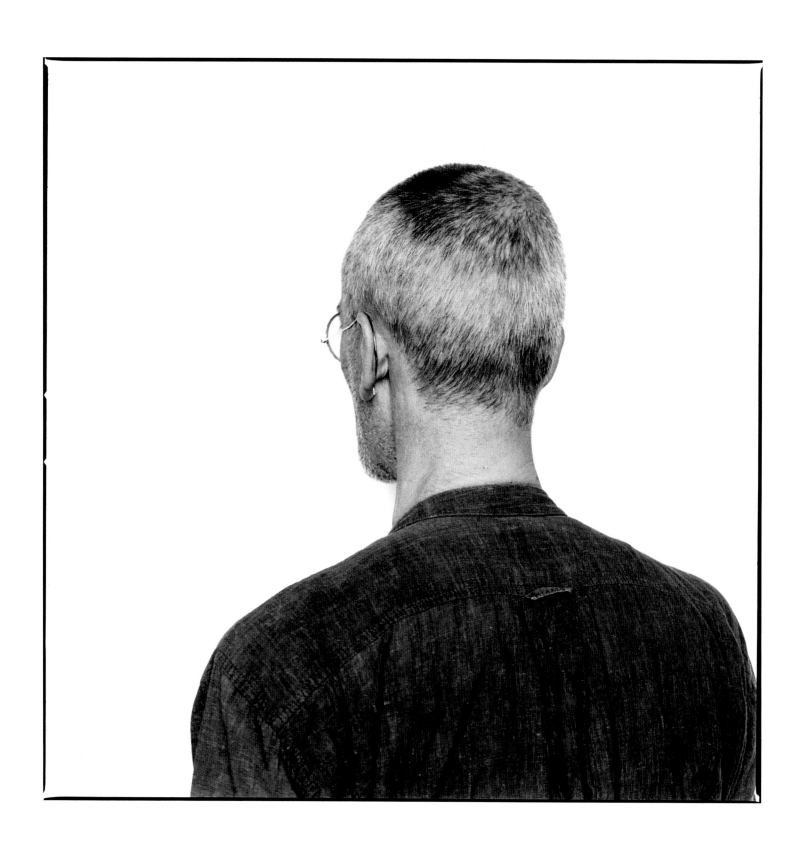

Self-Portrait (detail), 1983

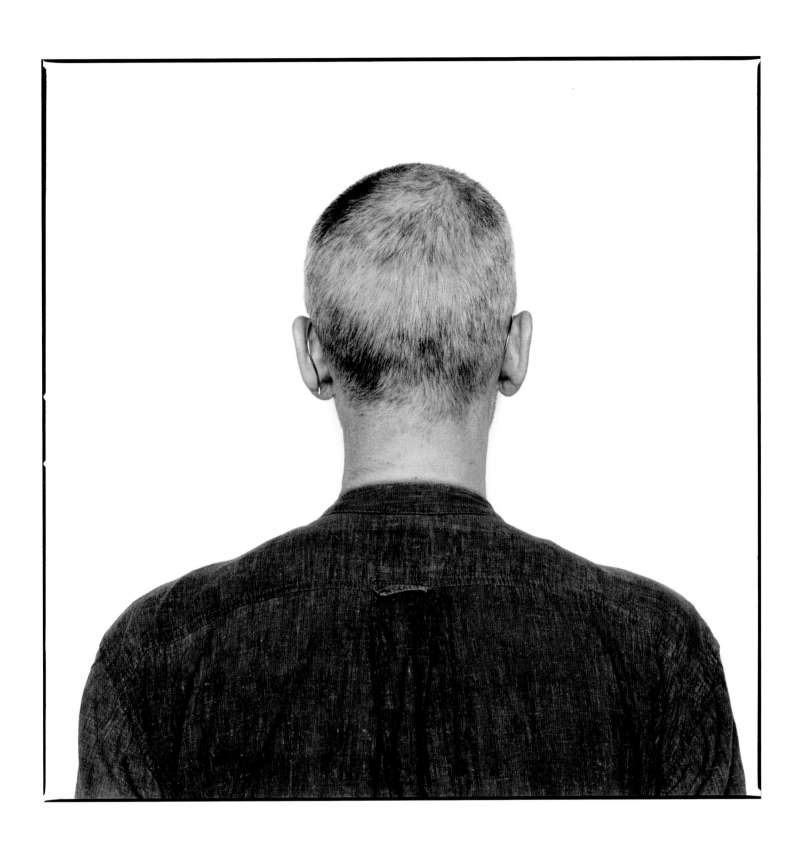

Self-Portrait (detail), 1983

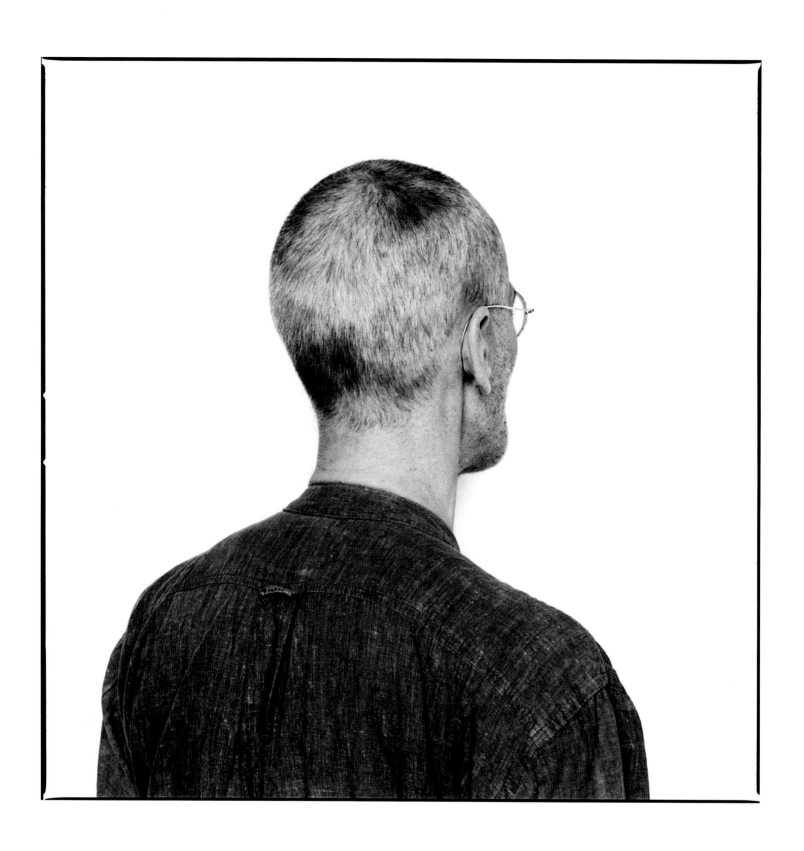

Self-Portrait (detail), 1983

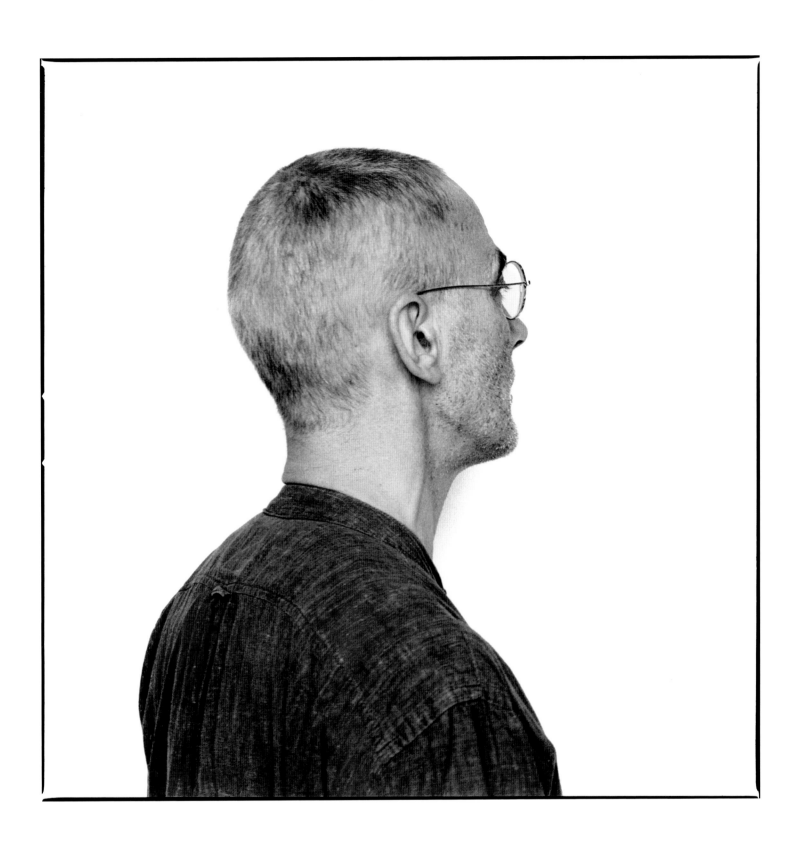

Self-Portrait (detail), 1983

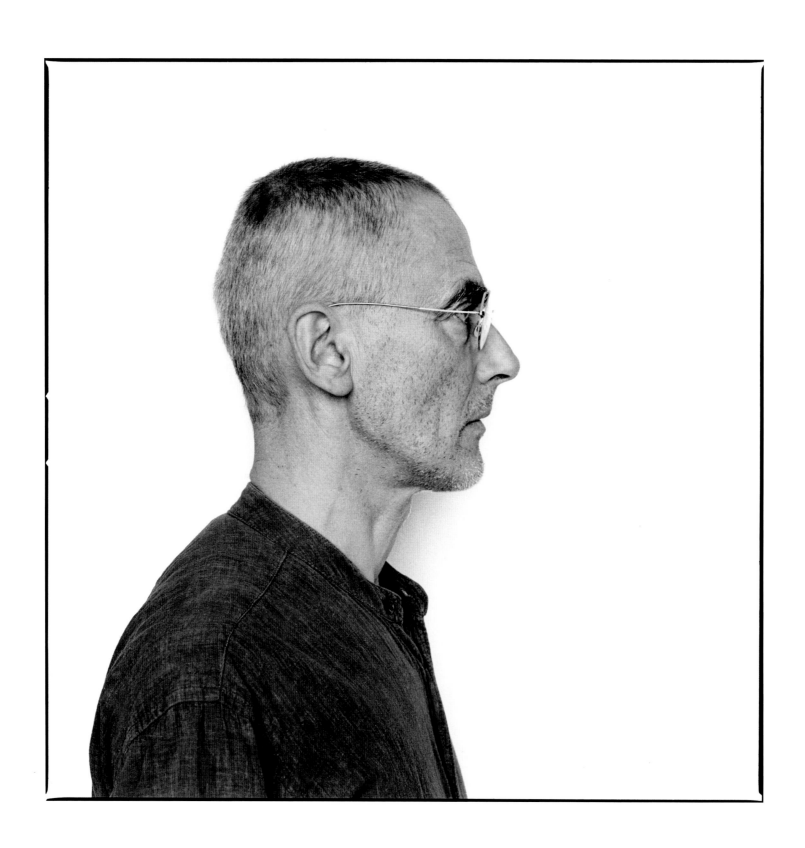

Self-Portrait (detail), 1983

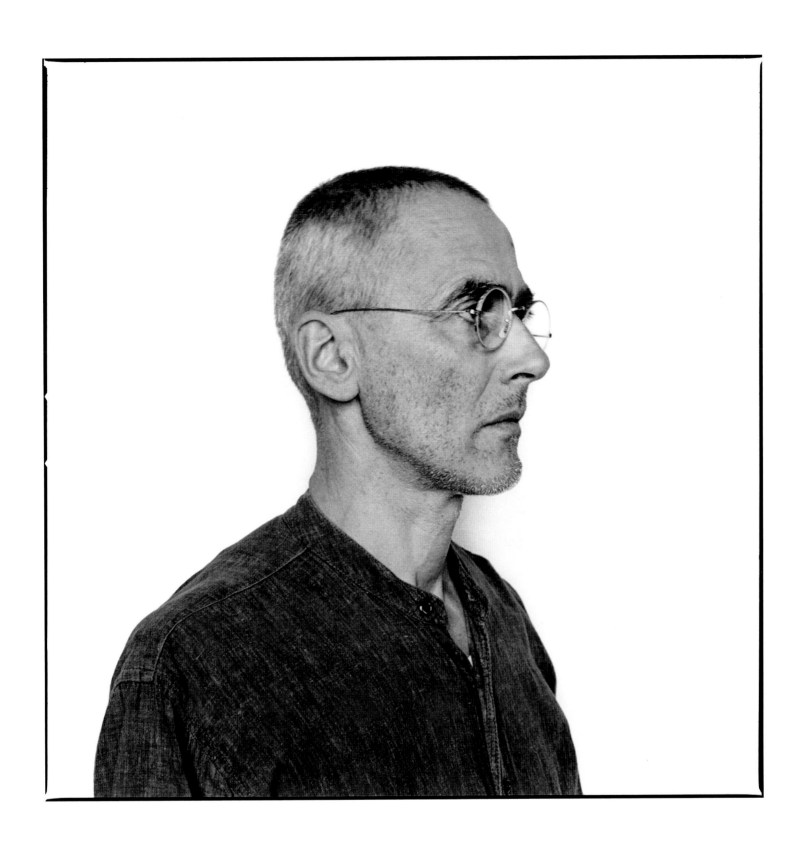

Self-Portrait (detail), 1983

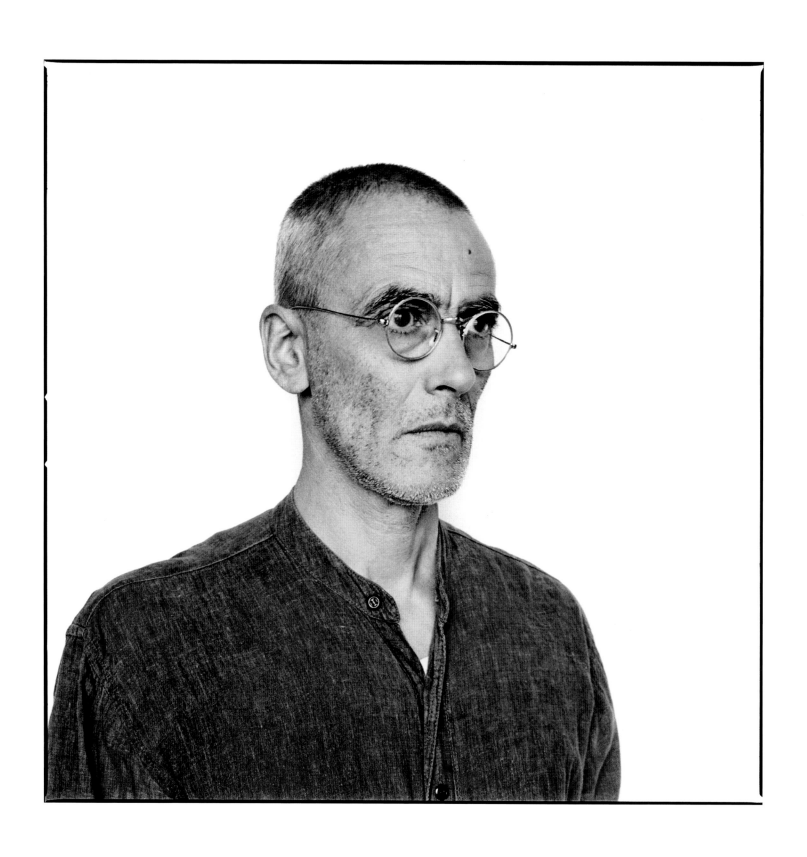

Self-Portrait (detail), 1983

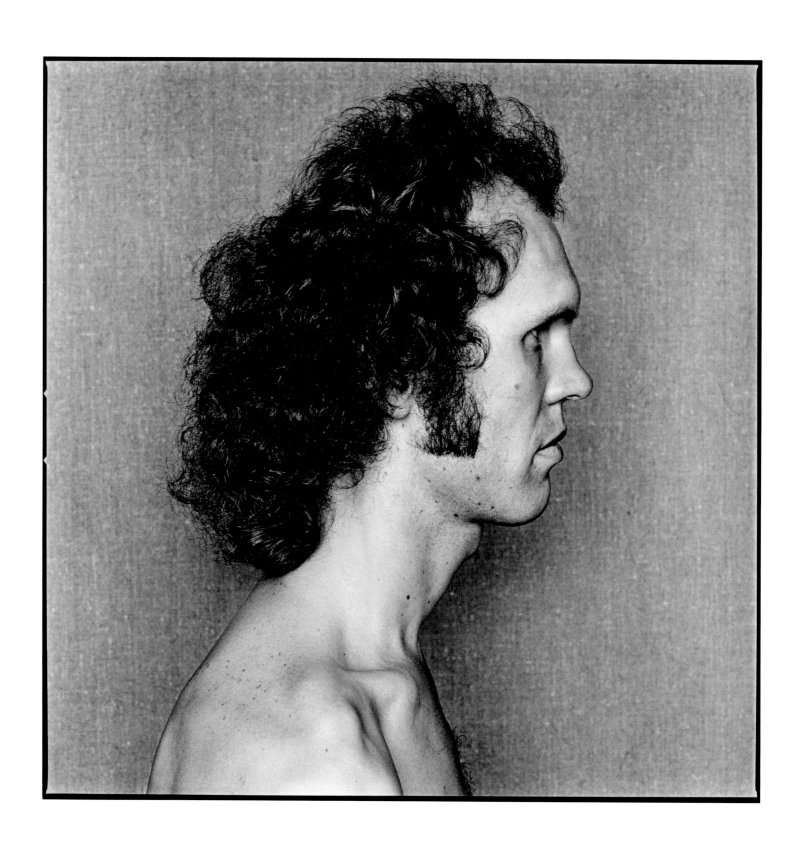

64 Portrait Studies (detail), 1976-1978

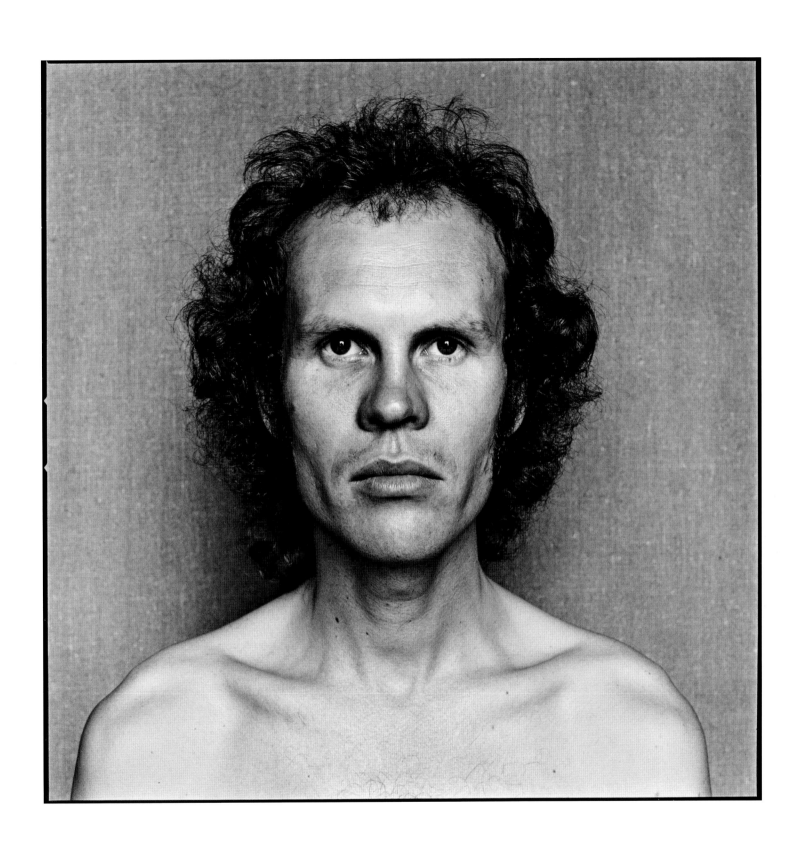

64 Portrait Studies (detail), 1976-1978

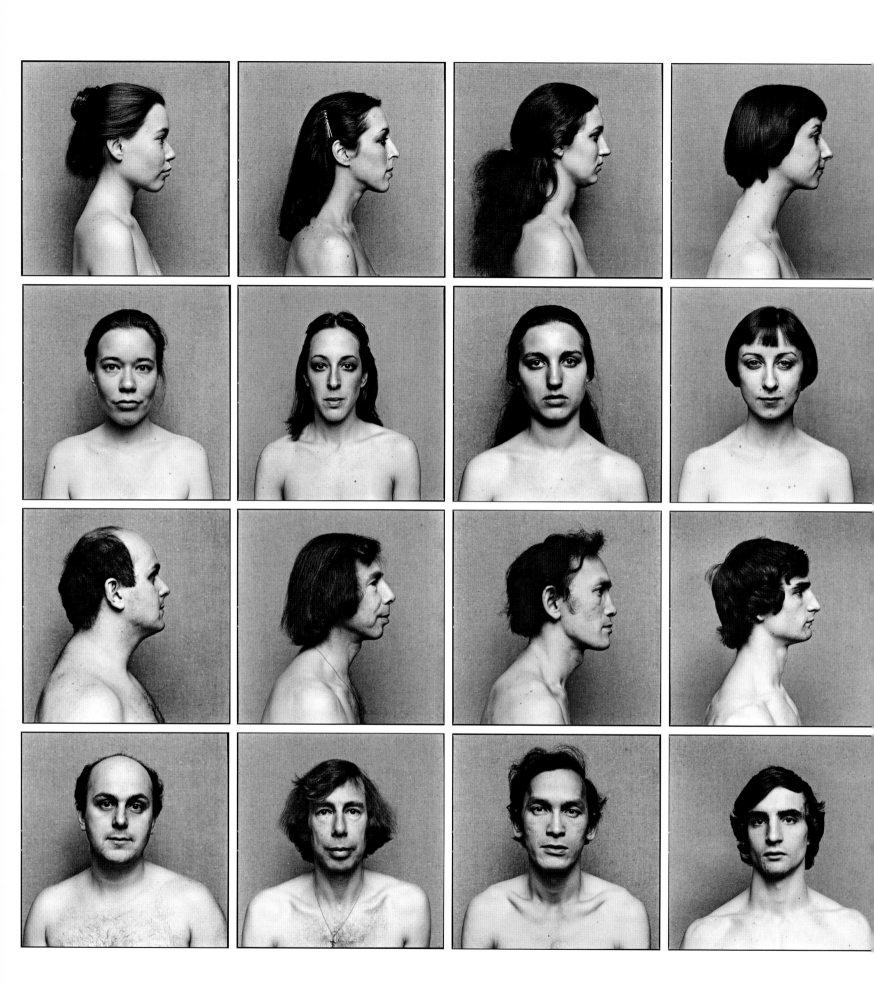

64 Portrait Studies, 1976-1978

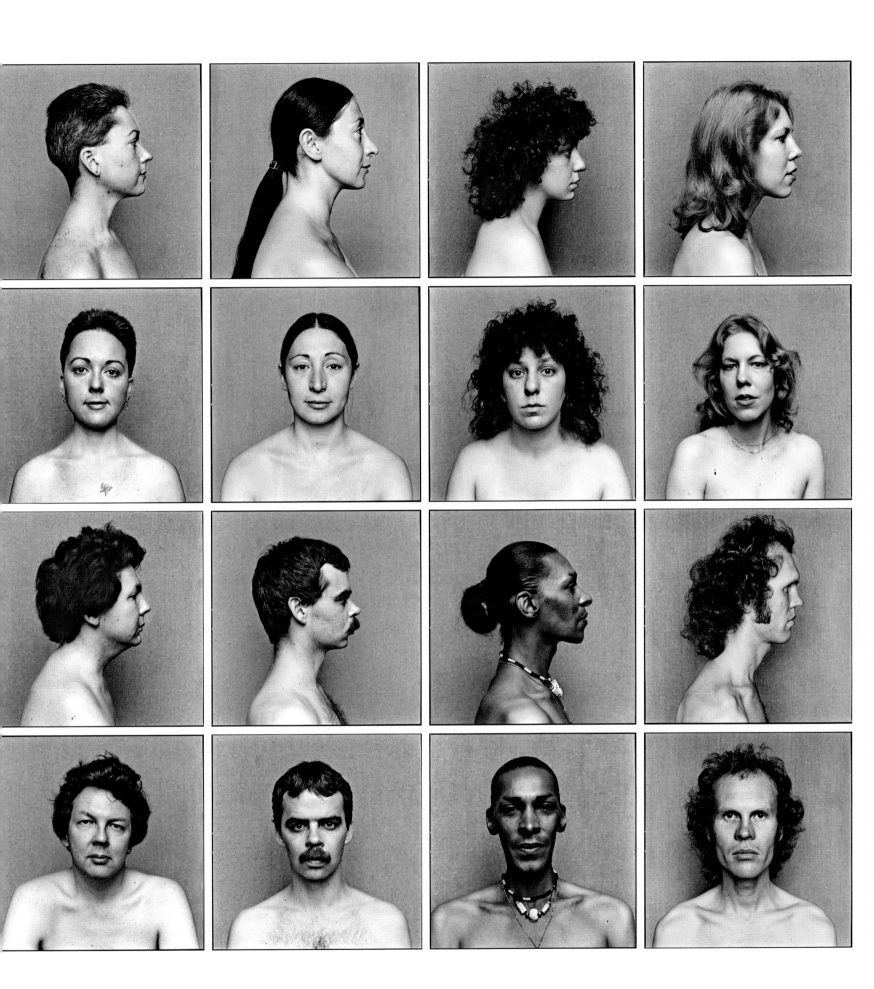

64 Portrait Studies, 1976-1978

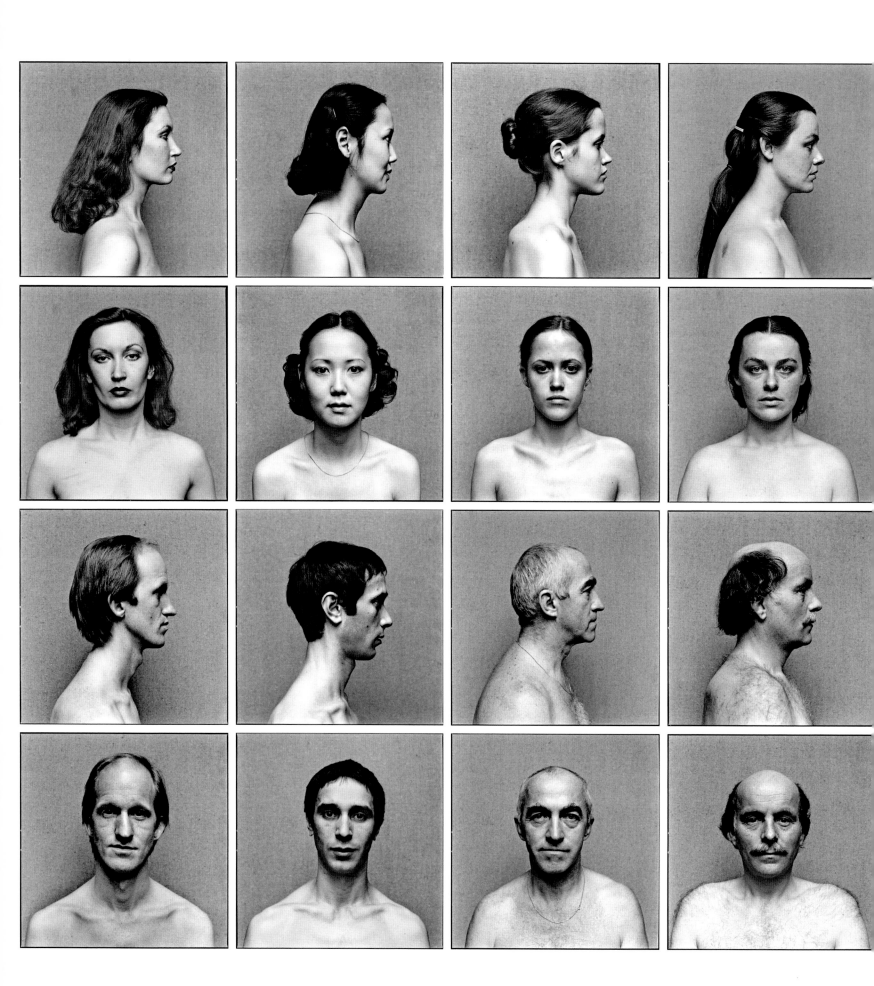

64 Portrait Studies, 1976-1978

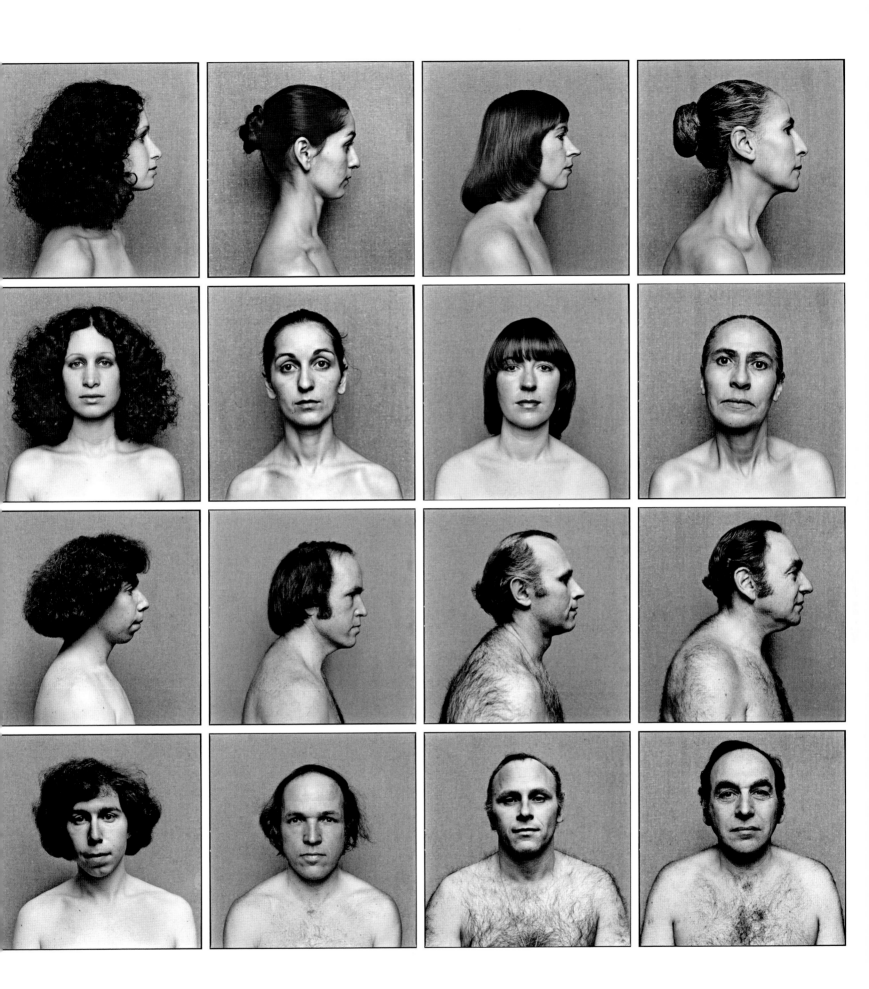

64 Portrait Studies, 1976-1978

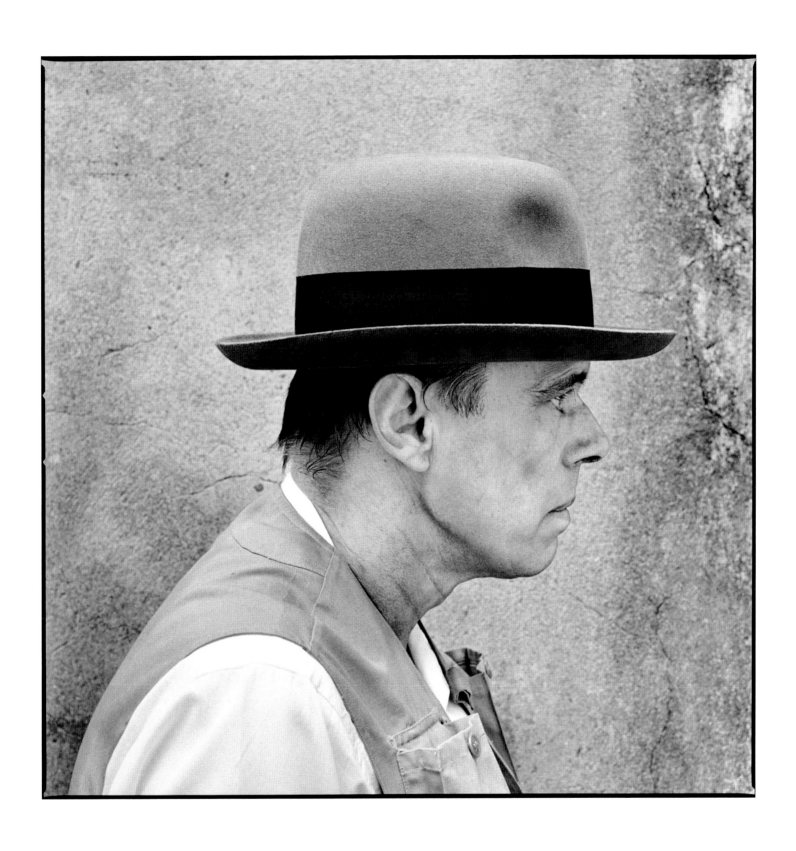

Joseph Beuys, 100 Profile Views (detail 60), 1980

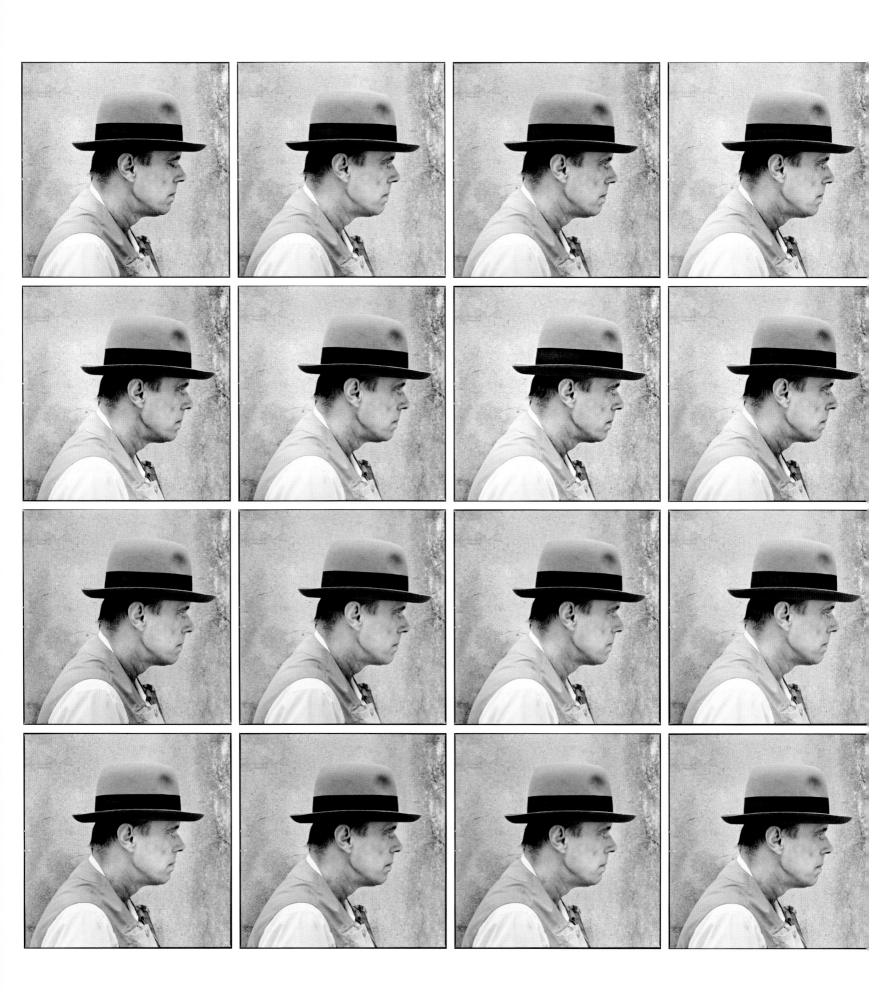

Joseph Beuys, 100 Profile Views, 1980

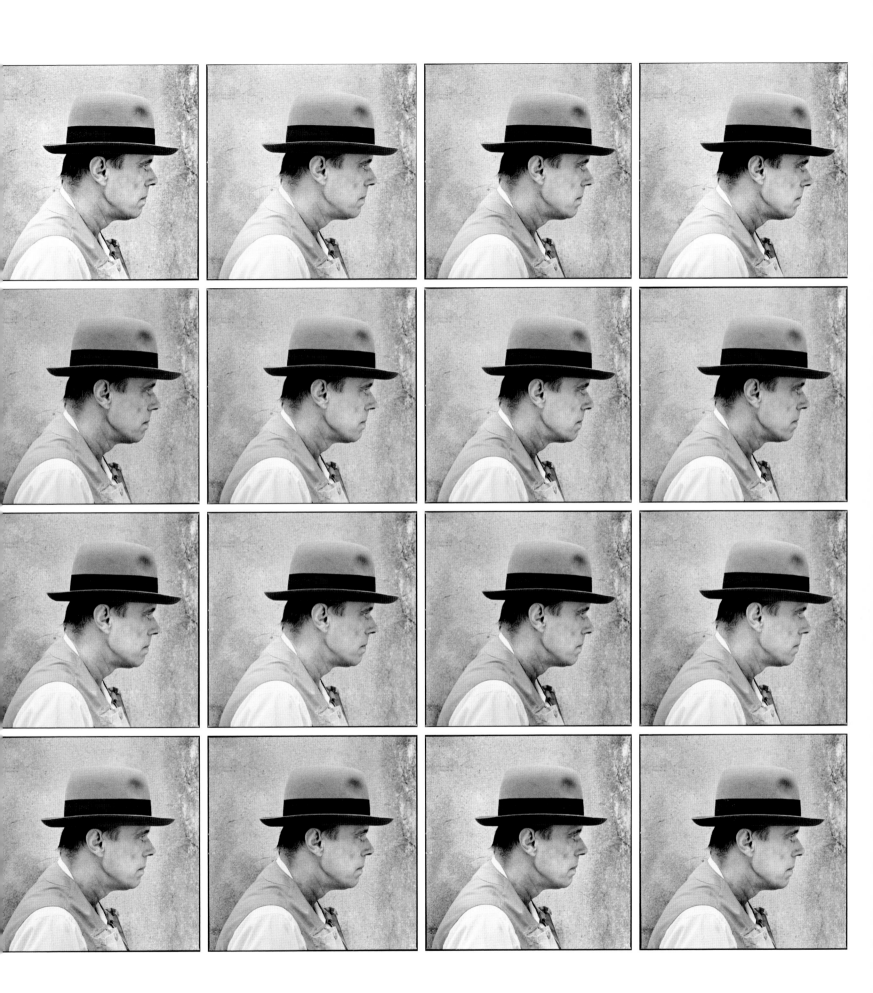

Joseph Beuys, 100 Profile Views, 1980

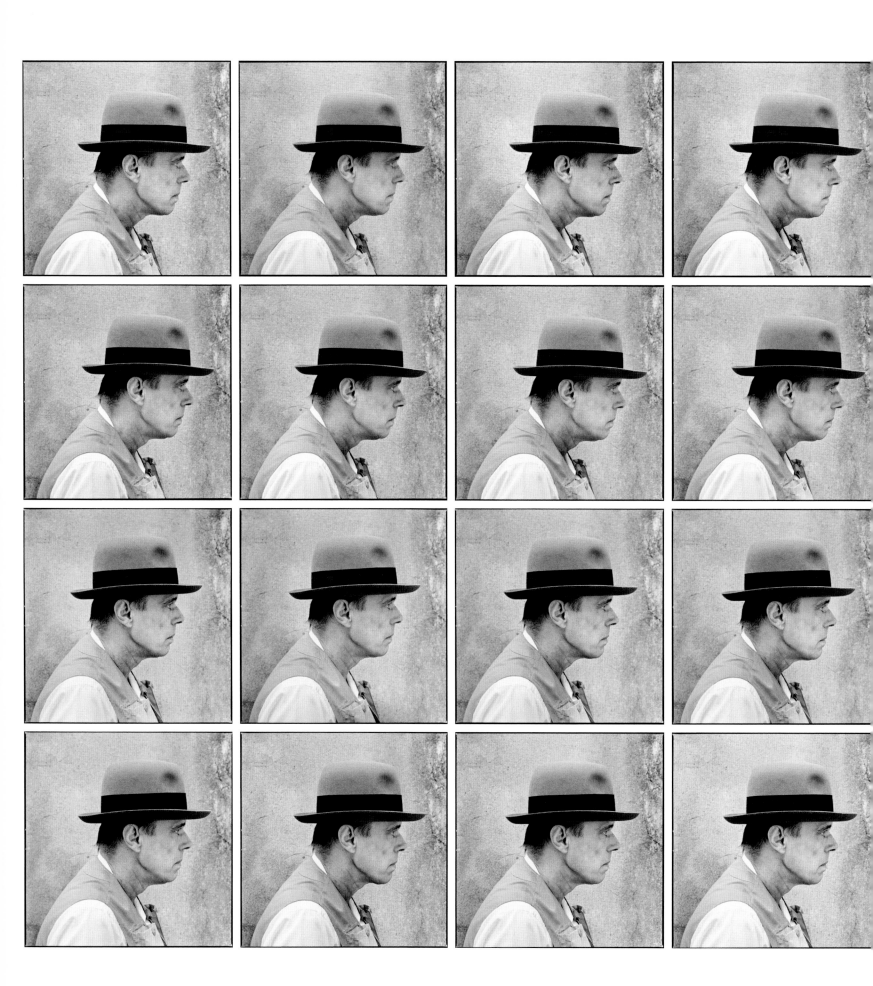

Joseph Beuys, 100 Profile Views, 1980

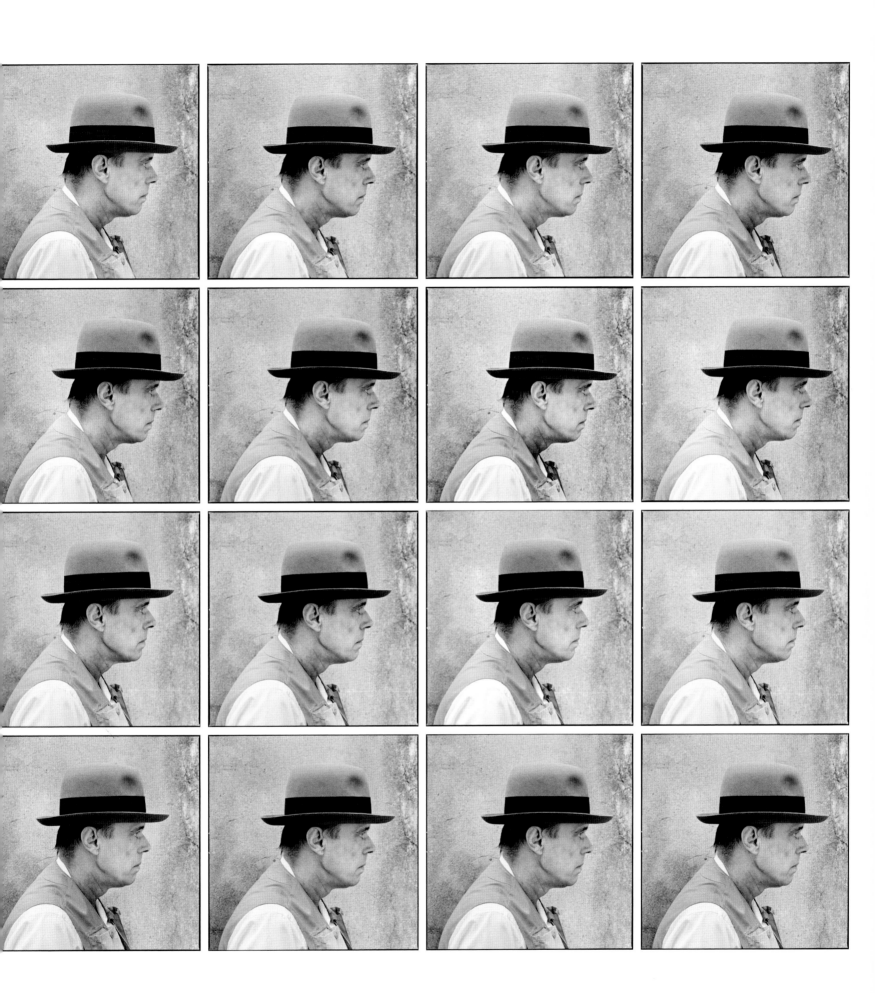

Joseph Beuys, 100 Profile Views, 1980

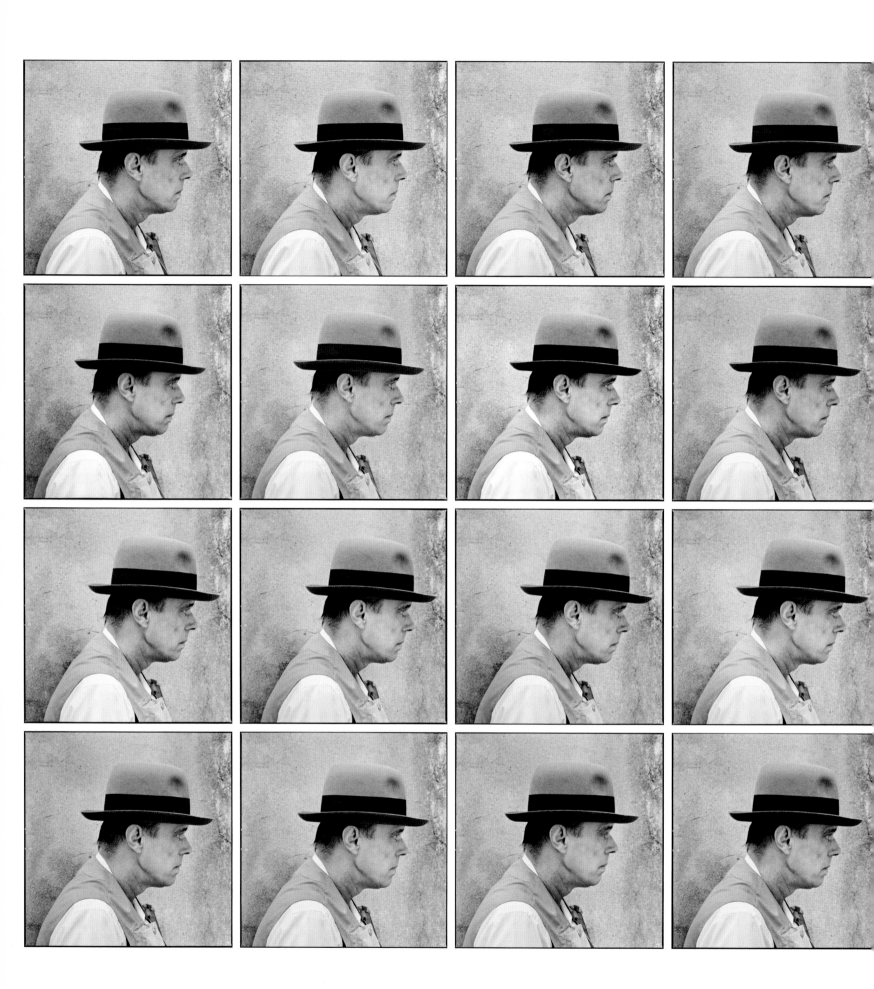

Joseph Beuys, 100 Profile Views, 1980

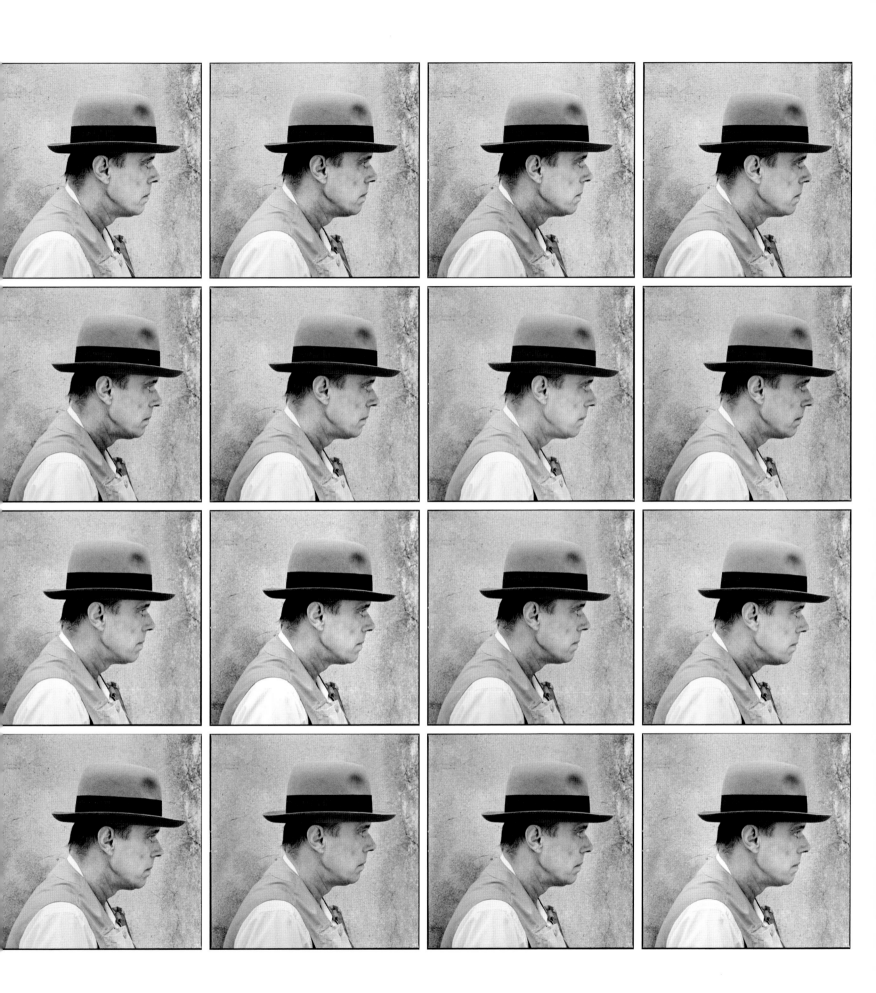

Joseph Beuys, 100 Profile Views, 1980

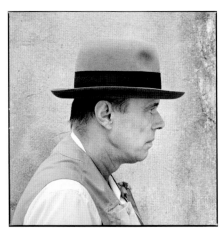

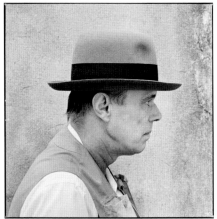

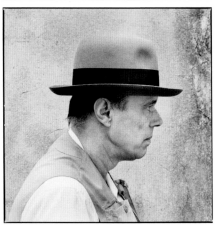

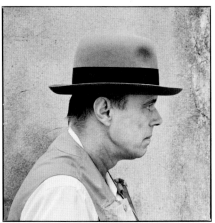

Joseph Beuys, 100 Profile Views, 1980

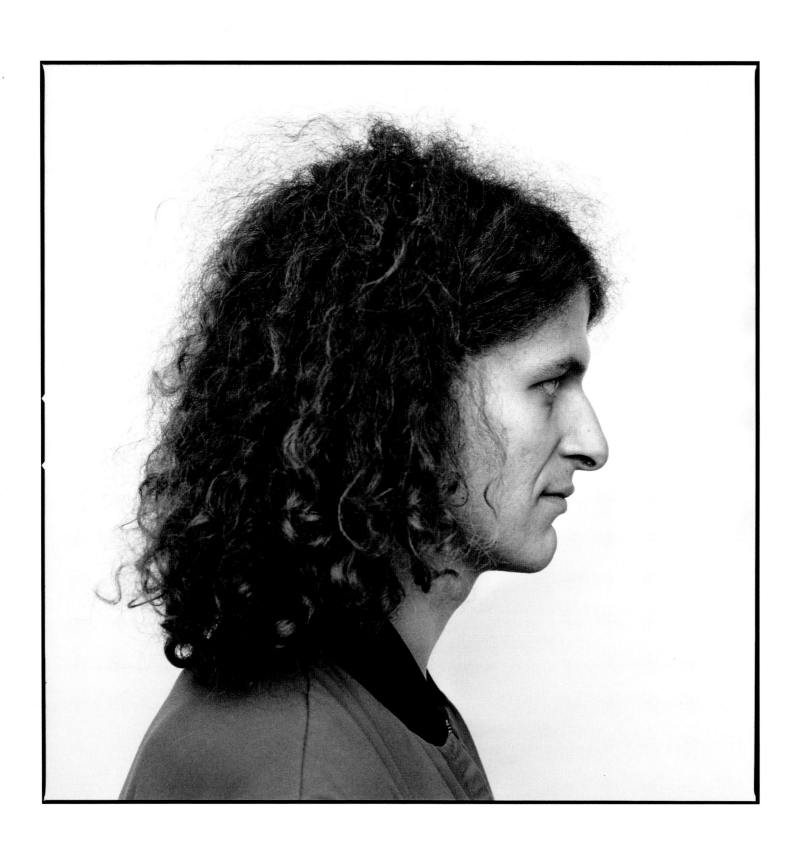

Kunstakademie (detail 6), 1980

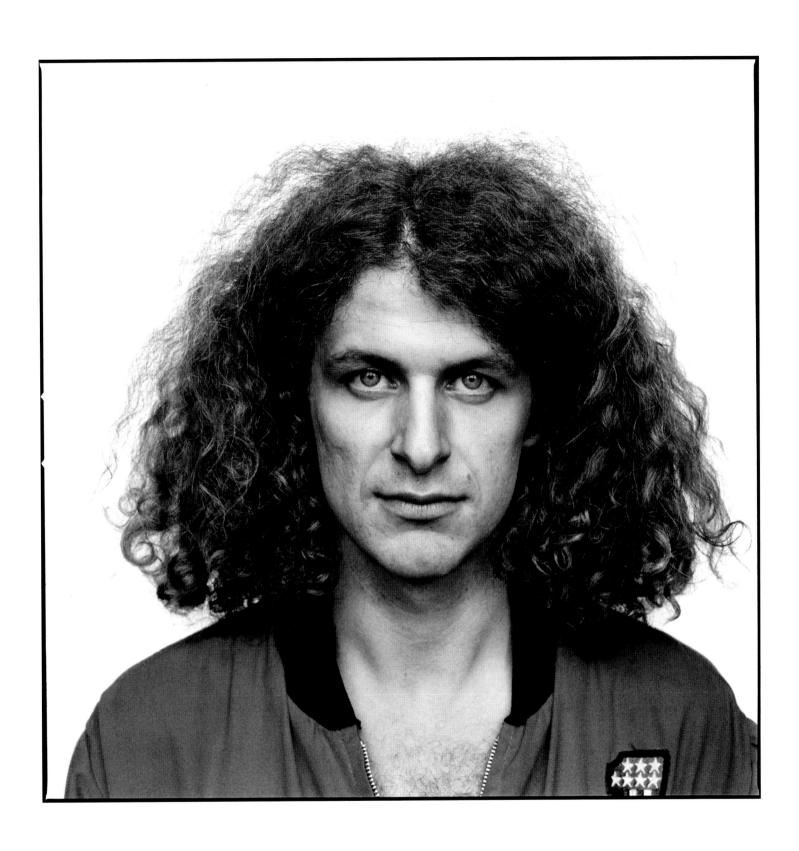

Kunstakademie (detail 1), 1980

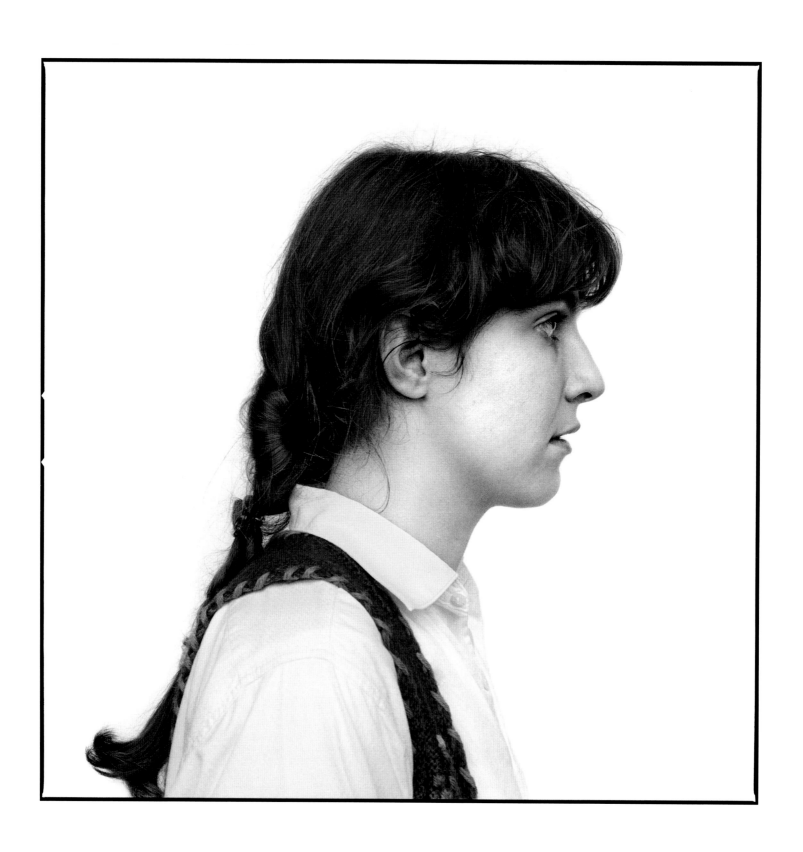

Kunstakademie (detail 36), 1980

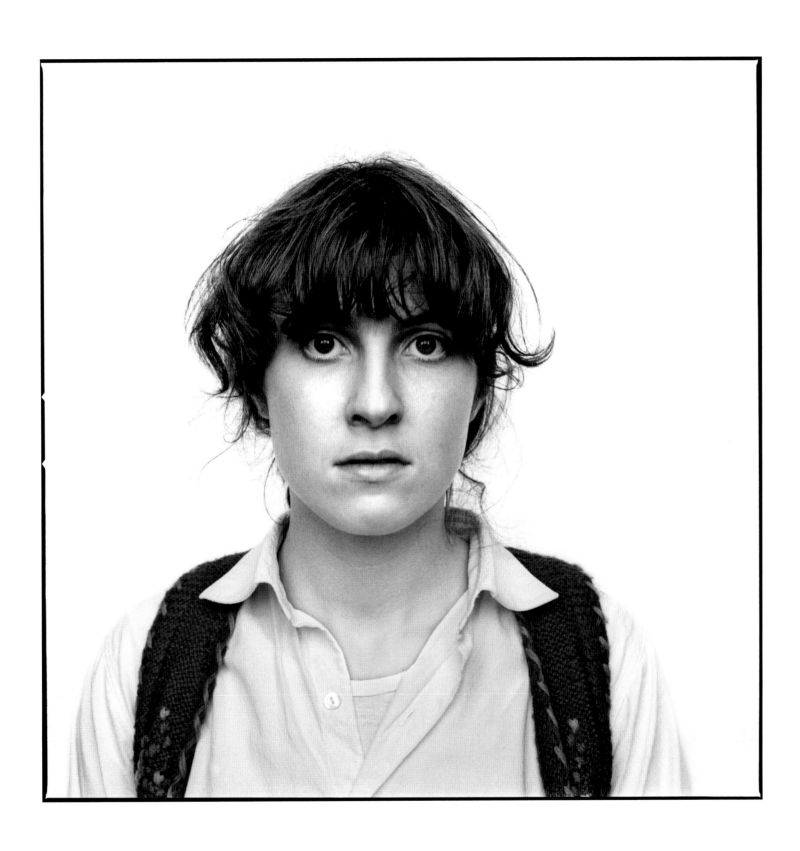

Kunstakademie (detail 33), 1980

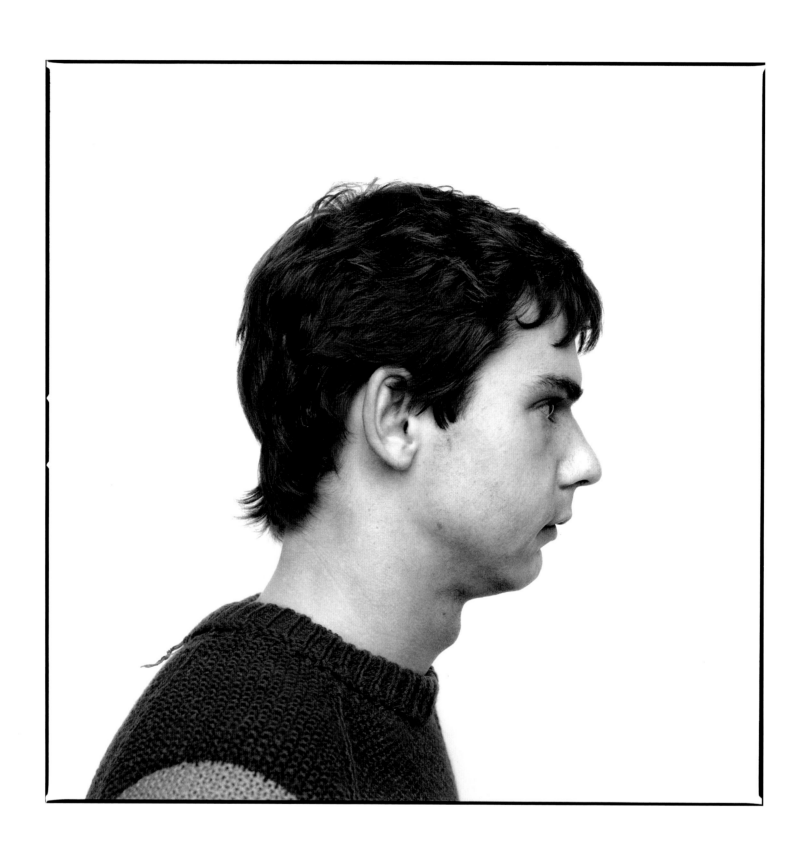

Kunstakademie (detail 120), 1980

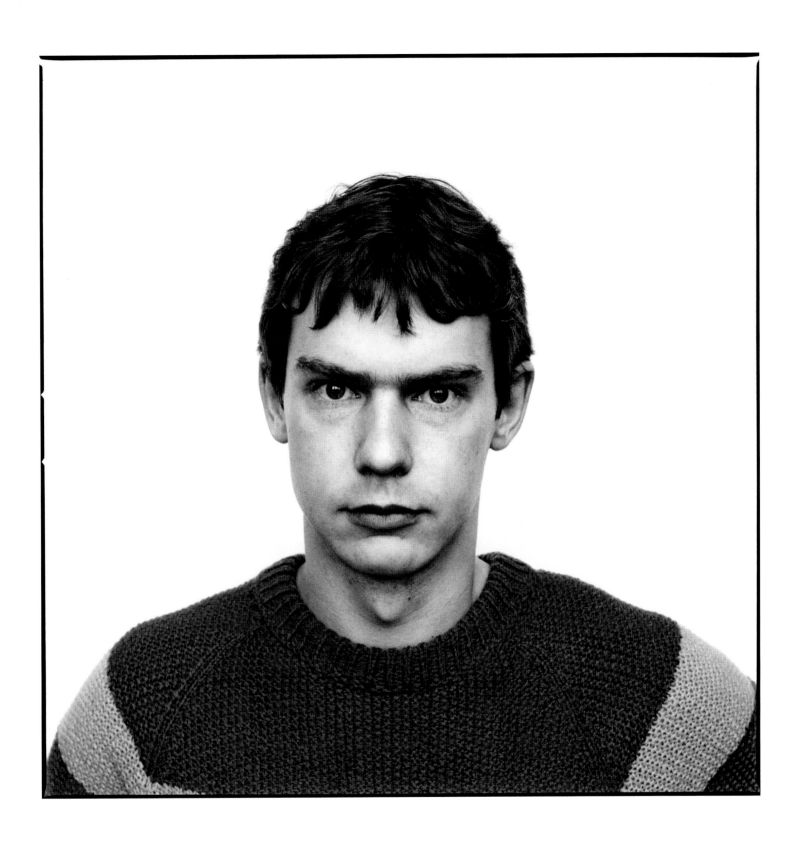

Kunstakademie (detail 116), 1980

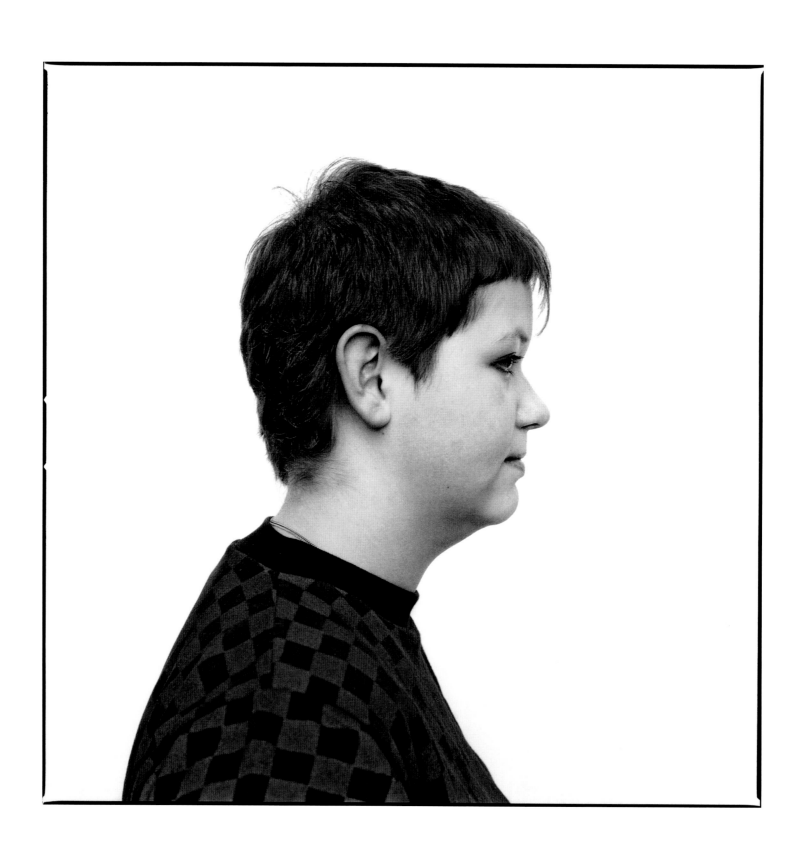

Kunstakademie (detail 131), 1980

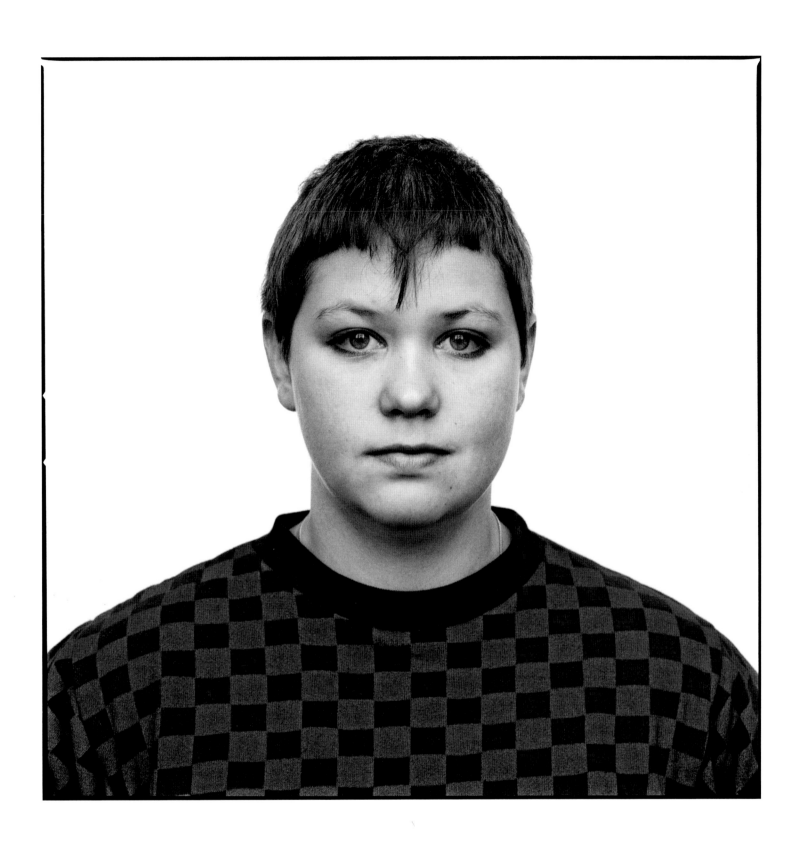

Kunstakademie (detail 128), 1980

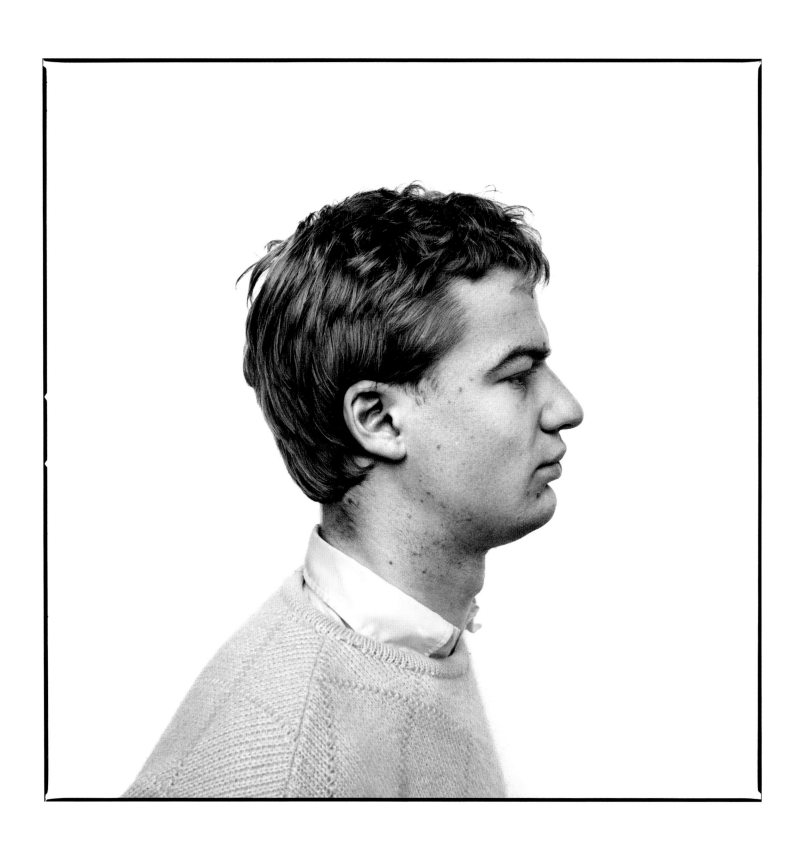

Kunstakademie (detail 197), 1980

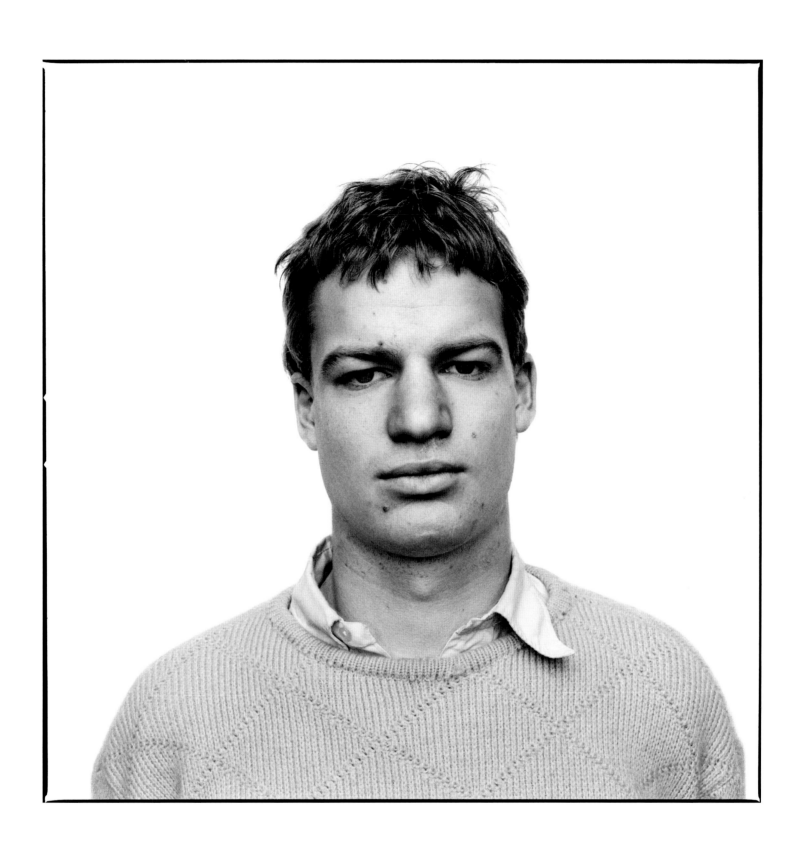

Kunstakademie (detail 192), 1980

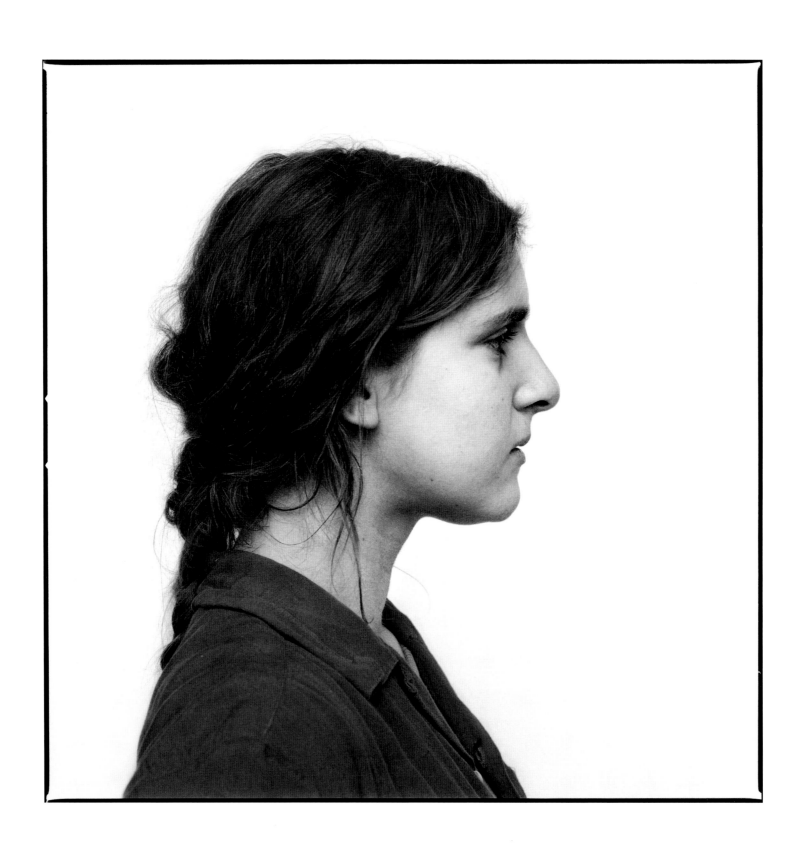

Kunstakademie (detail 365), 1980

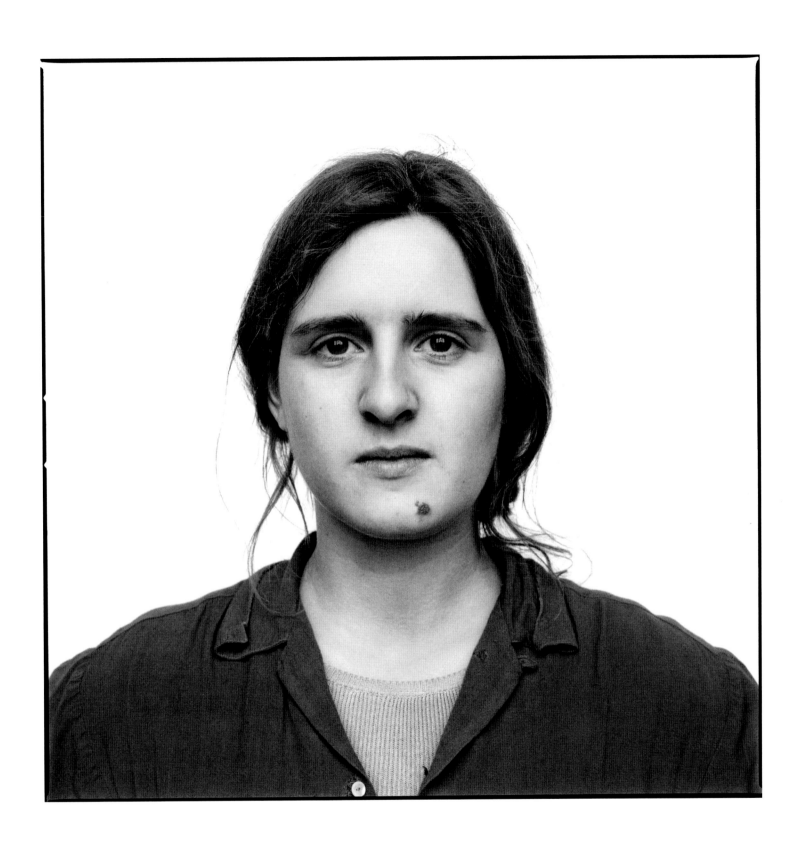

Kunstakademie (detail 361), 1980

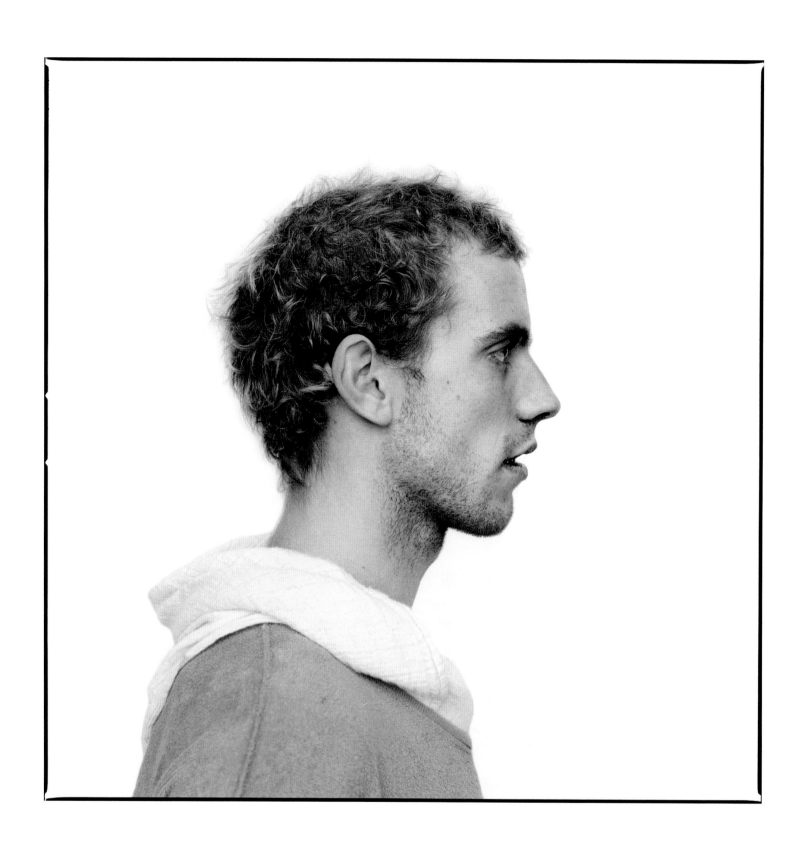

Kunstakademie (detail 417), 1980

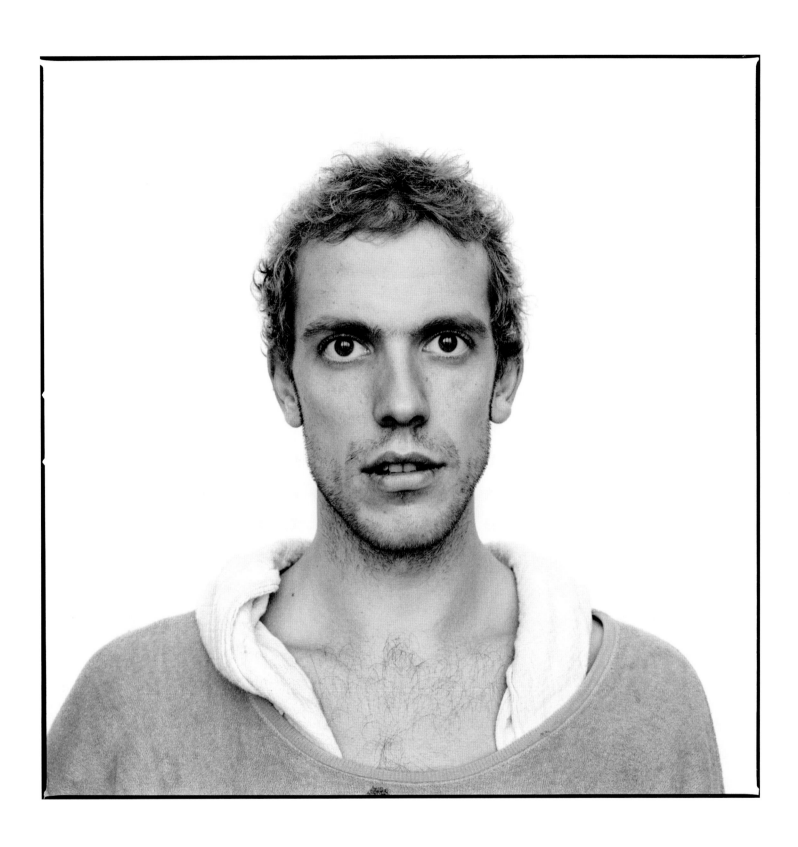

Kunstakademie (detail 415), 1980

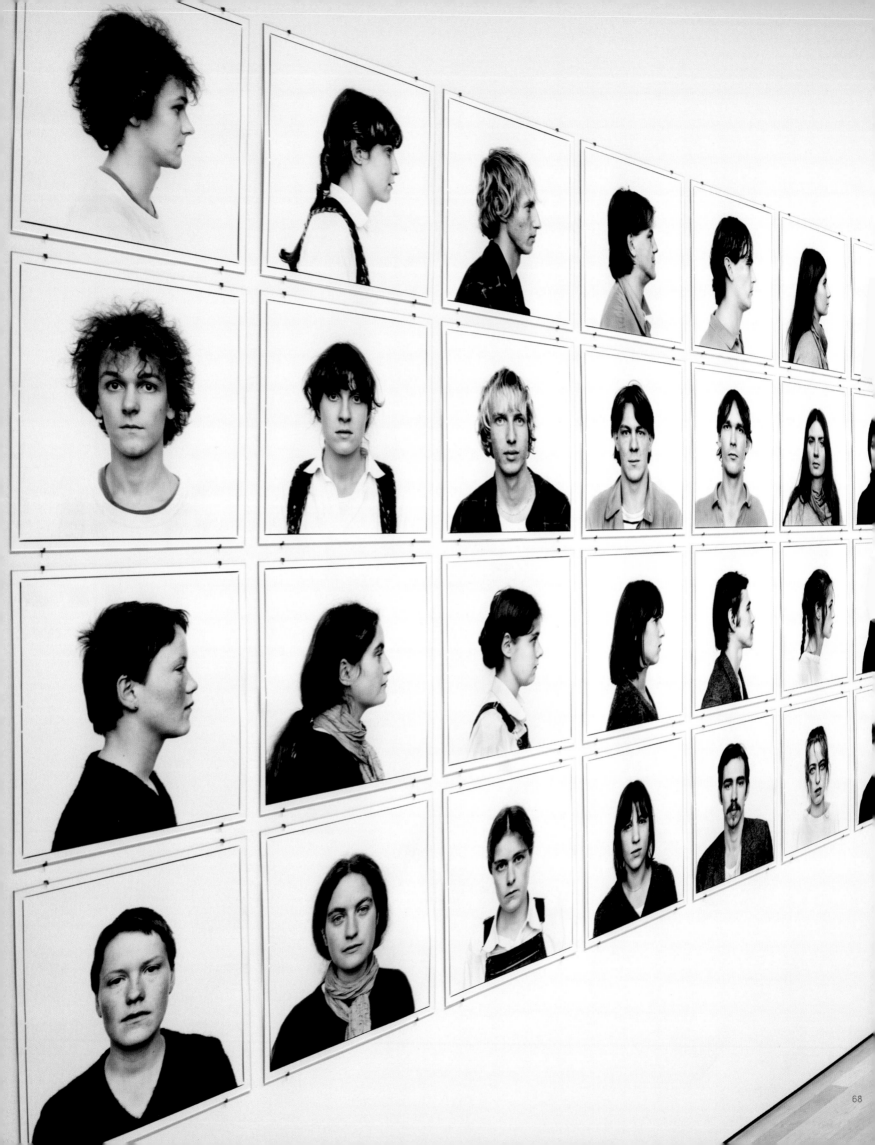

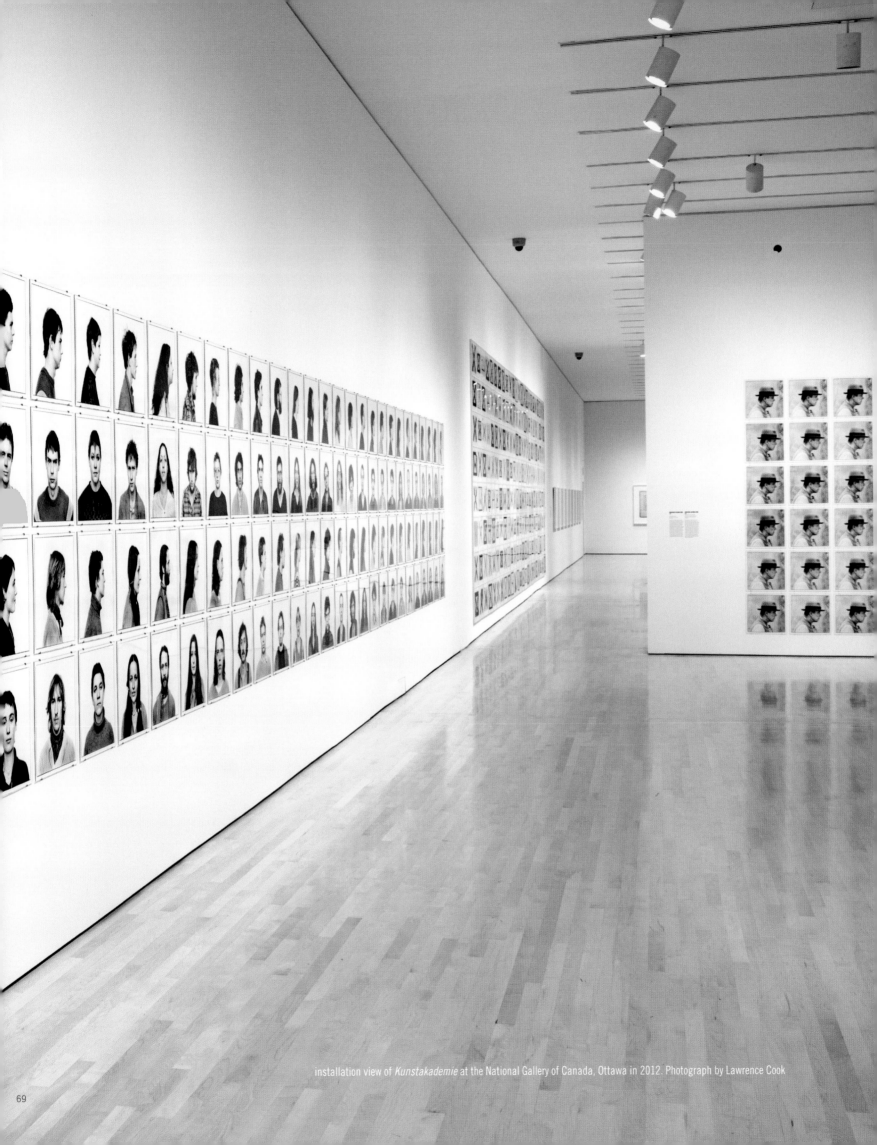

installation view of *Kunstakademie* at the National Gallery of Canada, Ottawa in 2012. Photograph by Lawrence Cook

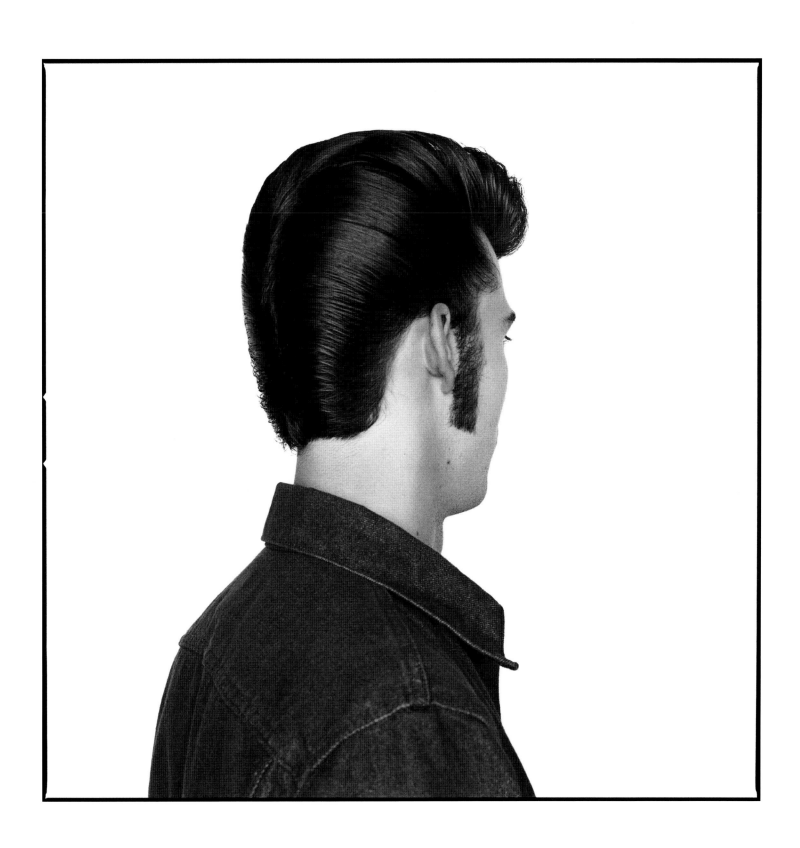

Downwind Photographs (detail), 1981-1983

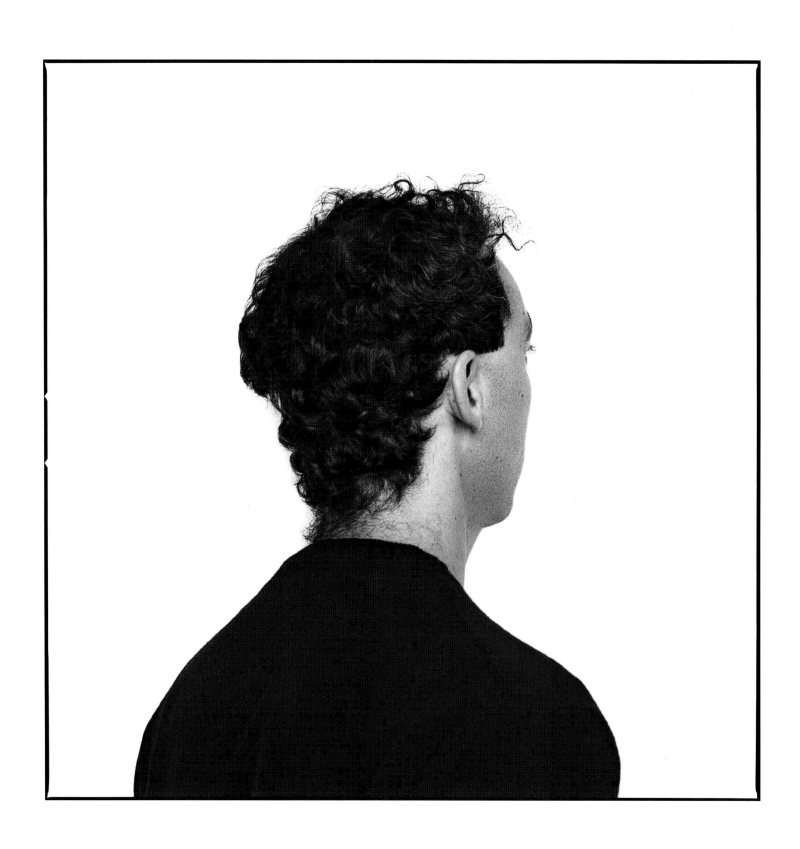

Downwind Photographs (detail), 1981-1983

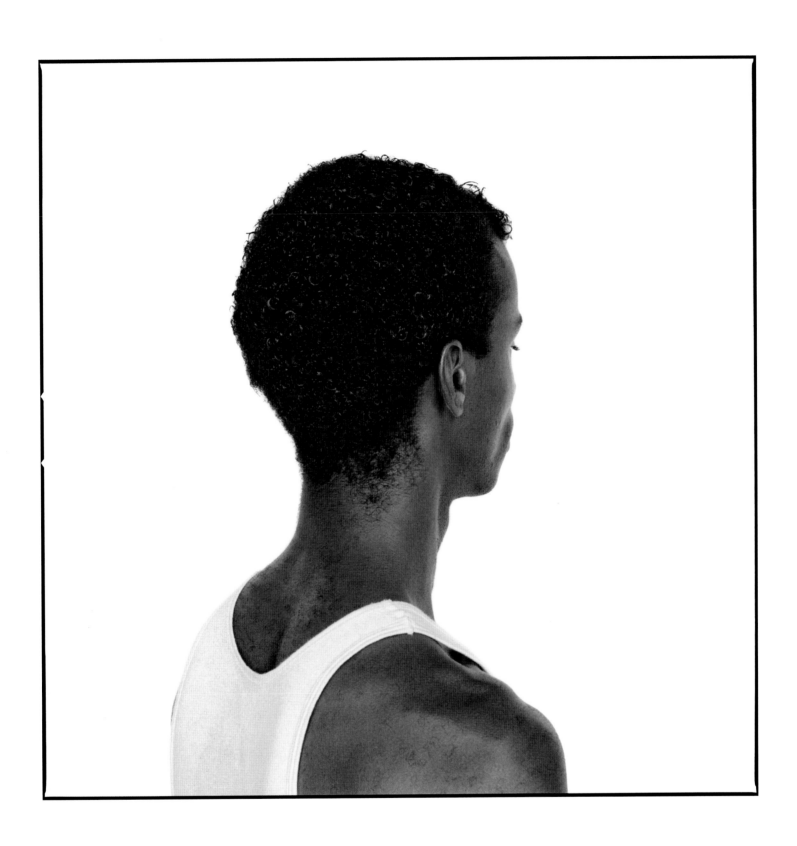

Downwind Photographs (detail), 1981-1983

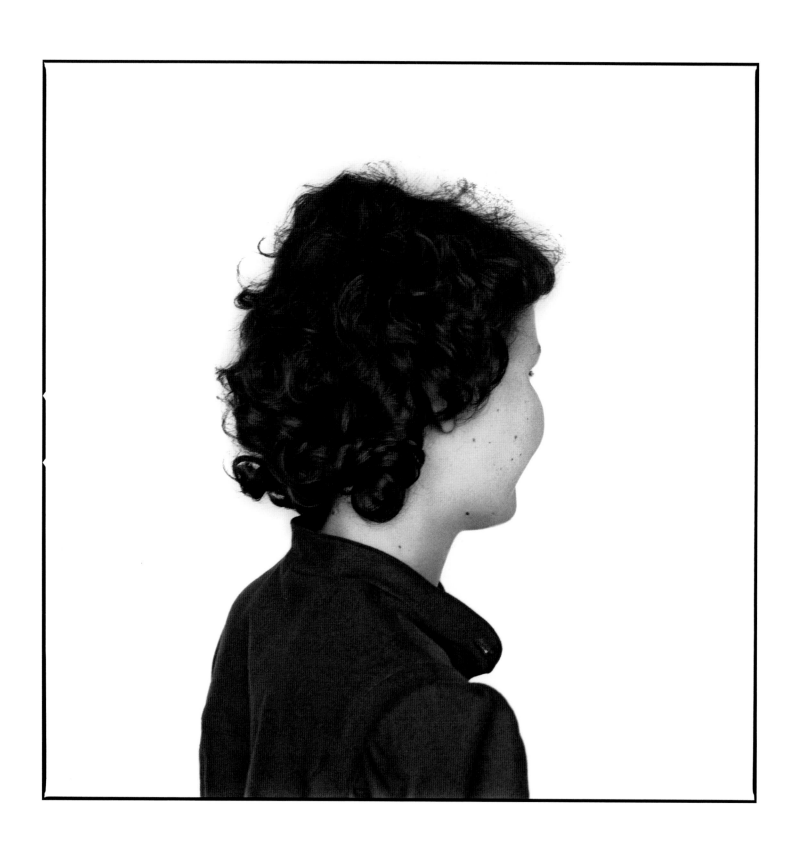

Downwind Photographs (detail), 1981-1983

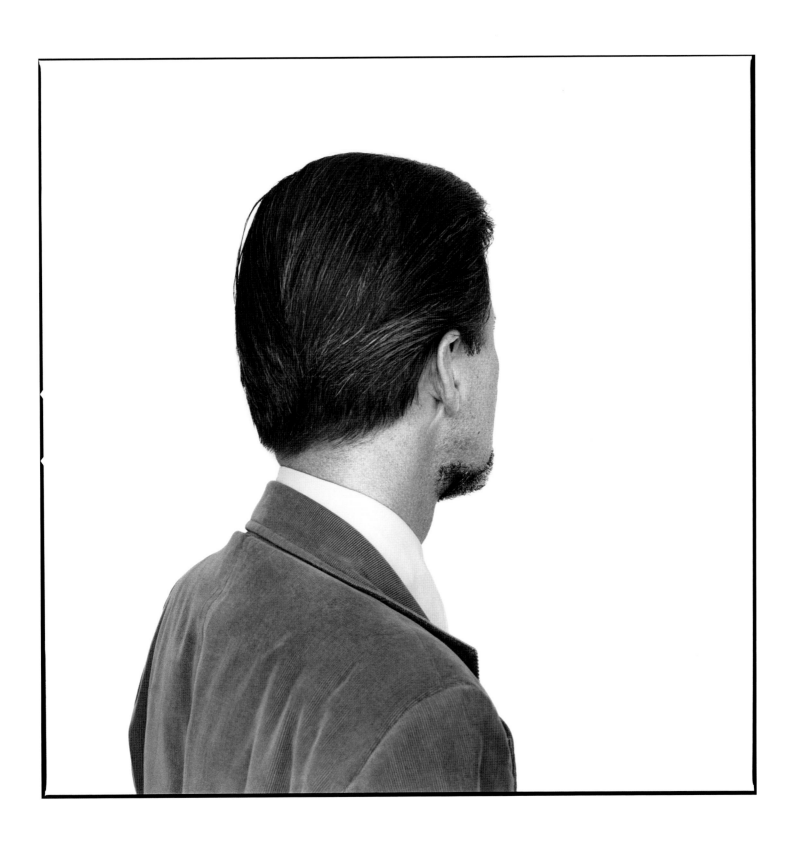

Downwind Photographs (detail), 1981-1983

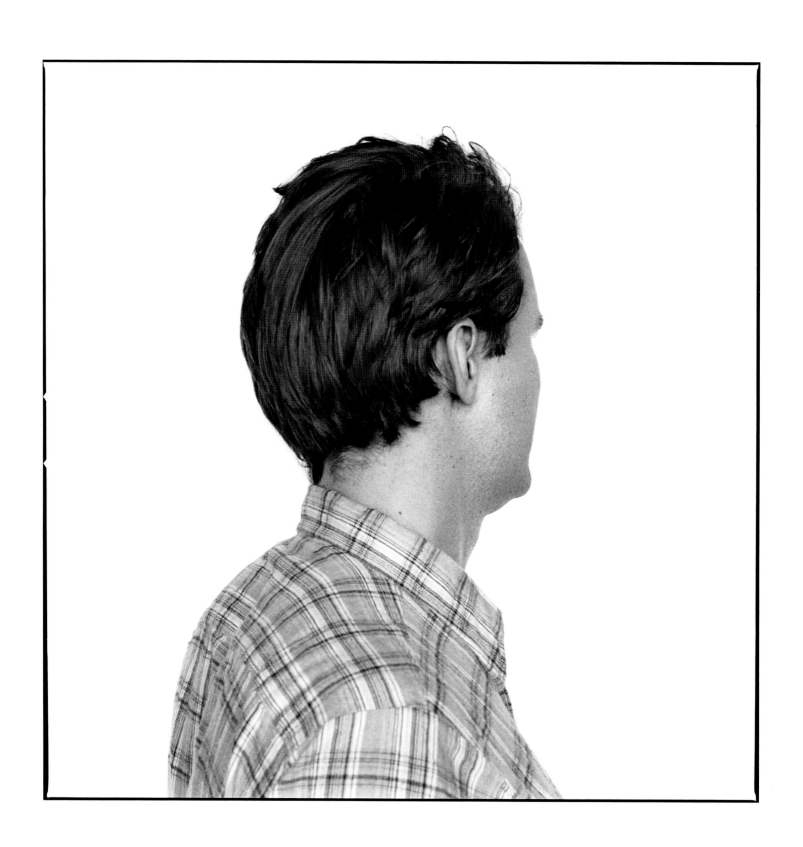

Downwind Photographs (detail), 1981-1983

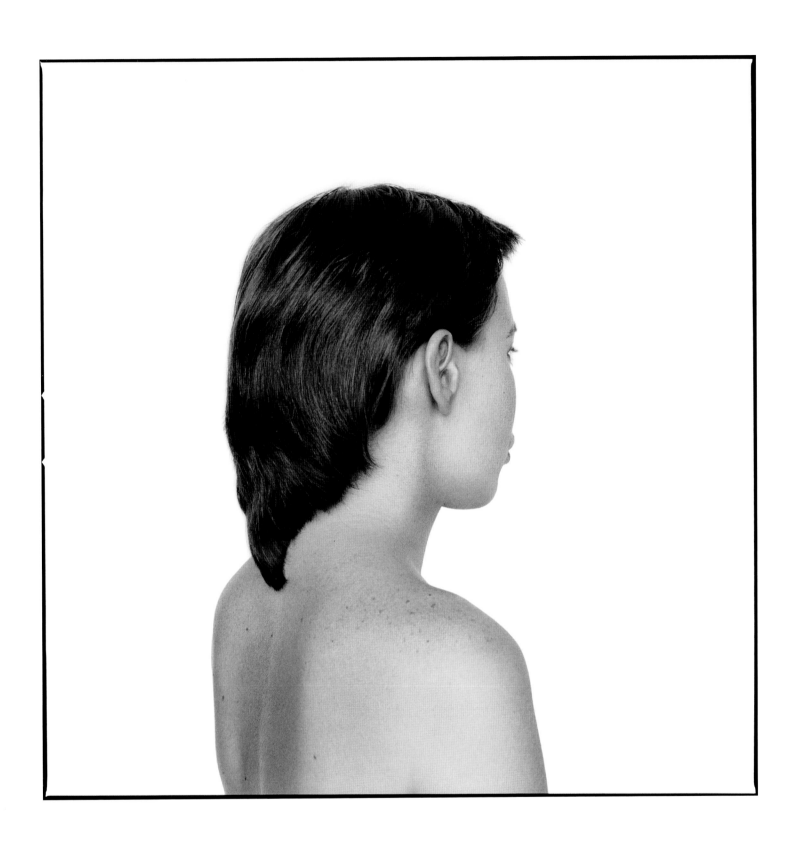

Downwind Photographs (detail), 1981-1983

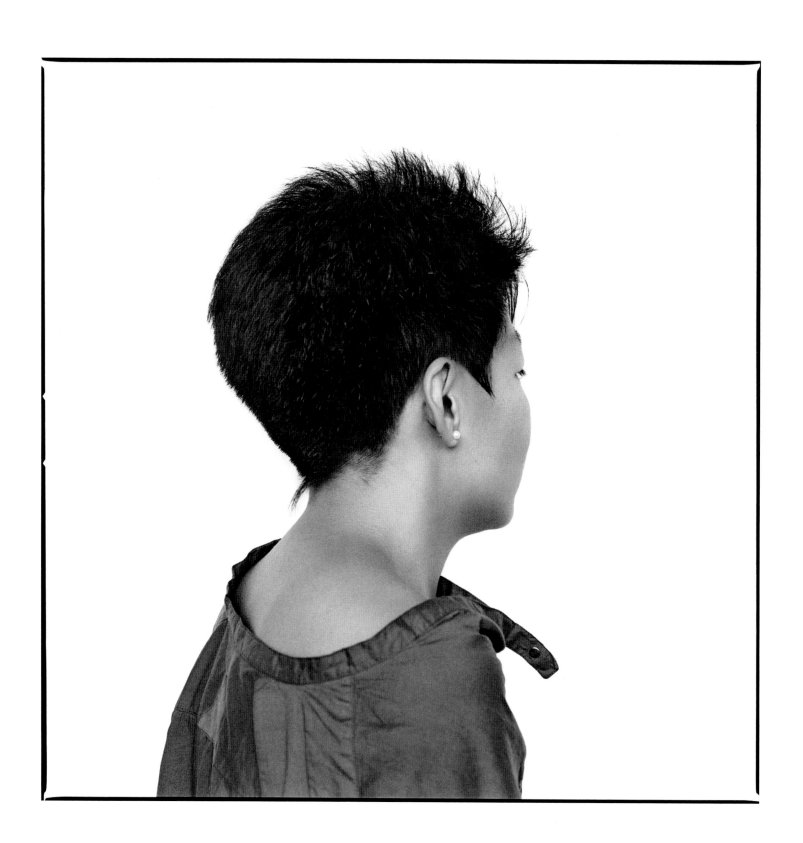

Downwind Photographs (detail), 1981-1983

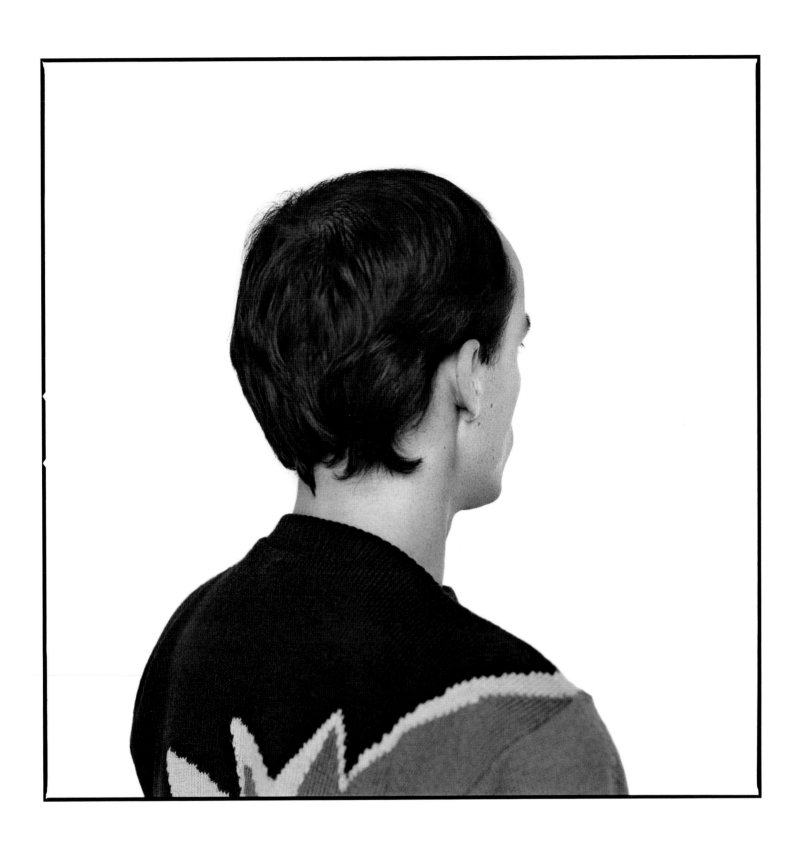

Downwind Photographs (detail), 1981-1983

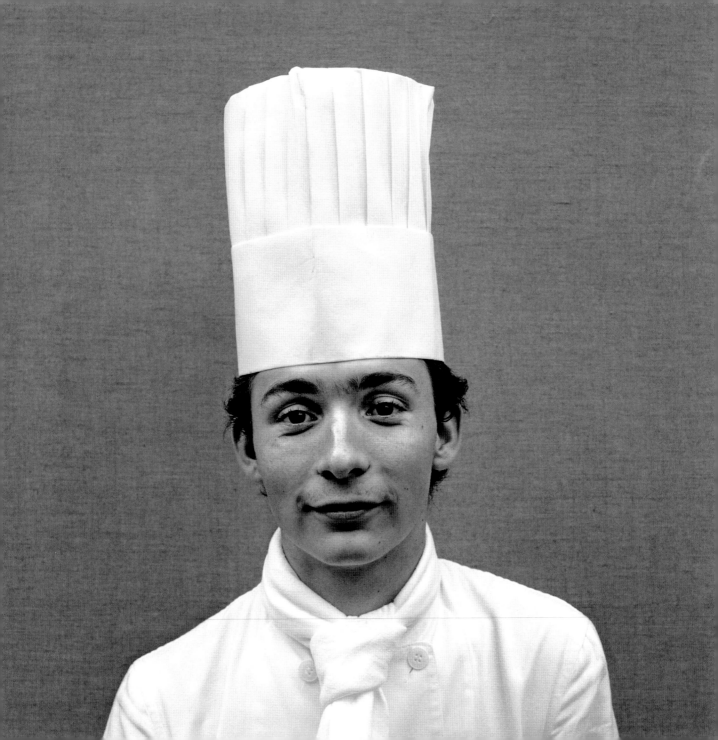

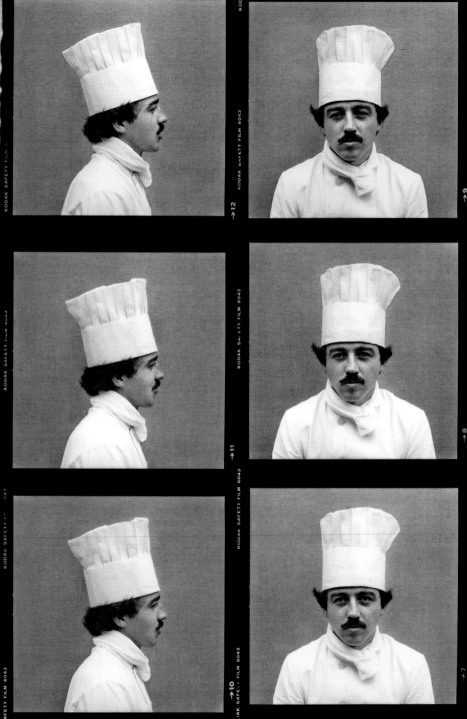

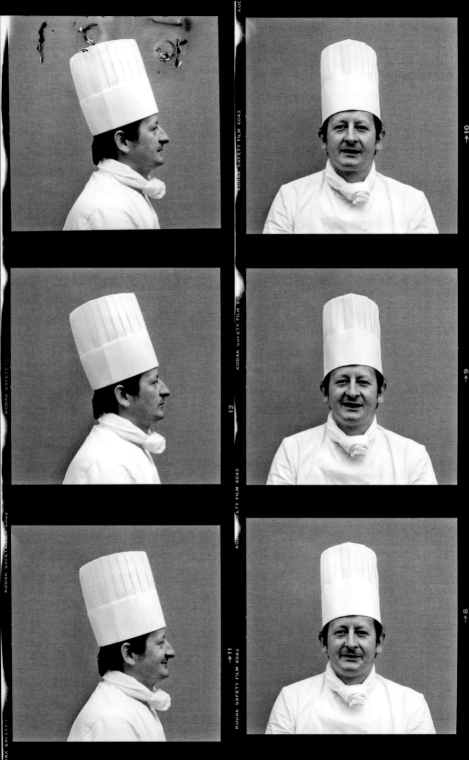

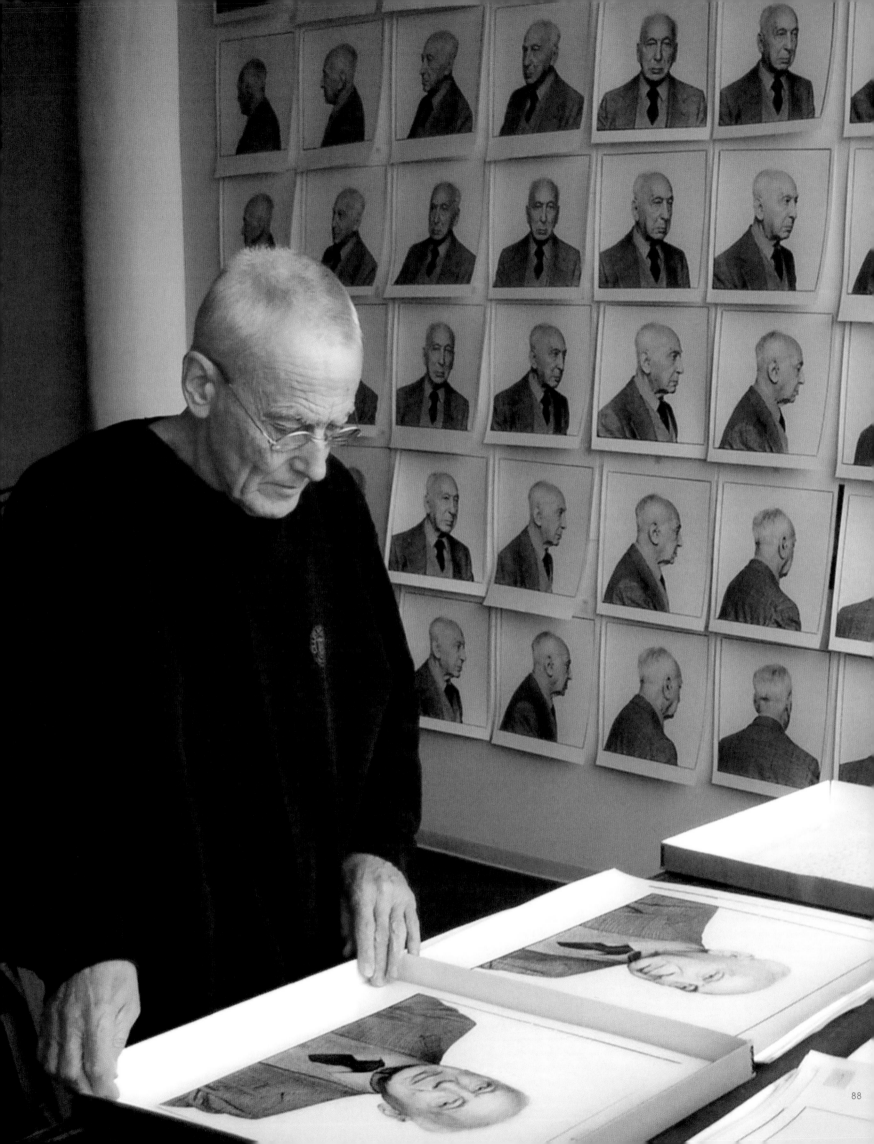

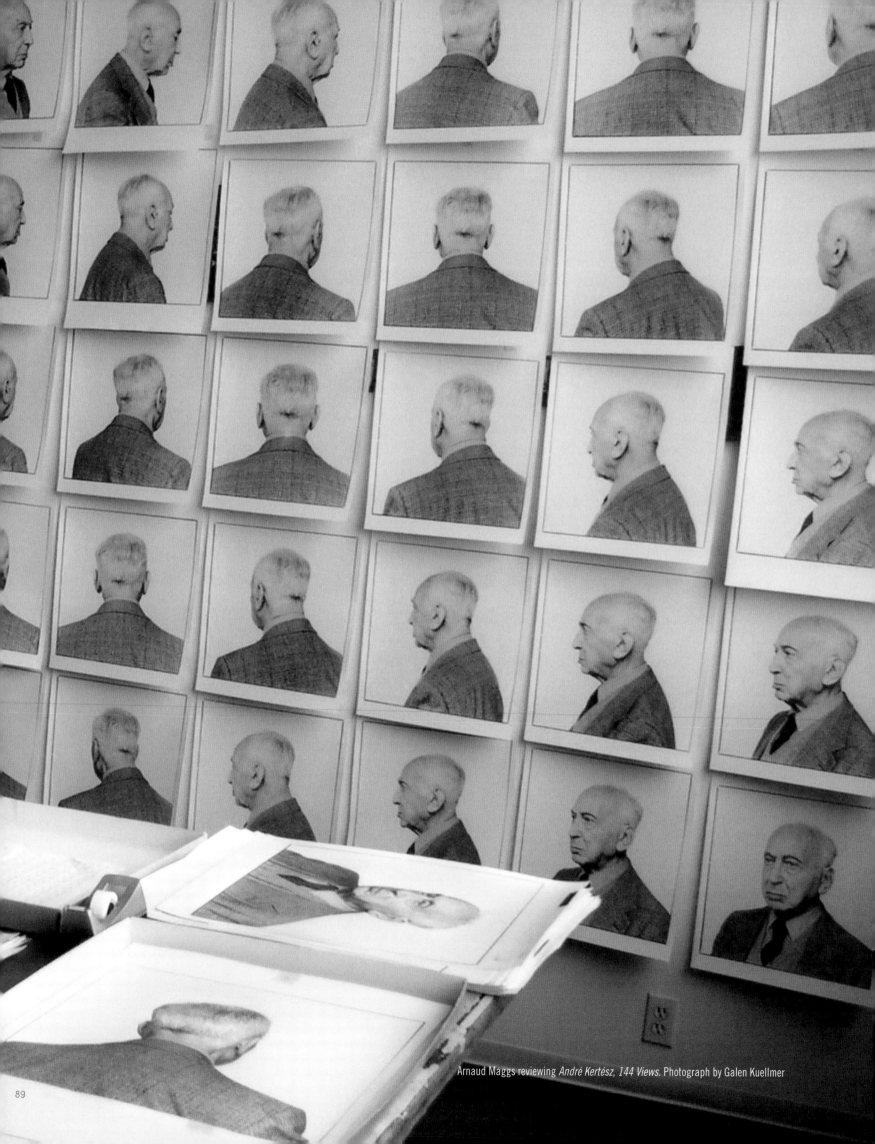

Arnaud Maggs reviewing *André Kertész, 144 Views.* Photograph by Galen Kuellmer

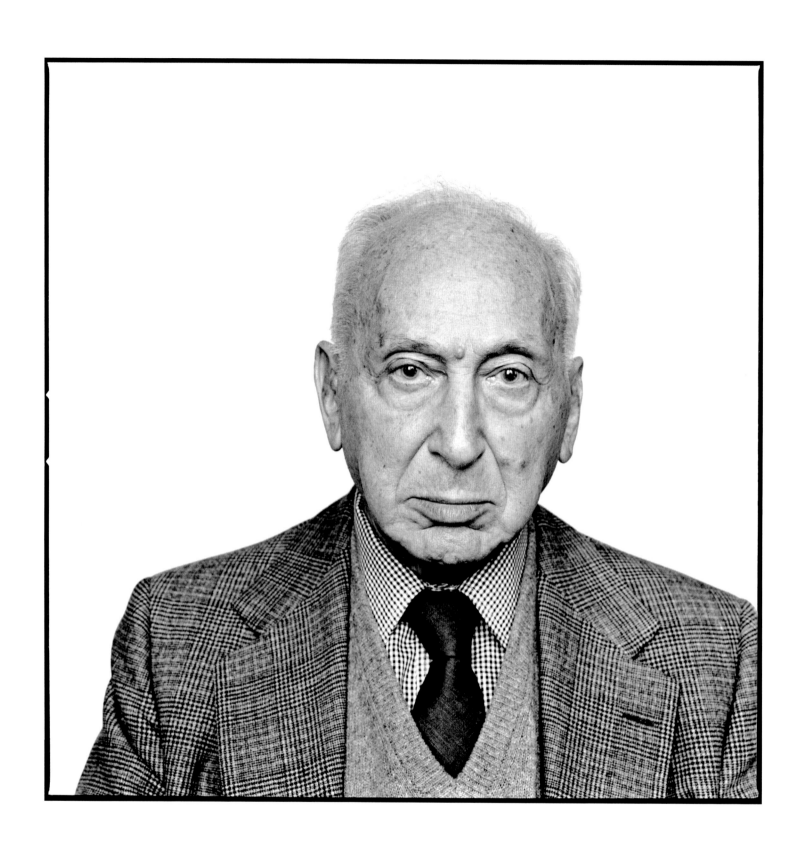

André Kertész, 144 Views (detail 1), 1980

André Kertész, 144 Views (detail 3), 1980

André Kertész, 144 Views (detail 5), 1980

André Kertész, 144 Views (detail 7), 1980

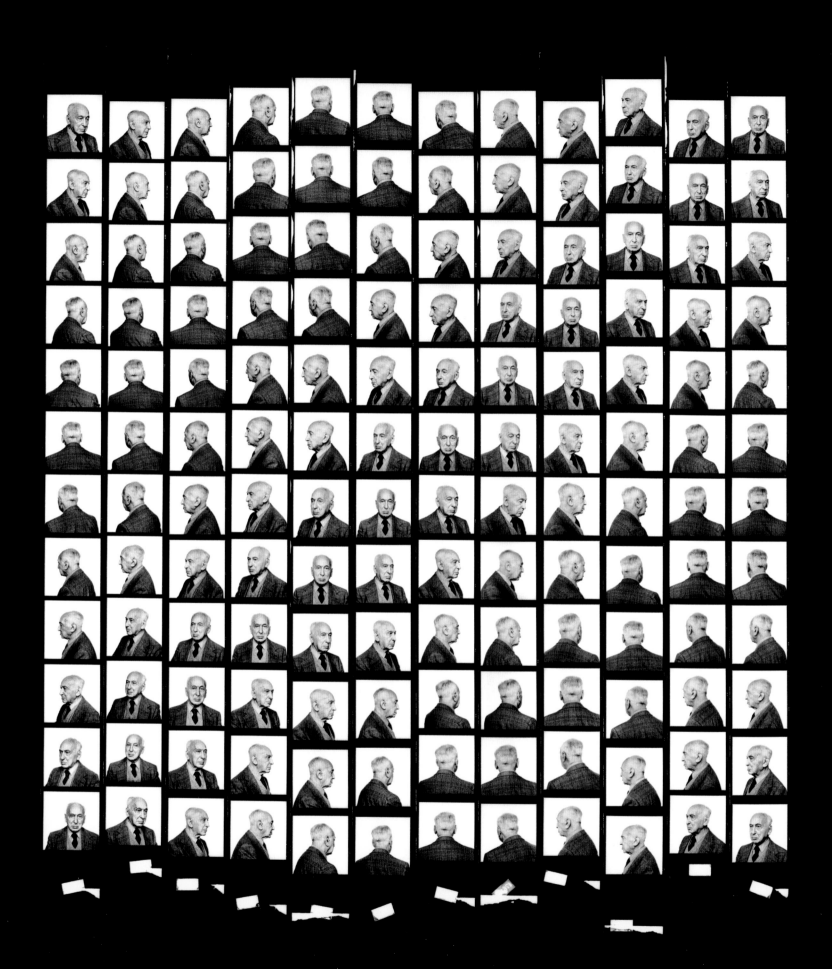

André Kertész, 144 Views, 1980

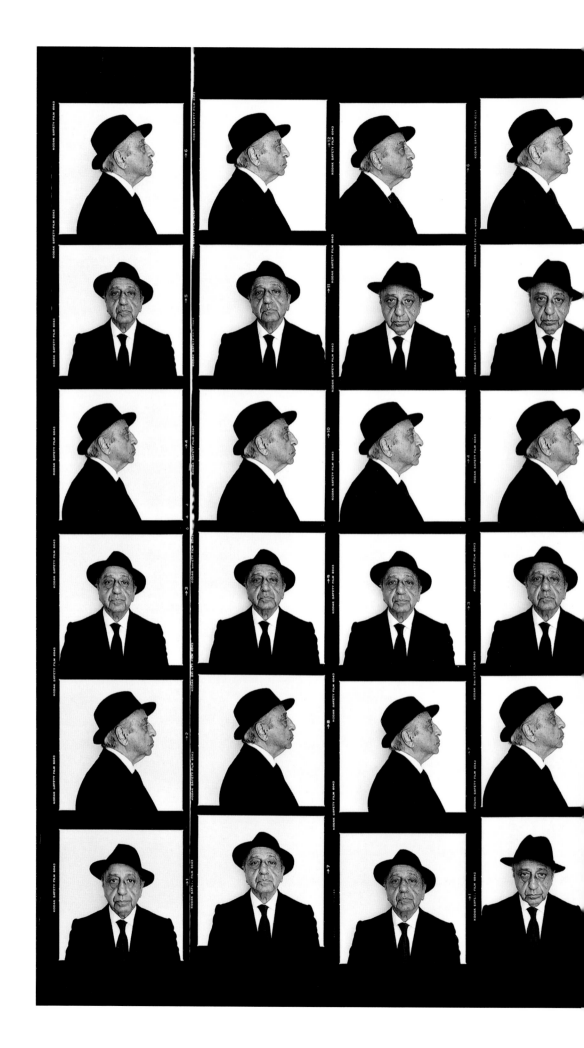

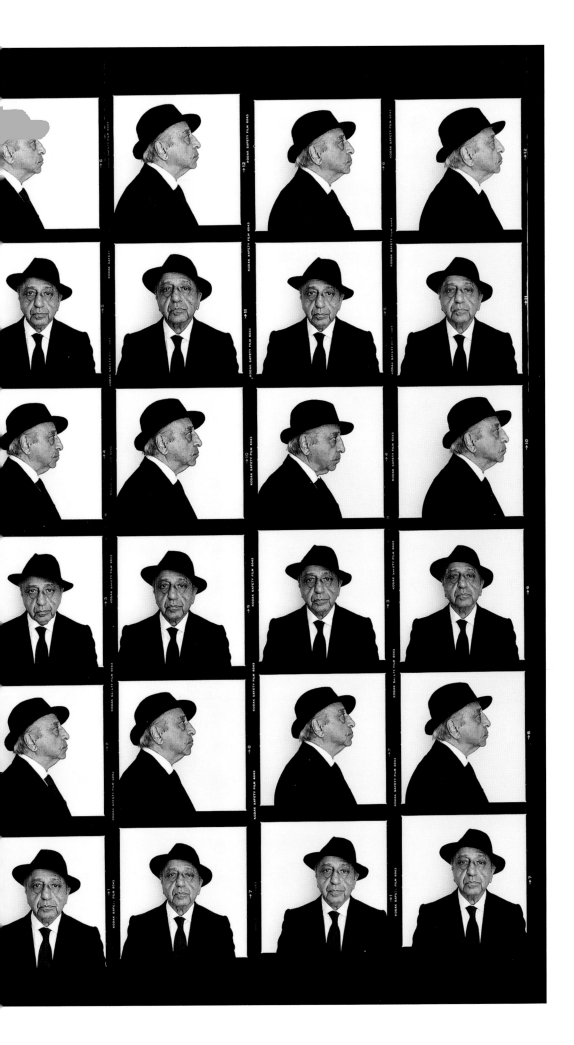

48 Views (Yousuf Karsh), 1981-1983

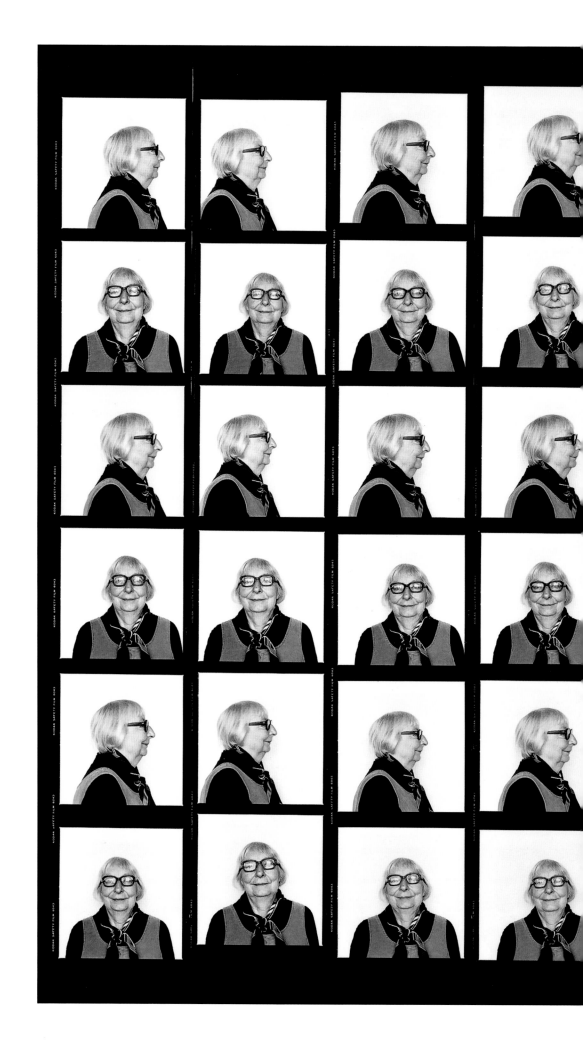

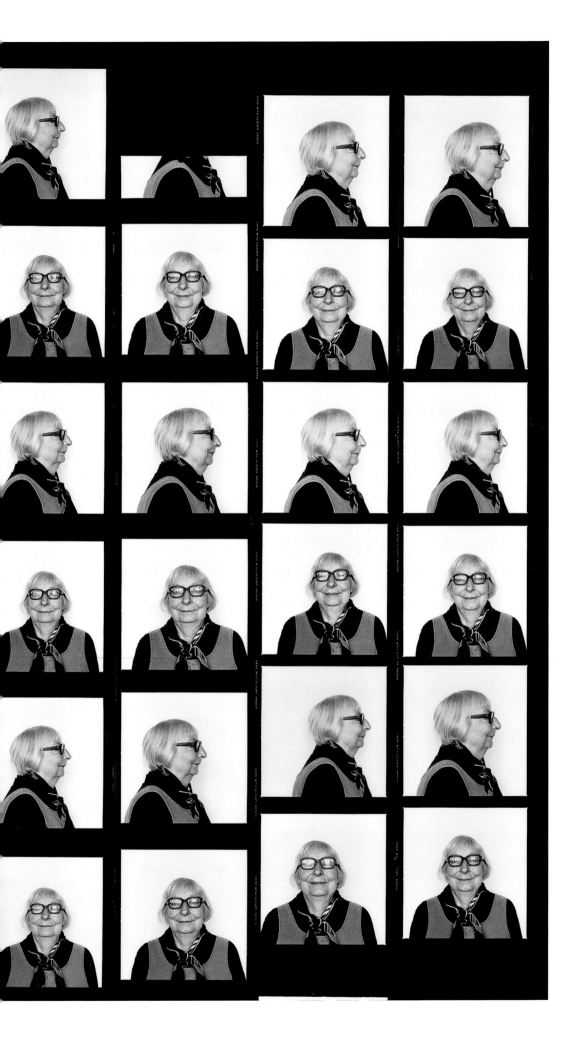

48 Views (Jane Jacobs), 1981-1983

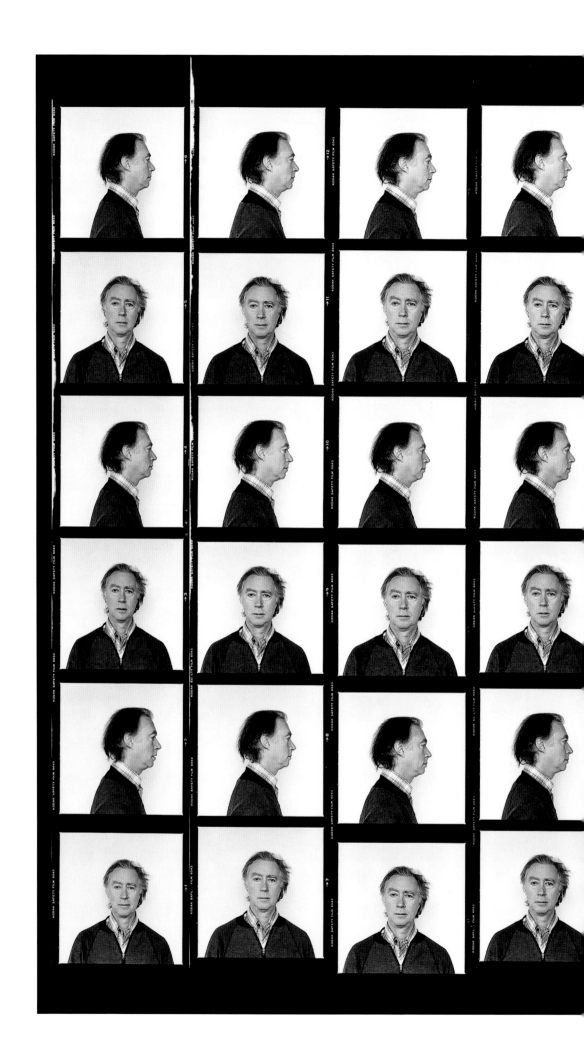

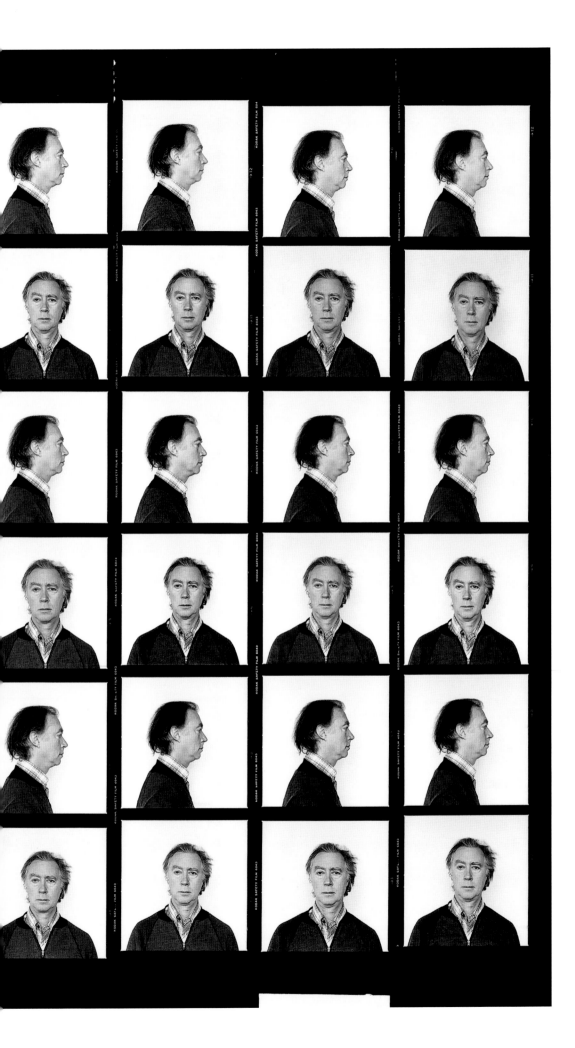

48 Views (Michael Snow), 1981-1983

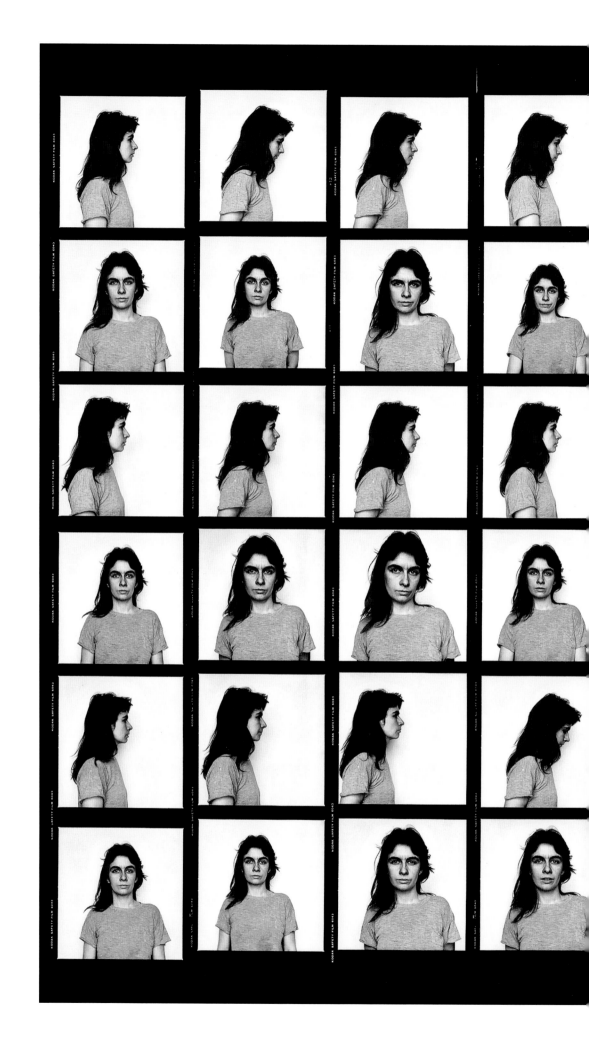

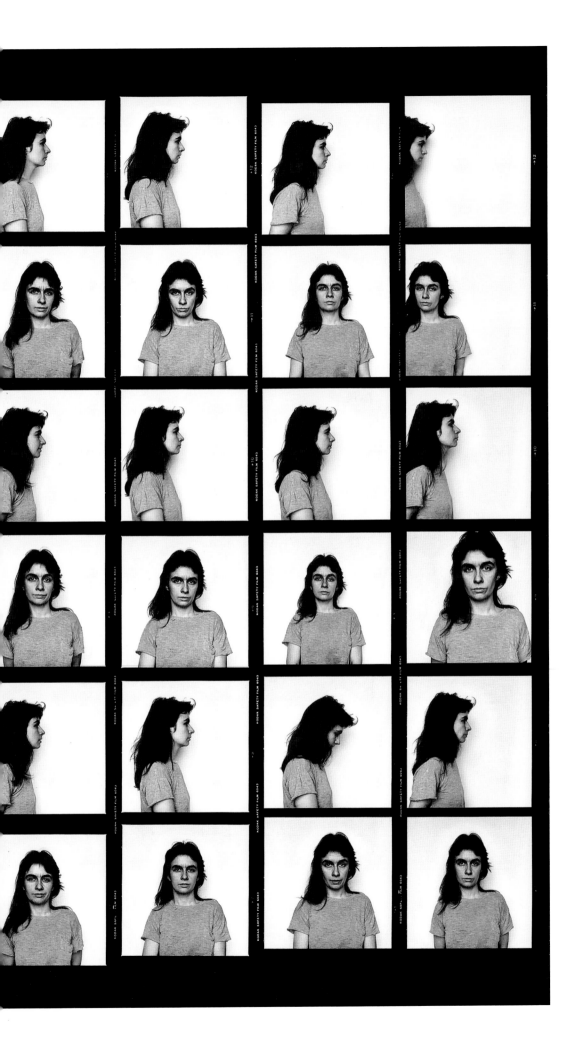

48 Views (Catherine Carmichael), 1981-1983

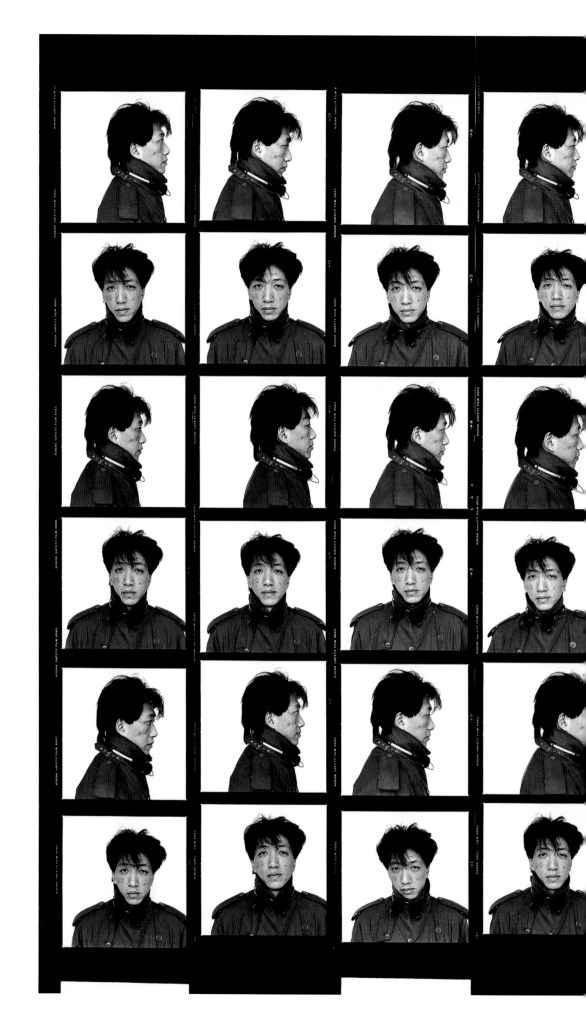

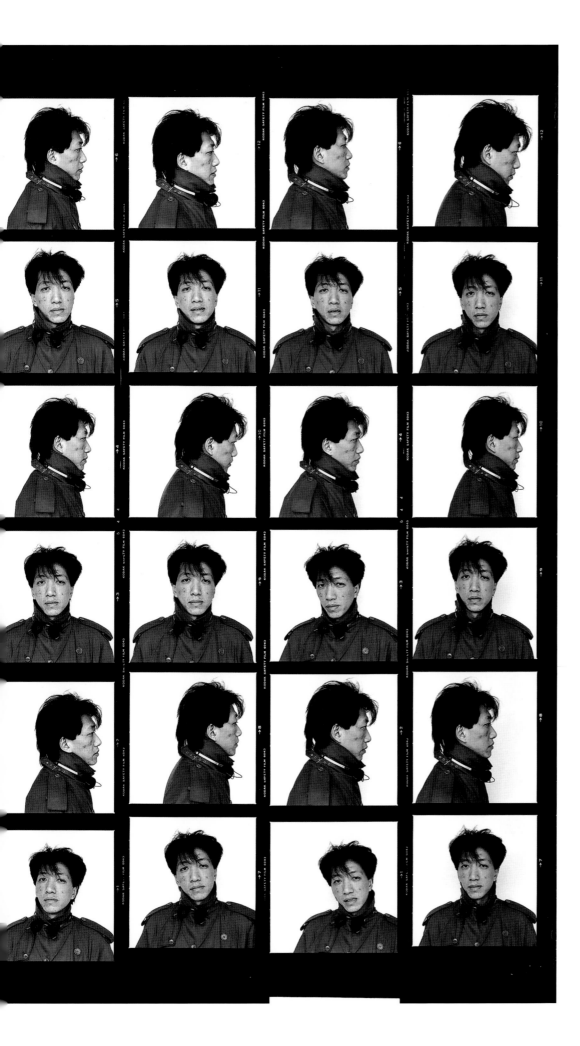

48 Views (Paul Wong), 1981-1983

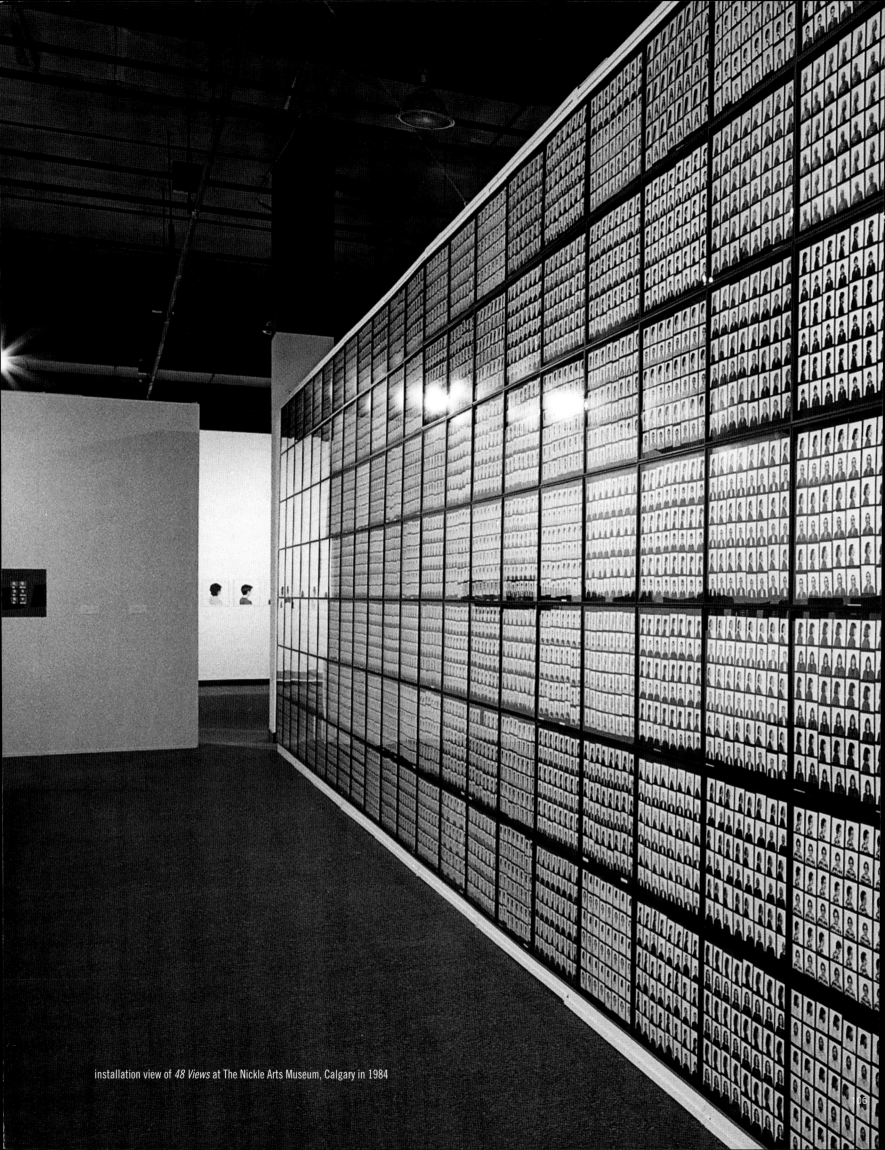

installation view of *48 Views* at The Nickle Arts Museum, Calgary in 1984

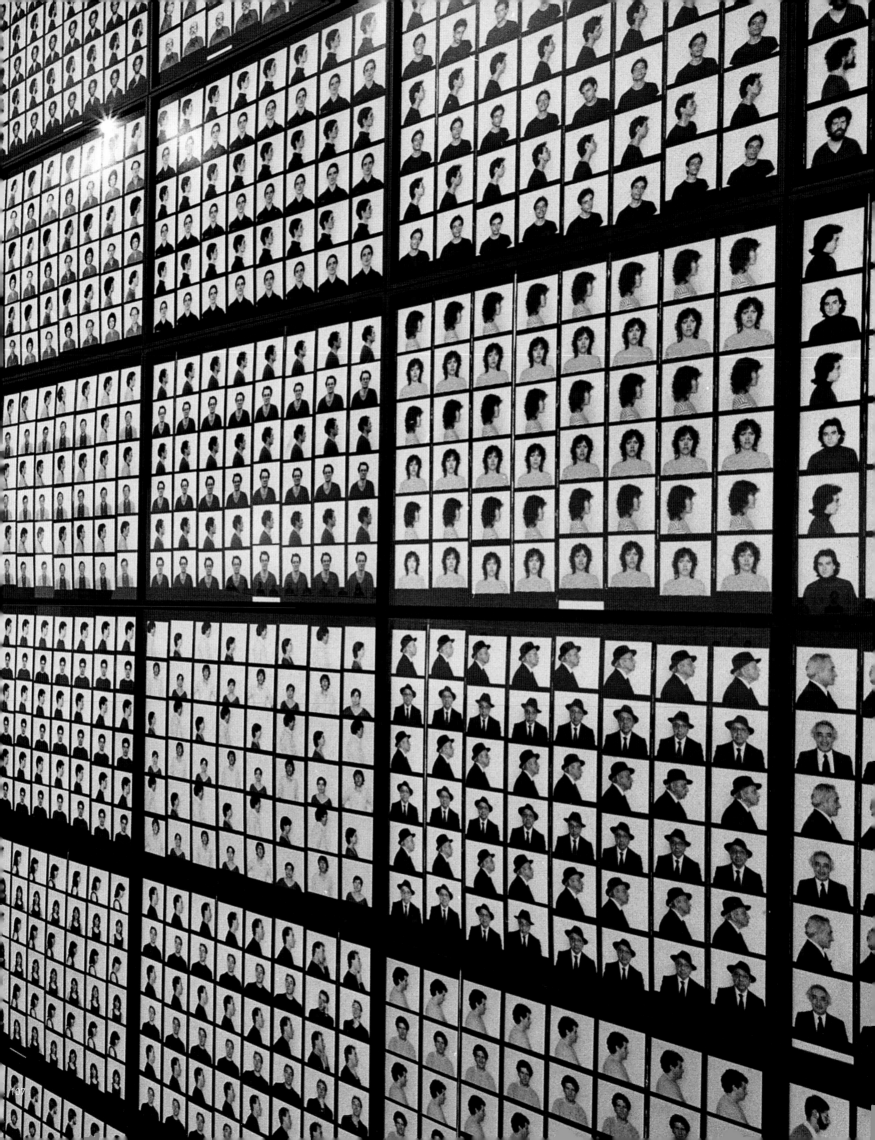

THE MORE ONE LOOKS THE MORE ONE SEES
PORTRAITS OF ARNAUD MAGGS

MAIA-MARI SUTNIK

Were you ever Daguerreotyped, O immortal man? And did look with all vigor at the lens of the camera or rather by the direction of the operator at the brass peg... to give the picture the full benefit of your expanded & flashing eye?... & in your resolution to keep your face still, did you feel every muscle becoming every moment more rigid...and the eyes fixed as only they are fixed, in madness, or in death...? [a] portrait of a mask instead of man.

RALPH WALDO EMERSON

Emerson's lament over photography's yielding nothing of one's "true likeness," and his complaint that, "total expression had escaped from the face" and that what one held is "the portrait of a mask instead of man"[1] is a disappointment of expectations. Whether this lament is about his rigid muscles and deathly stare is ambiguous; nevertheless he refers to an image of recognizable identity with which he took issue. The pursuit of locating a portrait that does not elude the perceived "true likeness"—meaning an image that on reflection satisfies the 'realism of me' in the mind of the subject, it is all about how one sees one's likeness, rather than what is captured by the lens of the portraitist. The expectation that photography can somehow provide infallible representation is still current today, just as it once was expressed by Emerson in his hope of truthful delineations. Some 170 years after the Daguerrean heyday, the challenges of a portrait extending the subject unaffected, remains puzzling and embedded in a grand enigma of the photographic 'likeness.' In the larger scheme, describing faces and features with accuracy also requires a new understanding of the nature of the portrait, and how it might faithfully relate to perceptual possibilities. But, for all of its ambivalence, the portrait genre can be revelatory in the depiction of a persona or, at least, the assumptions surrounding the subject—the aura of the portrait photograph remains compelling in the diversity of artistic formulations. Within the history of the medium, the portrait is invested in many photographers' individual concepts of representation, among which the extraordinarily probing portrait work of Arnaud Maggs is exemplary and commands attention.

Arnaud Maggs's large-scale grids of faces may conjure up a measure of the "fixed," as agonized by Emerson. But more so, they challenge notions of the formal studio portrait by generating such presence in their organization that the multiplicity of faces may at a glance appear as polarized in remoteness—but that is merely a reading of the control that Maggs asserts in his self-contained objectivity. Maggs's intention is not to seek for immediacy nor to register subjective emotion; rather he privileges the notion of distance for portraits that are descriptively clear and analyzed for their system of presentation. Any assumption that a Maggs portrait is a document of seemingly cheerless personalities does not even enter into his thinking. In fact, he sees the relationship with his subjects as participatory, otherwise the portrait work would simply not happen. His system of assembling photographic grids is to reveal something of the human subject that one single portrait view could not fully accomplish. The modular grid structure, as much as the camera, becomes a tool for expanded seeing.

Critic Robert Enright perceptively suggests that when Maggs entices viewers to partake in the ubiquity of portrait conventions—faces appearing all around us—he then "does everything he can to negate it."[2] By extending into the work a seamless descriptive rigour—scale of installation, organized grids, underlying graphic structure, clear print veracity—Maggs simply reconfigures viewers' observance by unifying the temporal and the psychological zones of the portrait. It is also evident then that his transactions with the subjects negate any of the familiar pictorial portrait conventions, and that his portraits are the antithesis of the commonplace nineteenth-century studio studies, or the dramatic visages in Julia Margaret Cameron's array of characters. The categorized societal panorama of subjects documented by August Sander, and the penny-arcade portrait displays photographed by Walker Evans in the 1930s, with which Maggs's portraits have been noted as associated sources, are more akin to his desire to collect and identify, than to act as specific source engagements related to the nature of his work. In the realms of portraiture Maggs's work remains independent from the larger pantheon of telling faces photographed by such famous twentieth-century photographers as Yousuf Karsh, Irving Penn, Arnold Newman, and Richard Avedon, whose style of still frontal views bring to fore the taxonomy of faces often associated with Maggs. But, the persistence of Maggs's cumulative serial and sequential intentions that are evident throughout his work presents a clear visual vocabulary of his own. If anything, his framed and fixed faces are perhaps reminders of photographic images that declare official recognition for identity purposes, be it the stare of the passport picture or the frontal and profile of police 'mug shots'; however, his portraits are not classifiable based on any sociological rationale. Maggs's series of horizontal and vertical rows—the organizing grid—is a compelling composite in which each subject is distant, yet insistently present. Once more he asserts that the photographic portrait is invariably elusive in nature, and a paradox of the subject and its representation. Maggs neither responds nor deflects this paradox, but addresses his portrait work programmatically with visual autonomy.

In 1980 Maggs achieved a landmark; three significant portrait works of which two were accomplished in Düsseldorf and one in Toronto. He spent a week photographing the art students at the Staatliche Kunstakademie, and later he spent a morning with the pioneering conceptual artist Joseph Beuys. Both works have been exhibited and reproduced to much critical acclaim. Only the Toronto project, *André Kertész: 144 Views*, has not received as much prominence until now, bringing to the foreground the three conceptually connected early works. Yet, on close observation each may be argued for their uniqueness.

In 1980 Beuys was fifty-nine and since the 1960s he was the pioneering performance artist of time-based "actions," a reference to his staging of time and sound, sculpture and natural materials. A member of the Fluxus group, he achieved international fame by proclaiming a metaphoric vocabulary for the merging of life with art, and interactions with social order and economic reforms. His notable 1979 retrospective at the Guggenheim Museum, New York, opened new frontiers, and became the inspiration for Maggs to search him out in Düsseldorf with the goal of photographing him.

The portraits of the students at the Kunstakademie, and more so, the Beuys and later Kertész, compellingly assert their own systems of organization. In effect the grids are rigorously formed to distance any metaphoric transcriptions—yet ironically, traces of the individual 'personas' act as equivocal to the uninflected orderly concept that Maggs instills in his portrait sessions. In his approach he conceptualizes a system of presentation—not one based on a singular reading—but one articulated in the sequences of frame after frame. This is clearly evident in portraits taken against neutral backgrounds and organized into grids that unify the individual frames in the large-scale installation work. These accumulative portraits are time-based sequences, often forming the basis of Maggs's distancing methodology. Yet, whether the face directly confronts the camera or details of features are concealed by an objective profile, or a turn of the head, being as the subject is literal, they impact the viewer's reading— traces of identity, individuality, and features—are all evident in degrees, which are both enigmatic and probing. Maggs's tendency to create order is likely a deep instinct, for his inner logic emerges from indelible experiences, observations and memories. His well-ordered grid portraits make demands on the viewer—their sheer presence in installation is inescapable, but they also invert meaning and generate participation. His formality of presenting

the subjects is not indifferent, and as portraits they materialize in nuanced inflections in the consciousness of the observer. Maggs himself has stated that the more one looks the more one sees.

In a recent interview with Robert Enright, Maggs reveals that a recording of Glenn Gould playing Bach's *Goldberg Variations* during a studio session was one way of "stilling the subject out"[3]—the work resulting in a clarity of classification, not unlike a record of taxonomy. The "Goldberg Variations" may not have played for the students at the Kunstakademie, but Maggs nevertheless achieved a unified expression of stillness and veracity, each student posed successively in three profile and three frontal views. Each resulting portrait is the antithesis of the traditional annual student "roll-call" portrait of gentle demeanour and fractional tilt to the head that eliminates that fixed stare into the camera. Maggs's construction of 443 views of students does not define an actual class, but is an assembly of portraits, each one persisting in the sequence the student came to be photographed. Their faces are "stilled" and dominant against a common white background, creating a visual document of a non-hierarchical collection of descriptions informed through their role as students, far removed from portraits of illusion and deep space.

Maggs's interest in proportion led him to the Kunstakademie where he noticed 'heads' that somehow reminded him of the drawings by the early sixteenth-century German artist, Albrecht Dürer. His 1528 studies delineating human proportions and physiognomy are masterful in exactness and meticulously detailed. At the Kunstakademie, Maggs found his Dürer heads and faces, and given a space with northern light to photograph, the students responded eagerly, and, within the course of the week, he analyzed a system: each completed film strip of twelve unedited views (one with eleven), organized in progressions of verticals, to be read vertically or alternatively viewed across the expanse of portraits. Maggs's desire for objectivity and distance in this larger presence is achieved, but nevertheless each frame holds its enigmatic nature. Since Maggs has selected individual details from the sequences he shows paradoxically the more one observes the whole, the more the details begin to register. The frontal views are confrontational, but are open to introspection, while the profile, on the other hand, is never so decisive, but acts as a visual counterpoint between objectivity and subjective speculation. Photography's immobility has 'fixed' each frame, yet details of features, hair, dress and style announces presences as much as the photographer's own observational powers. Looking closely, one sees in each portrait, nuance and inflection that are not subdued even in the 'stilling process.'

In a sense Maggs was preordained to meet up with the larger-than-life enigma personified by Joseph Beuys. Impressed by this art, Maggs flew to Düsseldorf with the idea of doing a portrait session with the artist. His first meeting with Beuys is now the stuff of legends, but bears recounting. Without any prior introduction or appointment, Maggs arrived at Beuys's house with some of his work as a way of introducing himself. Beuys who showed up at the door wearing his trademark hat, remarked that the work was nice, but he was much too busy for a portrait session. Maggs calmly responded that that was too bad because he had all the time in the world— after which Beuys told him to come back Wednesday at ten in the morning for an out-of-door session. Beuys's strategy may have been to defy and stare down the camera, but his restrained facial inflections bear evidence of time and thereby he played into Maggs's strategy of "synchronizing" photographic time with real time. Had Maggs attempted to avoid Beuys's monumental personality, it is not known whether he could have captured directly the very intensity of his presence, which he did in 100 frontal views and 100 profile views. An artist infused with a complex interior life and a haunting psychological presence, Beuys seemed ready to conduct another performance, requiring physical stamina and perseverance to confront Maggs's camera. But, registered in the sequenced portraits appears a battle of wills. The sequence of 100 frontal views convey his uncompromising and startling presence, yet, as one becomes at ease with Beuys's penetrating look, his 100 profile views evoke a sense of exhaustion evident in his stooped bearing. His individual inflections and the subtle tension from frame to frame serve as counterpoints to the first impulse of his defiance. Each of the 100 views foreground the other, and they are mutually contingent to the totality of Maggs's two separate grids.

Maggs arranged a grid of five vertical rows of seventeen views, ending the sixth rows with fifteen views, with both views sequenced systematically. Curator Josée Drouin-Brisebois has proposed that the absence of the last

rows suggests that the series is either unfinished or it continues.[4] One could agree on this notion, purely based on the mesmerizing and compelling impact this work makes by its grand scale and in the mind of the viewer. The Beuys persona is never ending. Beuys died six years after Maggs's portrait and his work is sustained in collections and writings where both history and mythology meet, so essential to Beuys's creative staging about his life and art. Among the hundreds of images of the artist, it is interesting to note that very few portraits have been taken while actually posing for the camera—most were taken during the course of his performances and other in-situ moments. It is then no wonder that Beuys was at once out of his natural element, and enticed by Maggs's performance with the camera.

As with Beuys, *André Kertész: 144 Views*, is a sequenced portrait of the great photographer, which brought another kind of challenge to Maggs, the most alarming being his 86-year-old subject collapsing from possible exhaustion. Maggs's studio at the time was situated in an industrial building and was reached by five flights of long stairs. Rather than taking the elevator, the elderly Kertész climbed the steps and arriving visibly 'stressed.' Maggs's concept for this portrait was to draw a clock-face on the floor and have Kertész make twelve full rotations with twelve views. In the course of synchronizing views with real time, it is evident by frame no. 89 that Kertész's challenge was not to fall asleep. Maggs's task was to sustain the systematic rotation to gain objectivity. Kertész, the great individualist photographer however seems to be oozing in character—dapperly dressed in a tweed and checker-patterned jacket and tie, and his wrinkles revealing years of introspection. Whether it is history or his genius that simultaneously takes over in such a presence is open to reflection.

When Kertész was creating his great portraits of Piet Mondrian, *The Satiric Dancer,* and the mystifying *Meudon,* Maggs had just been born (in 1926). Now, fifty-four years later, Maggs's rigorous systematic approach of a portrait is defied, not by any flaw in his system, but by a personality that pre-empts any perceived notions of the portrait as allusive reading. Much is dependent on how much one "knows" of the person, and the degree of public familiarity to which one has access, but as result, this too is an extraordinary portrait. Not unlike the hypnotic Beuys, Kertész also delivers his own independent cult status. The ordeal to which both subjects submitted to while enduring the time and stamina required for their portrait sessions recalls Emerson's lament of keeping the face still and muscles becoming more rigid. But, unlike Beuys's hypnotic frontal and profile views, Kertész's presence from frame to frame is more individualized and beholden to Maggs's clever rotational strategy. In such a portrait sitting that goes against the grain, one expects to find a moment when Kertész is in battle with the camera—he may have surrendered to a moment of sleep, but he is at ease. Seated in front of Maggs, he is so used to the camera as a photographer that he is not afraid to let the camera lens record it all, including his exhaustion. In fact, there is a kind of serene eloquence in the way that Maggs's rotational series actually does round out the subject in variegated nuances and subtle inflections. Kertész and Maggs united is a brilliant tour de force.

Portraits raise many issues—biography, history, genius, reception and portrayal—that arise from the subject as much as the photographer. Fundamentally there exists an agreement between the photographer and the subject. The subject transformed into a collection of physical properties—surface, scale, shape, posture, material, tone—and point of view as determined by the photographer is dependent on the willingness of the subject to relinquish control. What the subject receives in return, specifically with Maggs, is a sharpened perception of how one looks at the 'presence' of the portrait at work. One can appreciate the formality, the clarity of descriptions and the conceptual resolutions made by Maggs, yet his approach while highly analytical, and whether intended or not, does reveal the inescapable. It may as well be, as is said, that telling a story is dependent on how it is told. Unlike in a conventional portrait, Kertész emerges as a moving prism in Maggs's conceptual plan, with the rotating views showing both the exterior worldliness of which one may know and the self-containment of his interior life, in which we are not complicit, but the camera manages to identify. One cannot but wonder, how much Kertész set himself up for this session. He could not have been completely unaware of Maggs's approach to portraits. There is a 1963 photograph of Kertész by John Szarkowski (former director of photography at New York's Museum of Modern Art) snapped outside a display of prints in Paris of Eadweard Muybridge's serial *Animal Locomotion*—which surely would bring

to his mind what a Maggs's portrait may collectively entail. Who knows what web of factors Kertész brought to this sitting. In the history of photography he was a name of renown, a major figure of the avant-garde in Paris, where he pursued what he had begun in his native Hungary. With his Leica camera and extraordinary agility, Kertész captured images that are considered iconic today, firmly positioning photography as an independent form of art. Somewhere we can circle all of this into Maggs's portrait, so clear is his concept that allows for Kertész's senses of self—so much so that even nodding off becomes part of this measured portrait presence.

That *André Kertész: 144 Views* is now to be shown full scale for the first time,[5] makes one wonder about Maggs's decision of having kept it on hold for over thirty years. Of course, it could just be another case of having all the time in the world, but perhaps Maggs was simply not quite ready to install the complete large-scale work because it is more poignant than his cooler, more remote portrait work of the same year. Timing is providential in solving pictorial problems, an issue that Maggs has once more richly resolved. Over the decades, Maggs himself has had time to build upon his art programmatically. He has now himself stepped into the discourse of the portrait — linked to Nadar, the nineteenth-century French photographer, he is performing the enigma of an enigma. Clearly, the more we look at Maggs the more we see. •

1. *The Journals and Miscellaneous Notebooks of Ralph Waldo Emerson*, eds. W. H. Gilman and J. E. Parsons, 115–16, in A. Trachtenberg, "Reflections on the Daguerrean Mystique," *The Portrait in Photography*, ed. G. Clarke. (London: Reaktion Book), 191.
2. Robert Enright. "Designs of Life—An Interview with Arnaud Maggs," *Border Crossings*, 31, no. 2 (June-August 2012), 43.
3. Ibid.
4. Josée Drouin-Brisebois, *Arnaud Maggs: Identification*. (Ottawa: The National Gallery of Canada, 2012) 28.
5. To be exhibited at Ryerson Image Centre, Ryerson University, Toronto, Canada (May 2013)

Maia-Mari Sutnik is a Curator of Photography at the Art Gallery of Ontario, Toronto, and an Adjunct Professor at the School of Image Arts at Ryerson University, Toronto.
Her appreciation goes out to Susan Hobbs, Katyuska Doleatto, Michael Robinson, Michael Mitchell, and her colleague Sophie Hackett. She is deeply indebted to Arnaud Maggs whose art is an inspiration and to Spring Hurlbut for her support.

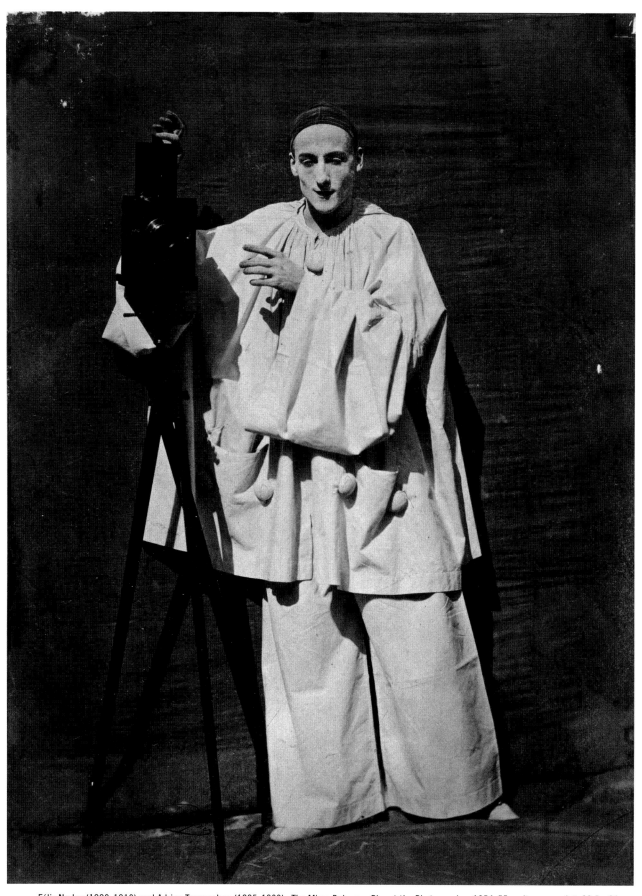

Félix Nadar (1820-1910) and Adrien Tournachon (1825-1903), *The Mime Deburau: Pierrot the Photographer*, 1854-55, salt paper print, 28.5 x 21 cm
© RMN-Grand Palais / Art Resource, New York

ARNAUD MAGGS TAKES A TURN AS PIERROT

SOPHIE HACKETT

"Mon coeur est comme mon visage," wrote the celebrated pantomime Jean-Baptiste Gaspard Deburau to French writer George Sand in the 1830s at the height of his fame.[1] Embraced by the working classes for his cheeky Everyman "catch me if you can" portrayal at the Théâtre des Funambules in Paris, Deburau also found favour with an influential, literary circle, including Sand, Théophile Gautier, Gérard de Nerval, and others. This circle came to identify with Deburau's Pierrot, a stand-in for the struggling artist in the city, living by his wits, devising any number of schemes.[2] When Deburau died in 1846, his son Charles donned his father's costume and took the stage in 1847, perpetuating the role and its interpretation.

Thus, when the journalist and caricaturist Félix Tournachon, better known to us now as Nadar, invited Charles Deburau to come to the photography studio he operated with his brother, Adrien, in late 1854 or early 1855 to pose for a series of *têtes d'expression*, the Deburau Pierrot was a well-known and beloved figure to Parisians, one with mass appeal and an artistic pedigree. A canny marketing move to promote the Nadar studio—if Félix and Adrien could create captivating likenesses of the famous pantomime, couldn't they also do the same for any visitor to the studio?—these twelve photographs have since become "legendary," a key part of Nadar's œuvre.[3] Indeed, one of these images, *Pierrot photographe*, graced the cover of a 1995 catalogue for a Nadar exhibition.[4] Which is where Arnaud Maggs first found Nadar's Pierrot, as he browsed the bookshop of the National Gallery of Canada in Ottawa in 2011.

•

Less than a year later, in March of 2012, the exhibition *After Nadar* opened at Toronto's Susan Hobbs Gallery. The gallery at street level was full and the delight palpable, as people looked intently at the group of nine photographs installed on the long wall so important for much of Maggs' work.[5] They found the artist in a costume almost identical to the one Pierrot wears in the photographs made by the brothers Tournachon:[6] the full muslin pants and large A-line blouse with big fabric-covered buttons, the black skull cap, the slippers. He wore the mime's white face, but made it more doll-like with black eyebrows, lips and a *mouche* (a beauty mark) high on his right cheekbone. He also added an elaborate frilled collar, a typical Pierrot costume element, though one Deburau *père* and *fils* had both dispensed with in their portrayals. Maggs has rigorously and stylishly dressed in black in recent years, in fitting contrast to his silver short-cropped hair and mischievous mien. His transformation in these photographs was total. What's more, he inhabited the Pierrot character fully and effortlessly—his stately presence suddenly boyish and more highly animated in this clown attire. Therein lay the surprise.

Like the nineteenth-century Pierrot compositions, in Maggs's version the backdrop is plain; the artist's gestures and expressions exaggerated; his body depicted in full. Maggs Pierrot, like Deburau Pierrot, pantomimes his way through a range of situations and emotional states: archival satisfaction, falling in love, working focus, mourning, playing his harmonica with carefree abandon. These states appear joyfully simple, easy to identify and identify with. The narrative that builds as we look at the nine photographs doesn't move in a linear fashion—the works, in fact, have no prescribed sequence[7]—but it does seem to add up to a life, an autobiography acted out before our eyes, a character brought to life.

The series title, *After Nadar*, seems straightforward as do the works' individual titles—*Pierrot the Collector*, *Pierrot the Storyteller*. There is a link between the episodes enacted and Maggs's life but it is not always easy to pinpoint. Maggs himself does collect the enamelware jugs that Pierrot holds in *Pierrot the Collector*, but who will receive the roses in *Pierrot Falls in Love*? This remains pure speculation. We recognize a piece of funerary stationary from his *Notification* series (1996) in *Pierrot Receives a Letter* but we do not know to whom the sad news pertains. The Bauchet film advertisement—in the shape of an oversized box of film—in *Pierrot and Bauchet* adds humour for its large scale and brings together references to his collecting forays in France, his love of typography and the evolution of photographic materials, more generally. *Pierrot the Painter* distills Maggs's former typographer self into a large painting of the number three from 1978, and *Pierrot the Musician* features his actual newfound love for the harmonica, sparked by a gift from a nephew for his 85th birthday. In *Pierrot the Archivist*, Pierrot takes an inventory of a group of archival boxes casting a cool, appraising look on the self-portrait clipped to his clipboard—this portrait acts as both a mirror and not a mirror, as it is a portrayal of Maggs in his younger years but does not reflect this latest incarnation of Maggs the mime, who is also Maggs the archivist mime, accounting for a life's work.

The most complex of these photographs is *Pierrot the Photographer*. It is the only photograph in the series that faithfully mimics the Tournachon brothers' photograph of the same name. Pierrot stands beside his large-format camera on a tripod, ready to make an exposure. There is humour in the mime assuming the photographer's role, as though anyone—even Pierrot!—could become a photographer, a suspicion that has dogged the medium from its beginnings. *Pierrot the Photographer* is a clear act of homage, in the classic sense of tribute, and a rich one too, with its references to the photographer, the performer and the photograph in question, and even the medium itself, all at once.[8] This single episode gives a frame to all the others—fittingly it was installed in the centre of the others—and to be generous in the taking signals that *After Nadar* is a celebration of the artist's ability to interpret and reinterpret, to take artistic license. Here is a character who has worked and loved and collected and played and looked at the world around him with a deep and compassionate curiosity. Maggs Pierrot clearly enacts the perils and joys of a life in art, but also of a life lived artfully.

·

When Maggs found the book of Nadar's photographs, he had only been vaguely aware of this photographer's œuvre—"Nadar was off my radar," he has simply stated.[9] But he certainly could not have made a more apt choice. The two men have led parallel lives in some ways, working in the graphic arts—Nadar as a caricaturist and Maggs as a typographer and graphic designer—before moving on to photography, reinventing themselves at mid-life. The two also share a Romantic sensibility about the artistic instinct, with its aesthetic imperatives and "zealous dedication to ever higher ideals of expression."[10] Maggs's work until now has belied this reading, but in looking again at his self-portrait from 1983, it could be described as the quintessential portrait of the conceptual artist, cool rigour reflected in his appearance—short hair, wire-framed glasses, strong facial bone structure, sober shirt, and piercing gaze—as well as in the simple rotation of the subject and the grid presentation of the work. Seen this way, it seems no accident then that one of Maggs's early major portrait works was of German artist Joseph Beuys, whose forceful persona is closely intertwined with the objects and performances he produced. *After Nadar* follows in this vein, likewise sparked by a chance encounter with the work, expanding Maggs's meditations on artistic being.

"I couldn't believe, looking at [Nadar's portraits], how alive they were compared to other portraits of that period," Maggs remarked. "The people seemed to be *right* there, and they were very much today, these people—he caught something. It was very exciting for me."[11]

That quality of aliveness is also what struck those at the opening gathering, as visitors marveled at Maggs the mime. He pantomimed photographs from 1854-1855, channeling them through his particular sensibility in 2012, shuttling viewers back and forth across more than 150 years and along what Robert Enright has described as a "complicated loop of aesthetic reiterations."[12]

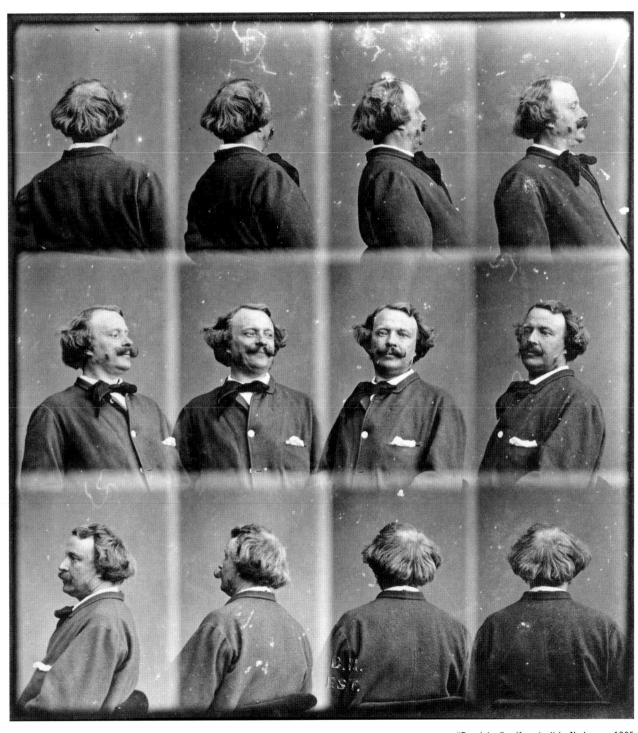

"Revolving" self-portrait by Nadar, ca. 1865
© Bibliothèque nationale de France

Upstairs on the gallery's second floor, the related work, *After Nadar: Pierrot Turning*, greeted visitors with the bust of Maggs Pierrot rotating through 360 degrees in twelve frames. Installed in a grid of three by four photographs, *Pierrot Turning* is a direct reference to a later self-portrait by Nadar, from about 1864. It is also a direct reference to that rare self-portrait of Maggs's own from 1983, described above. Nadar was likely experimenting with a new process for creating a three-dimensional sculpture bust from photographs.[13] In a strong echo of this interest, Maggs recently described the moment that set him off on his first portrait project, *64 Portrait Studies* (1976–1978): "One day I was drawing the head of a model. It was a profile and I just drew a circle and found that the back of the head formed part of the circle… I immediately saw the different shapes of people's heads as sculpture."[14] He opted to render these as photographs, rather than as drawings, and cites police official Alphonse Bertillon and his system for identifying people with photographs as inspiring the grid display.[15] Maggs, however, never saw Nadar's self-portrait until he began this recent project.

It was a serendipitous discovery. "I was delighted to find it," Maggs exclaimed (though, ever exacting in his execution, he also cheekily declared Nadar's version "sloppy").[16] Of course, the historical moment when each of these artists was drawing a relationship between photographic description and three-dimensional form was vastly different, as were their respective goals. At the time Nadar made his famous portraits, the prevailing view found individual character inscribed in appearance—something Nadar the caricaturist became well-practised at as he worked to locate and illuminate each of his subject's particularities. In the well-known defense he wrote in the legal suit against his brother in 1856, Nadar articulated the highest goal of the portrait in photography as the *ressemblance intime*, the intimate resemblance, by which he meant the aligning of pictorial elements through lighting, pose and an ability to commune with the model to deliver an image with psychological force.[17]

Maggs did not seek to reveal any interior state or character likeness in his subjects, in his early portrait works, but rather to focus on the surface alone to describe their relative features. At this period in the late 1970s and early 1980s, the photographic image was being critically tested, and Maggs joined a diverse group of artists who worked to expand its expressive possibilities.[18] The photographers of the 1975 *New Topographics* exhibition, like Bernd and Hilla Becher and Lewis Baltz, adopted a cool eye for their scenes of landscape and the built environment; Cindy Sherman staged feminine types in her *Untitled Film Stills* (1979); and Sherrie Levine created anti-homages, like *After Walker Evans* (1981), by simply and radically rephotographing Evans's 1930s photographs of the Burroughs Family in Alabama. Save for the Bechers, Maggs did not directly engage with his peers working in photography— he cites Beuys, Carl André, Andy Warhol as well as figures like Walker Evans and Eugène Atget as particularly influential—but their work in this context and his own spring from a common context.

As has been noted elsewhere, what results in Maggs's ambitious early works—fusions of a documentary impulse and a conceptual system—are portrait typologies.[19] These typologies echo those nineteenth-century projects that used photography to classify different physiognomic or ethnographic types in the name of law-enforcement or pseudo-science[20] (as Maggs attests in drawing a link to Bertillon), but they are in fact exercises in graphic exposition as Maggs compares the shapes of chins, noses and hairlines. For all their precision, these typologies are also deeply empathetic for the way they lay out an overwhelming diversity of human form, impossible to generalize.

Maggs hasn't worked in this analytical portrait mode for a number of years. *Pierrot Turning* thus brings us back to his beginnings as an artist. Subjecting Pierrot to such rigorous examination seems to quietly mock his own past production and perhaps even his own early, earnest ambitions. At the same time, if Pierrot does indeed stand-in for the Everyman/artist, Maggs then delivers a wittily succinct version of these early portrait grids.

•

The other Pierrot pictures in *After Nadar* stand apart from any of Maggs's previous work, for their narrative elements, for the way he used himself as a central subject—literally and figuratively—and for the way he so

directly links himself to another artist and his output. The trajectory from there to here is a long one, but its seeds can perhaps first be found in his 2007 work, *Contamination*, for which Maggs photographed the pages of an old ledger on which blooms of pinkish mould flourished. The embrace of the accidental, organic forms of the mould signals a "disruption in Maggs's own system of production."[21] Maggs took another step away from this system in 2010 when he created *The Dada Portraits*. Taking pages from an 1850 French carpenter's guidebook, Maggs re-presented a group of these architectural drawings at larger scale and christened each with the name of a Dada artist. In attempting to discern a specific likeness from the constellation of lines in each carpenter's drawing, resemblance here *must* be invented, first by the artist and then by the viewer.[22] This imaginative act is the conceptual leap that makes *After Nadar* possible.

With *After Nadar*, Maggs delves not only into creating a series with a narrative, but it is also autobiographical:

"In this group of pictures of the mime Pierrot, I saw a good vehicle for doing pictures of myself. And, when someone asked me why I was doing these pictures of myself, I saw that it has a lot to do with my age: I want to leave traces of myself," Maggs explained.[23]

These traces come in the form of the objects in each photograph, most from Maggs's own collections, some of which have appeared in other works of his which he activates through pantomime. Indeed, the mime becomes the perfect character in which to enact these scenes in photographs: mute but highly expressive. Add to this formula an homage to one of photography's foundational figures and the loop of aesthetic reiteration is complete.

In these nine pictures, Maggs inhabits the role of a man inhabiting the role of his father as Pierrot, as photographed by two brothers, for whom the famous Pierrot was compelling because he represented both their plight as young artists in 1850s Paris, but also their hope for commercial success. Maggs interprets the role of Pierrot as Arnaud Maggs himself, with all of these resonances. Even the collaborative element of the brothers' work echoes here: Maggs worked closely with his long-time studio assistant, Katyuska Doleatto, to create *After Nadar*.

Looking again at the photographs of Pierrot with his camera, one crucial difference emerges between the two versions photographs: where Deburau Pierrot looks towards his left hand, gesturing his sitter to look at the camera lens, Maggs Pierrot looks directly out at the viewer.[24] Aligned with the camera lens, Maggs's look is clear and arresting, as though he would fix us, his viewers, with his very eyes. His left hand is also raised but in a gesture that suggests "Please hold still." Maggs is turning us into photographs. Even more importantly, he immortalizes himself doing the thing he loved: making a photograph.

•

At the *After Nadar* opening, Maggs had clearly set something alight in the visitors. People were captivated. The artist fielded a fierce crush of friends, family, colleagues, students and strangers as they congratulated him on the work. The star that night, though, was undeniably Pierrot, a comically old-fashioned clown figure from the mid-1800s, finding a new place under the gallery lights in 2012.

Mon coeur est comme mon visage—my heart is like my face—wrote Deburau *père*. Perhaps Maggs would write "My heart is like my photographs." Or perhaps more simply: "This is how I *look*." •

1. Maria Morris Hambourg, Françoise Heilbrun and Philippe Néagu, *Nadar* (New York: The Metropolitan Museum of Art, 1995), 224.

2. Ibid, 224.

3. Ibid, 224.

4. Maria Morris Hambourg, Françoise Heilbrun and Philippe Néagu, *Nadar* (New York: The Metropolitan Museum of Art, 1995).

5. Robert Enright. "Designs on Life: An Interview with Arnaud Maggs," in *Border Crossings*, vol. 31, no. 2 (June/July/August, 2012), 47.

6. Françoise Heilbrun makes a strong case for attributing the Pierrot photographs to both Félix and Adrien. Françoise Heilbrun, "Nadar and the Art of Portrait Photography," in Maria Morris Hambourg, Françoise Heilbrun and Philippe Néagu, *Nadar* (New York: The Metropolitan Museum of Art, 1995), 35-36.

7. Interview with the artist, Toronto, October 9, 2012.

8. Maggs professes to dislike the idea of "homage" intensely. He finds the concept of "after" much stronger. Interview with the artist, October 9, 2012.

9. Ibid.

10. Hambourg, et al., 25.

11. Interview with the artist, October 9, 2012.

12. Enright, 44.

13. Gordon Baldwin and Judith Keller. *Nadar Warhol: Paris New York*, Los Angeles, CA: J. Paul Getty Museum, 1999, 73.

14. Charles A. Stainback. "Q and A with Arnaud Maggs," in Josée Drouin-Brisebois, *Identification* (Ottawa, ON: National Gallery of Canada, 2012), 112.

15. Ibid, 112.

16. Interview with the artist, Toronto, October 9, 2012.

17. Cited in Hambourg, et al., 25.

18. See eg. Douglas Fogle, *The Last Picture Show: Artists Using Photography, 1960–1982*. Minneapolis, MN: Walker Art Center, 2003.

19. Maia-Mari Sutnick. "Portraits by Arnaud Maggs," in *Arnaud Maggs: Works 1976–1999* (Toronto, ON: The Power Plant Contemporary Art Gallery, 1999), 10-12.

20. See for eg. Michel Frizot, "Body of Evidence: The ethnophotography of difference," in Michel Frizot, ed., *A New History of Photography* (Cologne: Könemann, 1998), 259-271.

21. Josée Drouin-Brisebois. "Portrait of a Working Artist," in Josée Drouin-Brisebois, *Identification* (Ottawa, ON: National Gallery of Canada, 2012), 31.

22. Citing Francis Bacon, Michael Mitchell refers to this as "a whole harvest of invention." Michael Mitchell, "Abracadabra: Arnaud Maggs makes portrait magic" in *Canadian Art*, fall 2010, 144.

23. Interview with the artist, October 9, 2012

24. Hambourg, et al., 225.

Sophie Hackett is the Assistant Curator, Photography at the Art Gallery of Ontario, Toronto.
The author would like to thank Max Dean, Katyuska Doleatto, Thierry Gervais, Amy Langstaff, Gaëlle Morel and Maia-Mari Sutnik for their invaluable insights, and Spring Hurlbut and Arnaud Maggs for their love and friendship.

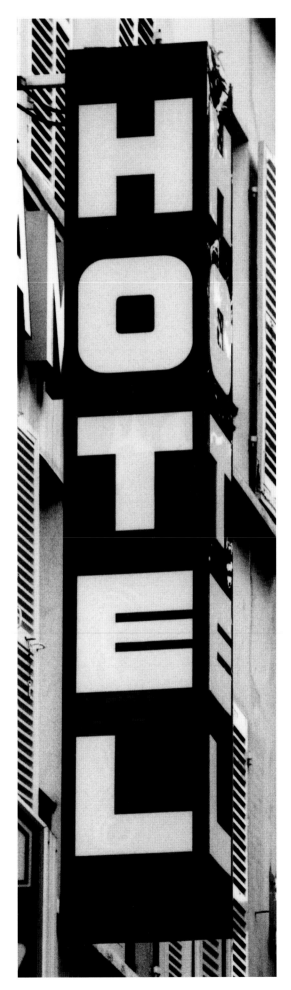

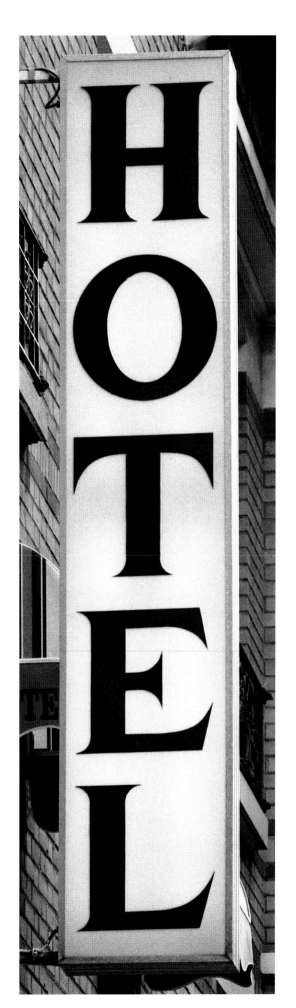

Hotel (76, boulevard de Strasbourg, 10 ᵉ), 1991

Hotel (6, rue de la Bidassoa, 20 ᵉ), 1991

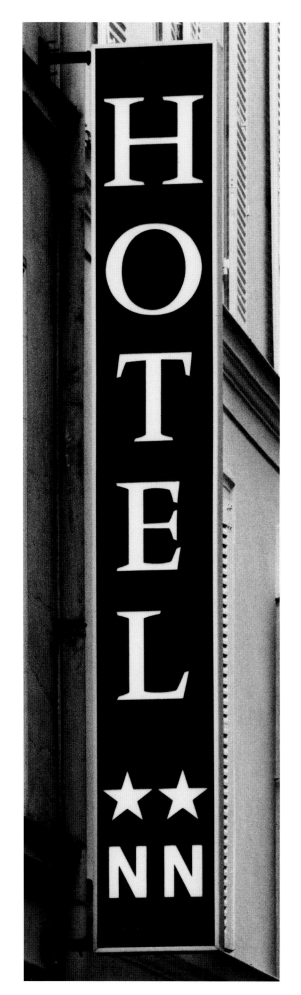

Hotel (39, rue Claude-Tillier, 12ᵉ), 1991

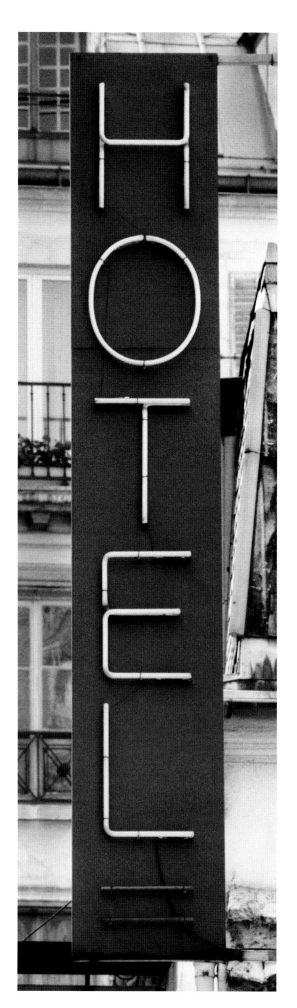

Hotel (5, rue de Malte, 11ᵉ), 1991

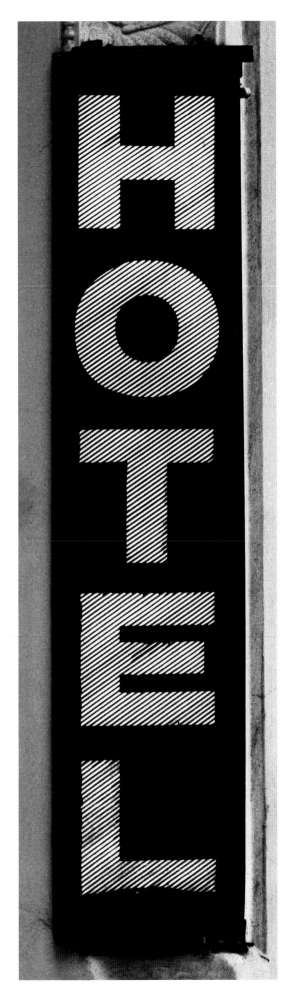

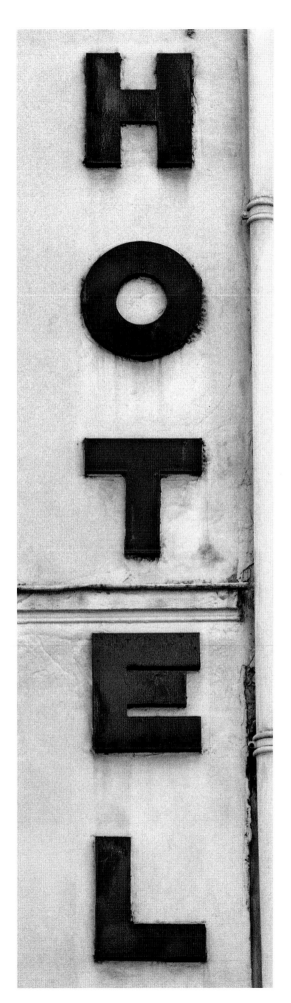

Hotel (77, avenue de St.-Ouen, 17 ᵉ), 1991

Hotel (18, rue Beauregard, 2 ᵉ), 1991

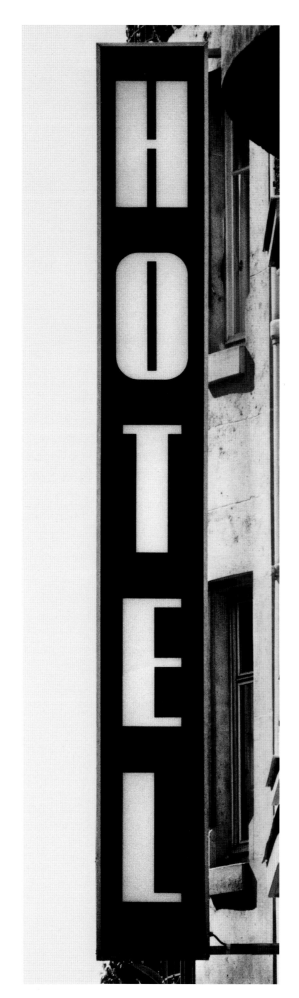

Hotel (23, rue Henri-Monnier, 9 e), 1991

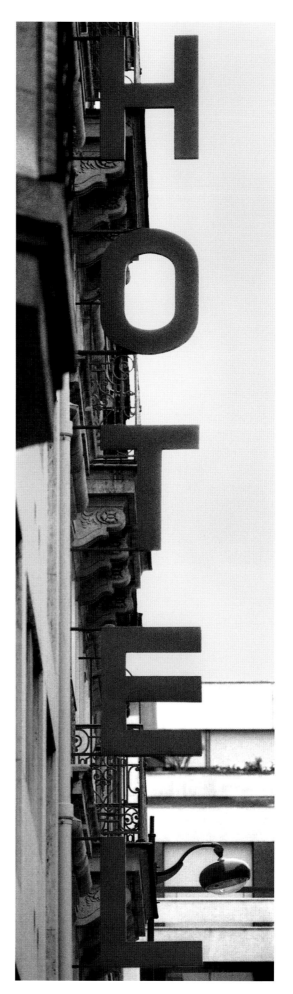

Hotel (9, rue Jean Bart, 6 e), 1991

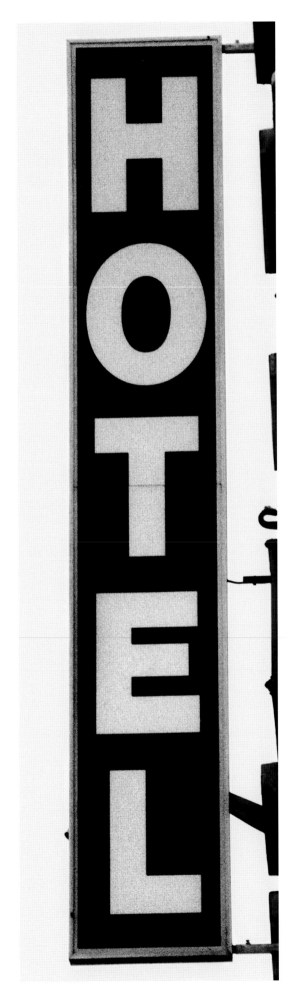

Hotel (7, rue du Général-Beuret, 15 ᵉ), 1991

Hotel (22, rue de la Parcheminerie, 5 ᵉ), 1991

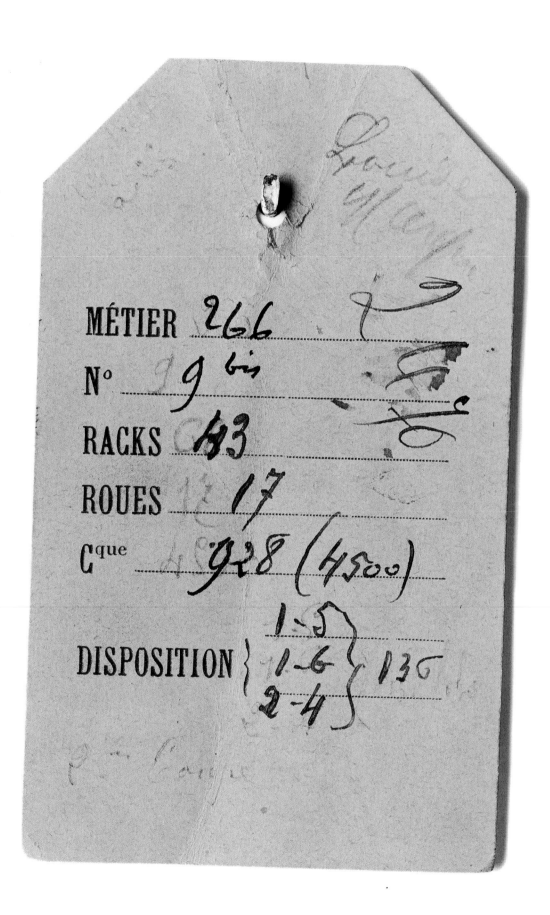

Travail des enfants dans l'industrie: Les étiquettes (detail), 1994

Travail des enfants dans l'industrie: Les étiquettes (detail), 1994

Travail des enfants dans l'industrie: Les étiquettes (detail), 1994

Travail des enfants dans l'industrie: Les étiquettes (detail), 1994

Travail des enfants dans l'industrie: Les étiquettes (detail), 1994

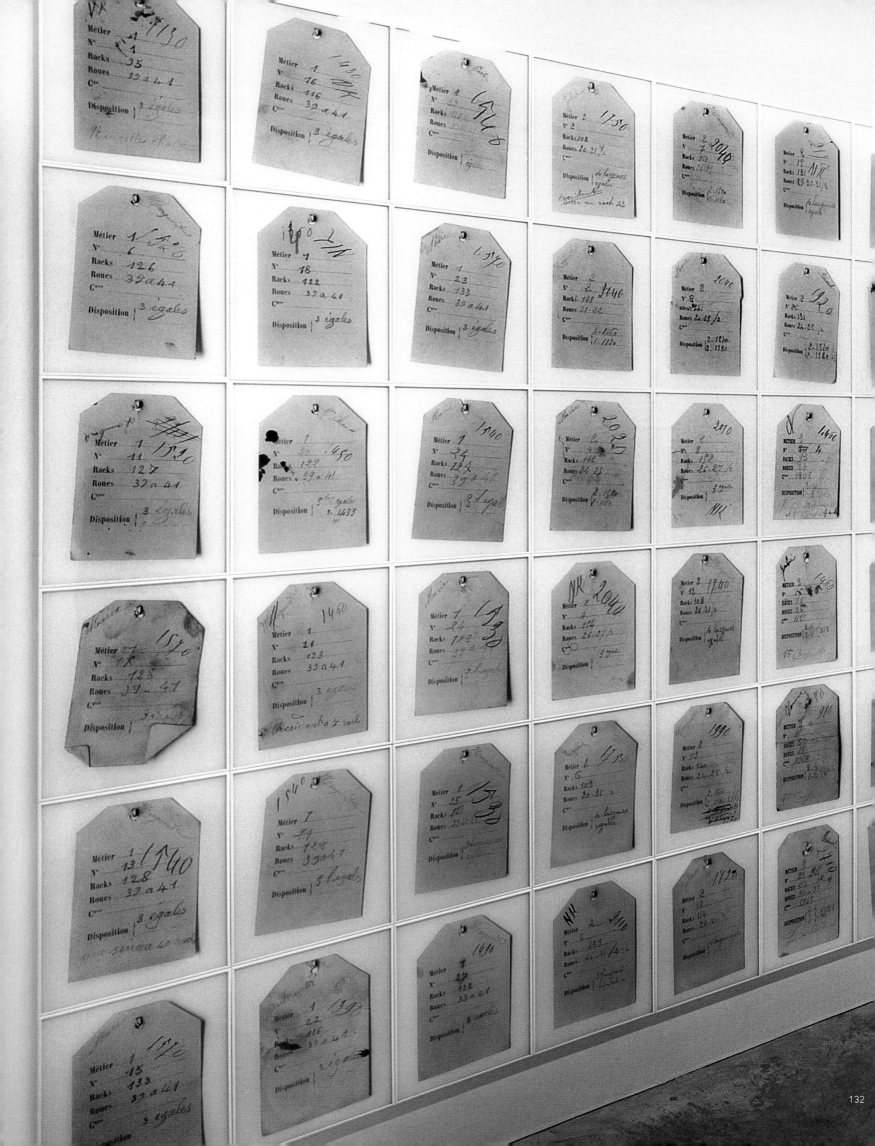

132

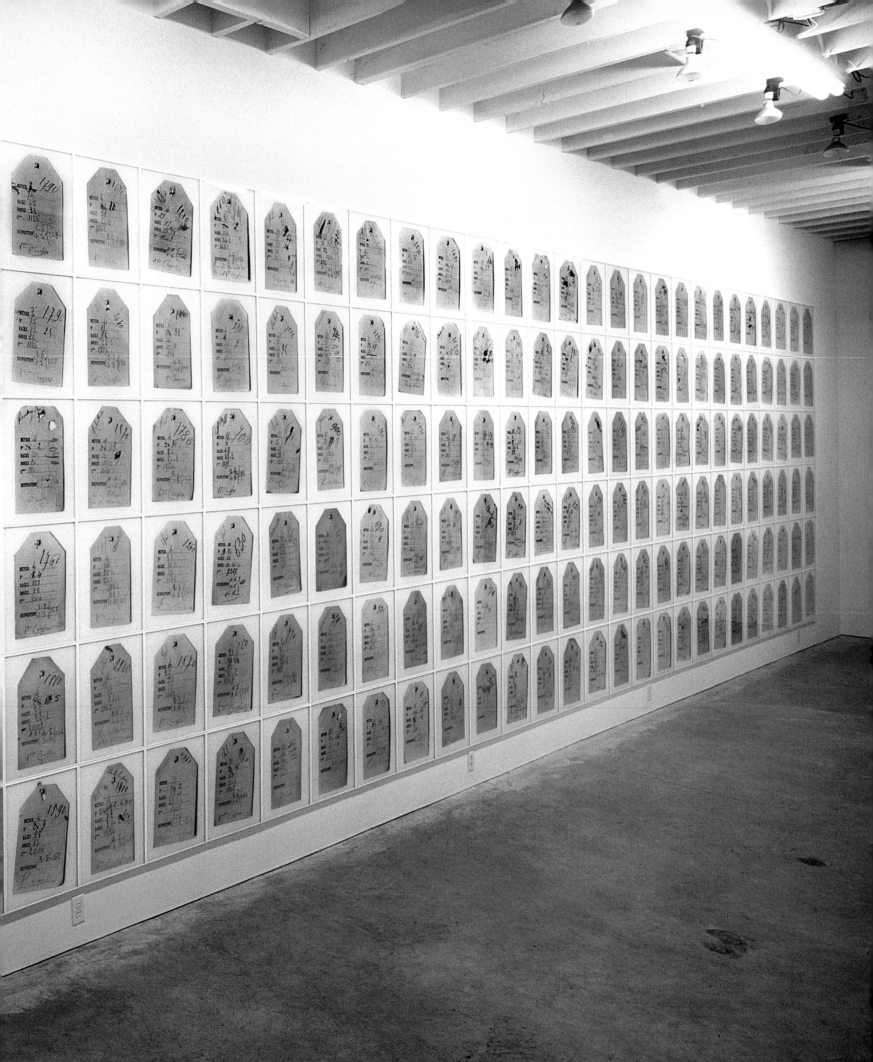

installation view of *Travail des enfants dans l'industrie: Les étiquettes* at Susan Hobbs Gallery, Toronto in 1994. Photograph by Isaac Applebaum

Notification XIII (detail), 1996

Notification XIII (detail), 1996

Notification XIII (detail), 1996

Notification XIII (detail), 1996

Notification XIII (detail), 1996

Notification XIII (detail), 1996

Notification XIII (detail), 1996

installation view of *Notification XIII* at the National Gallery of Canada, Ottawa in 2006. Photograph by Lawrence Cook

Répertoire (detail), 1997

Répertoire (detail), 1997

4

~~Reichelet, Ornemaniste) Quai de
Jemmapes et Rue Louis Blanc
et Adam (cheminées) 1 / Rue
Louis Blanc.~~

Poteau — Rue de Turenne 59

Renard (Ferronier) Avenue de
Versailles 200 (Part Poteau)

Hamet, Hubert et Berson) Rue
Marcadet 243 (Grelu) Part
Bercia Tourette.

~~Junot et Jalot — Bd Montparnasse 82
Part Cavalier) le matin 8 h. le Revoir~~
dans les premiers jours de Septembre

Delisle — Rue Pavée 24.

D'Hière Rue Amelot 70 — Part
Montmelian — Le matin avant 9 heures
de 1 heure à 2 heures (1er et 2e épreuve)

~~Voir — Ferronerie, Tapissiers etc etc
dans le liste précédente~~
~~Marbriers — Sculpteurs et Bois —
Ornemanistes — Ameublement~~

148

B C E F H I K N O P Q R

~~Bibliothèque Ville de Paris Bât historique~~
~~(Mardi & Vendredi de 9 a 11 h)~~
~~Boileau architecte (142 R du Bac)~~
~~(la 1 et 2ᵉ série des Portes)~~
~~la 3ᵉ série Portes et la 1ʳᵉ série (architecture) Xᵇʳ (6ᵗ)~~

		Amable
Mareuse	Devèche	Parent (archᵗᵉ)
Jambon	Bergeote	Flameng
Grasset	Rateau	Vogel
Pancalou	Gegondez	Goelzen
Laurin	Roescher	
Sardou	Detaille	
Chaperon	Loichmolle	
Rousin	Lalique	
Guiffrey	D'Albret	
Flandrin	Fortuny	
Paul Gervais	Guillemant	
Lebic	Destailleur	
Kolakouski	Gaston Bideaux	
André Michel	Valet	
Van	Sergent (architecte)	
Vinant	Mercia Courette	
Huvé	Cernitien Daulant	
Risler (archᵗᵉ)	Bakis	
Girauet	Leloir	
Cruchet	Lineune	
Lafon (architecte)	Forgeron	
les Bricard	Jusseaume	

Répertoire (detail), 1997

~~Bricard 39 R. Richelieu (ap... m~~
~~2h — Guillot et Heurtou) ... toute les~~
~~Collection — 464 (Studio — excepté Guille ... Salp~~
~~7 Janvier 1903 — (23 x)~~

Goelzer — Maison Heschel. cité du
retiro

~~Janot et Jalot — B⁴ Montparnasse~~
~~82 (Part Cavalier (le matin 8 h 1/2~~

~~Morel — Constructeur fer (Escaliers)~~
~~99 et 101 B⁴ de Grenelle (a voir~~
~~vers le 1ᶠ Février)~~

~~Petit — Ferronnier — F... 17 Honoré 2...~~
~~le matin de 10 h à 11 heures~~

~~Mercadier — Rue Caumartin 25~~
~~(Grilles) ... à 1 heure~~

~~Baudoin — Rue Lalande 40 (Grilles~~
~~le matin de 7 à 8 heures~~

~~Lachasagne — (Dessinateur) Rue~~
~~Denfert 68 (Avenue du Bernet) voir le même~~
~~jour que G Remond — (Part Goelzer)(4ᵉ Étage)~~

Beaulieu – 7 R Crevaux le Fabre
Parti a ... faire ... Voir d'arrivé – 1902.
Vu jusqu'au ... fin de la 2ᵉ série (Janvier 1903

Henri Rémoud – (Tapissier) Rue
Caumartin 17 – (Part Goelzer)

Gélis – Impasse Amelot (au fond de
l'impasse (Cheminées) Part Goelzer
...onne R. Amelot 62 (à 1ʰ après midi)
1ᵉ 2ᵉ

Damou et Colin – (Décorateur)
... le Fg Antoine 94 – (Le matin
...Mr Coursier – vers 3 heures 10 heures

Mᵐᵉ Maubert (Tapissier)
28 Bis avenue de l'Opéra
Part Gégoudez – (Le matin vers 10ʰ

Baillet (Serrurier) 10 Rue
Robert... (Le matin avant 9 heures

Caillandier, Boyer et Cie (Escaliers)
Rue Damrémont 131 – (autobus Montmartre
...Germain des Prés) Voir Mr Boyer vers 2 heures

...isson – Marbrier 18 de Strasbourg
...(Cheminées) – le Voir de 6 à 7ʰ soir ou laisse
...allumé (Demander Mr Bernard)

Répertoire (detail), 1997

151

(Éditeurs americains)

American Architect -
409 Times BLD G. New-York .
(Etats unis).

Architural - Record C⁰ᵉ
11 E. 24 th. Str.
New-York. (Etats unis)

Industrial Publication C⁰ᵉ
16 Thomas Str.
New-York (Etats Unis)

Voir les Joailliers - Bijoutiers -
Modernes - Graveurs y Verre -
(avec Ferronerie)

Willer - Bijoutier
Pofilet - Part Cavalier.

Fontaine - Rue St Honoré (Vers 8 heures
(Hautours et Escaliers) - Voir Mr Chéron
l'épreuve

Flandrin — 1, quai Bourbon — Flandrin
vu la 1re et 2e série des Portes — (Décembre 1902)

37

Galli — 20 Rue du Petit Musc
le mardi de 6 à 8 heures (soir)
pour album — (Conseiller municipal)

Mr Henri Martin de
L'arsenal — Président de la Cité
à la Mairie du 4e arr. Part
Damblemont.

Mr Damblemont. Directeur
de l'École de la Place des Vosges 6

Dactylographe
Guérin — Rue St Séverin 25.

Mercier — 100 Fg St
Antoine (Voir les dessinateurs)
et épreuves (après midi) (3 heures)

Mrs Fontaine et Vaillant
(Serrures, Heurtoirs, Escaliers) Part Boisselier
Demander Mr Chéron
188 Rue St Honoré

Mr Jansen — ameublement
Demander Mr Brévois (Dessinateur)

Répertoire (detail), 1997

L'art et les Artistes, 23 Quai
Voltaire - Directeur Fondateur
Armand Dayot - 8 Bd Flandrin
(Station Dauphine) 6ème Droite -

Ramin, Maison Firmin Didot
Rue Jacob. Part Jouas -

Dété, graveur, Rue Séguier 2
Part Jouas - (3 Etage -)

Piret, Aquafortiste, Rue Alésia
126, Part Dette.

Majeur, Aquafortiste, Rue
Denfert Rochereau 95 - Part
Dette.

Charles Saunier, Bibliothécaire
du Sous secretariat d'état des Postes
et des télégraphes, 27 Rue de L'abbé
Grégoire.

Pardinel

~~*Joseph Doussot De de la Paix*~~ ~~*Pardinel ... 8 R. des Écoles*~~
Pardinel . 5 Rue Bonaparte
~~*Vieux Paris . Jusqu'au N° 4431 Inclus*~~

Éditeurs.

Les Annales, 51 Rue St George
écrire Service de l'illustration de
l'Université des annales.
M.e Serre, M.r Baschet directeur.
vendredi et Samedi, Réception après midi

Journal L'Illustration :
Baschet Directeur
Voir M.r Lenormant, ou M.r
Sorbet. Part Baschet des annalles
ou Part Duval.

Hachette : 79 Bd St Germain
(av.) Lecture pour tous pour le
Directeur Jacquin (Le soir) — payement
 des épreuves
 Bureau
 de la
 Gravure

Armand Colin 163 Bd St
Michel . (art Vieux Paris) Voir
M.r Jolis. 3.e Étage gauche, N° 76
M.r Répeure, (5.e droit de Reproduction .)

Répertoire (detail), 1997

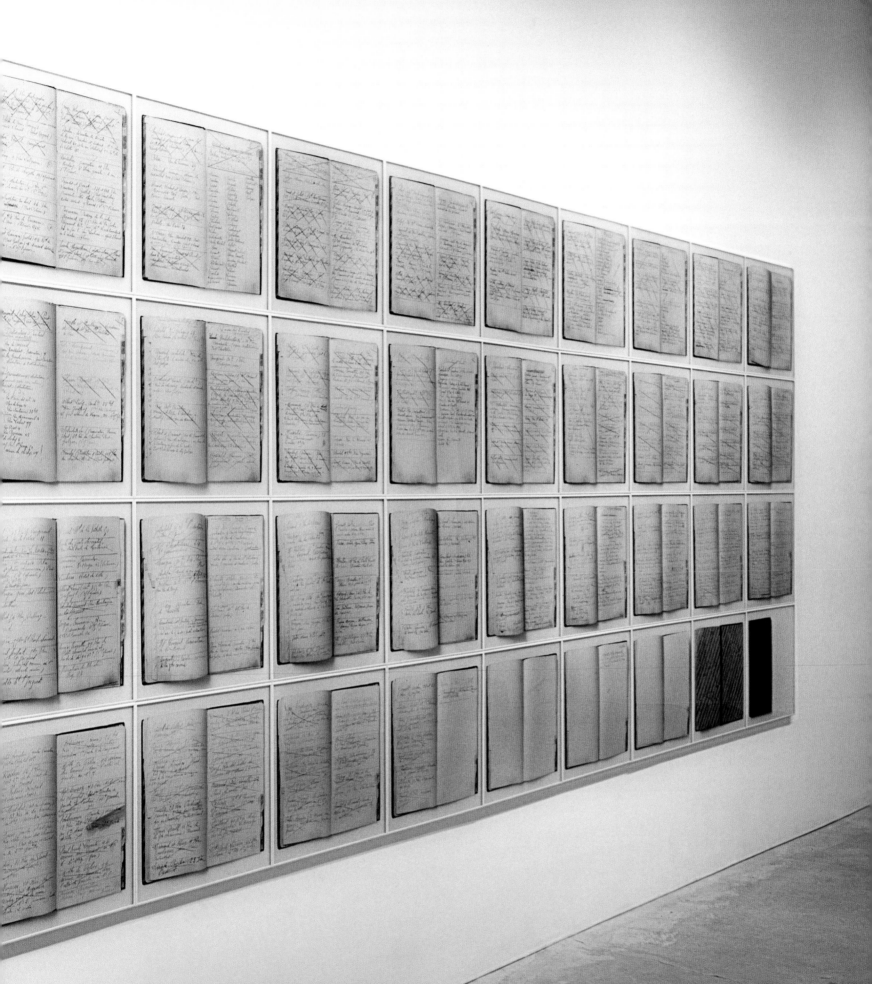

Installation view of *Répertoire* at Susan Hobbs Gallery, Toronto in 1997. Photograph by Isaac Applebaum

Les factures de Lupé, recto (detail), 1999-2001

Les factures de Lupé, verso (detail), 1999-2001

Les factures de Lupé, recto (detail), 1999-2001

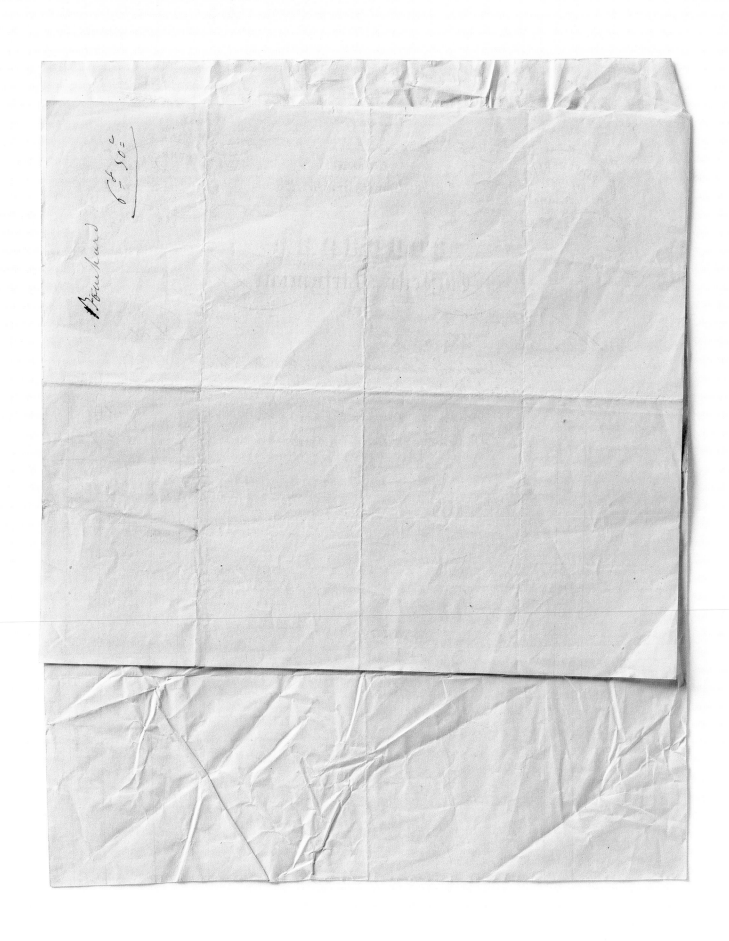

Les factures de Lupé, verso (detail), 1999-2001

Les factures de Lupé, recto (detail), 1999-2001

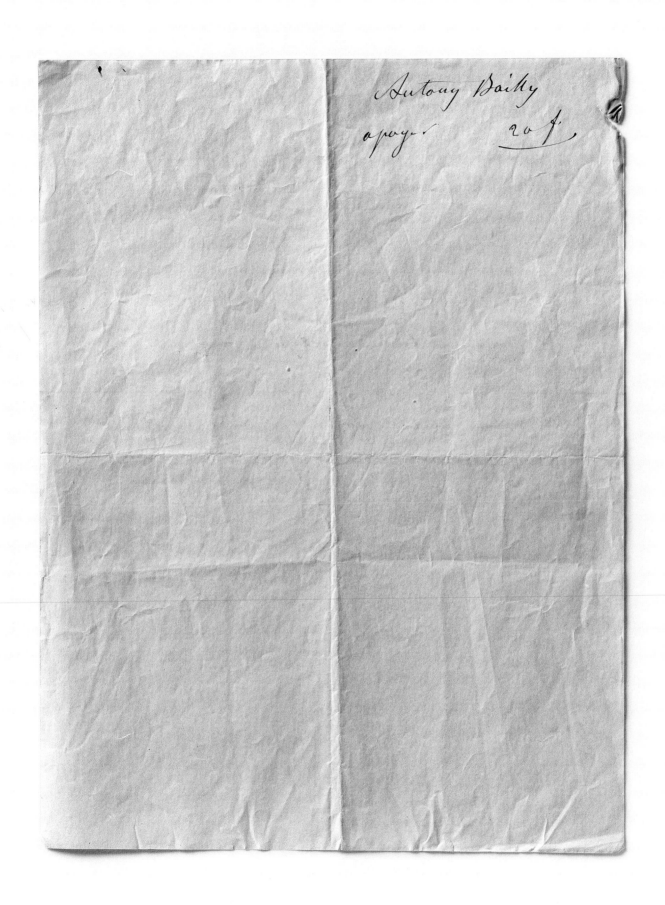

Les factures de Lupé, verso (detail), 1999-2001

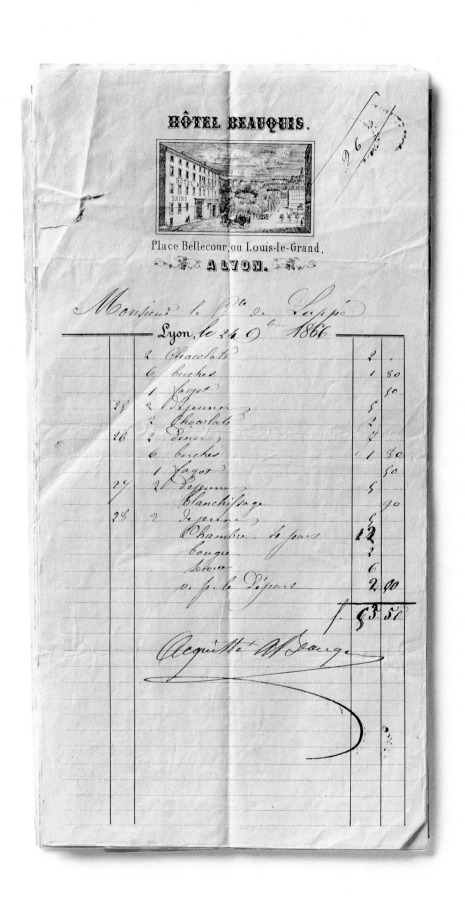

Les factures de Lupé, recto (detail), 1999-2001

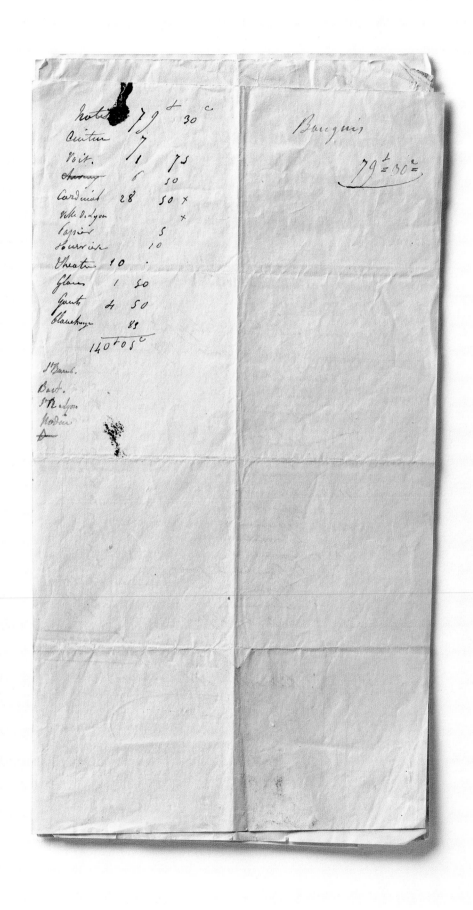

Les factures de Lupé, verso (detail), 1999-2001

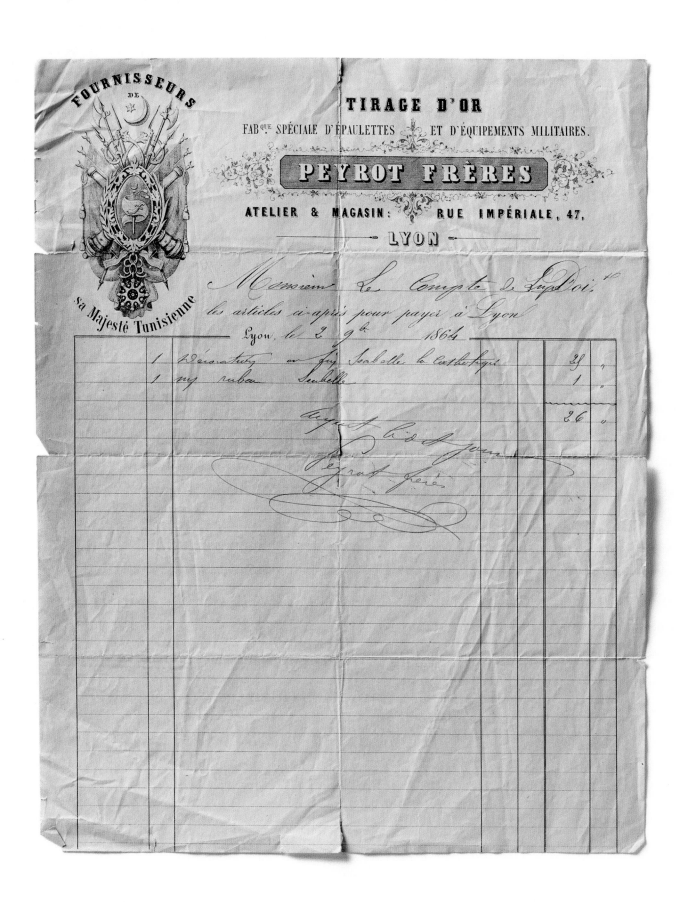

Les factures de Lupé, recto (detail), 1999-2001

Les factures de Lupé, verso (detail), 1999-2001

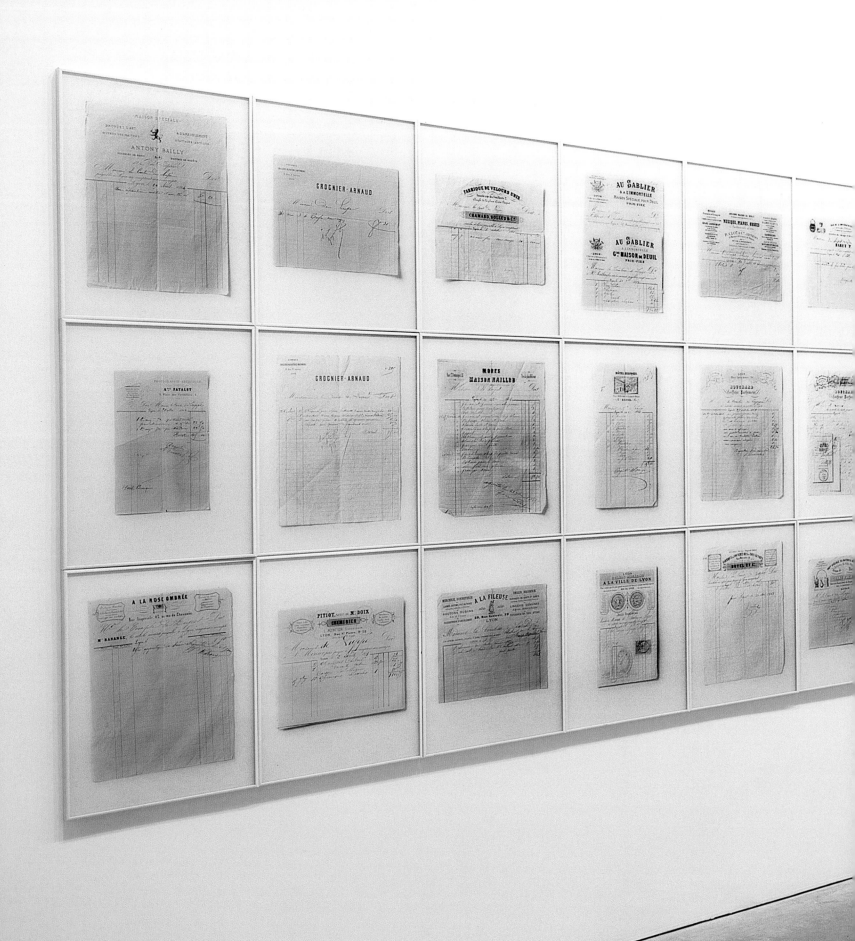

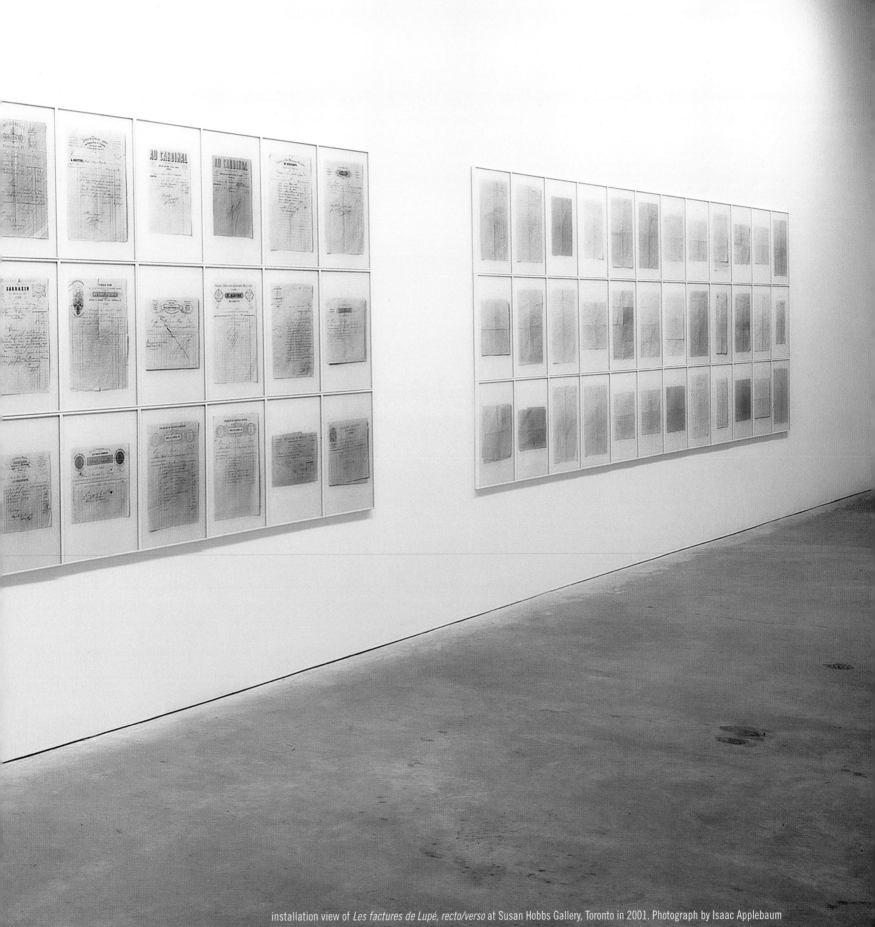

installation view of *Les factures de Lupé, recto/verso* at Susan Hobbs Gallery, Toronto in 2001. Photograph by Isaac Applebaum

Contamination (detail 136/137), 2007

Contamination (detail 140/141), 2007

145

Contamination (detail 144/145), 2007

Contamination (detail 148/149), 2007

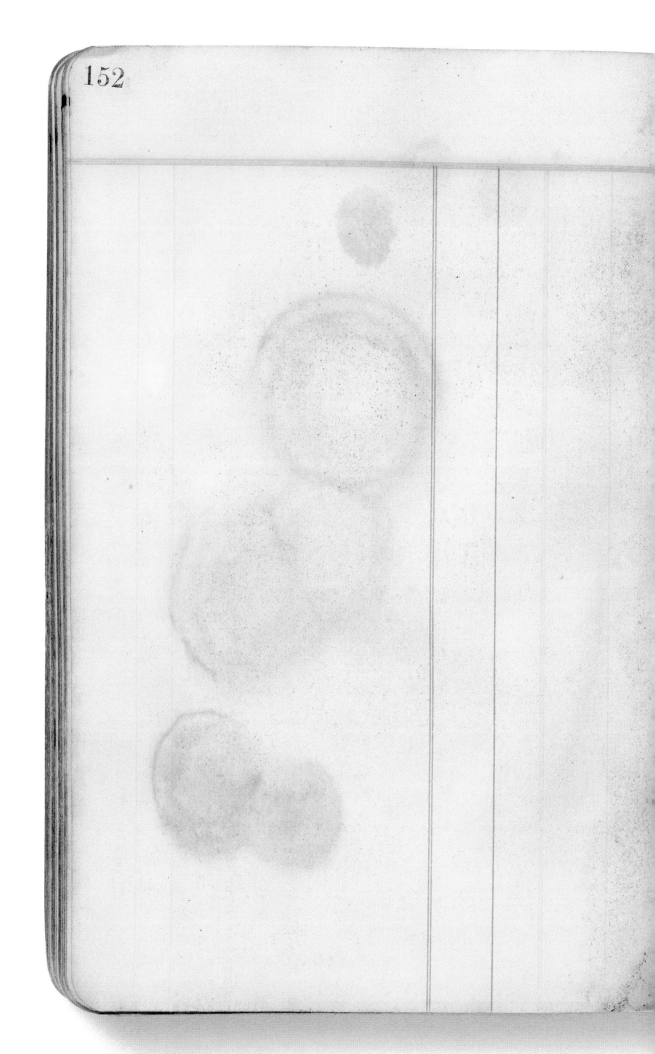

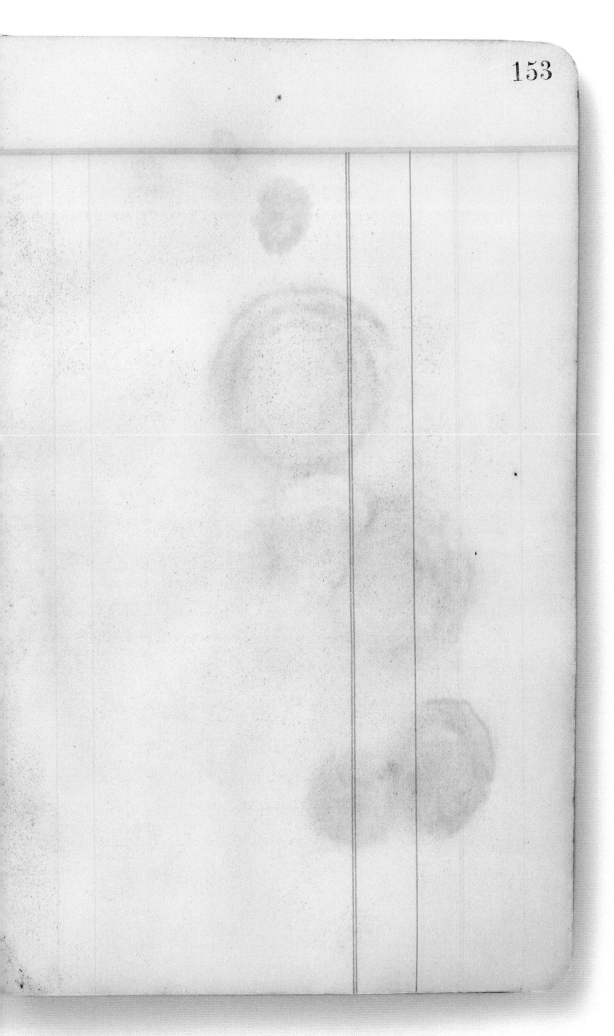

Contamination (detail 152/153), 2007

installation view of *Contamination* at Susan Hobbs Gallery, Toronto in 2007. Photograph by Toni Hafkenscheid

Pl. 79.

BARONESS ELSA VON FREYTAG-LORINGHOVEN

The Dada Portraits (detail), 2010

EL LISSITZKY

The Dada Portraits (detail), 2010

MARCEL DUCHAMP

The Dada Portraits (detail), 2010

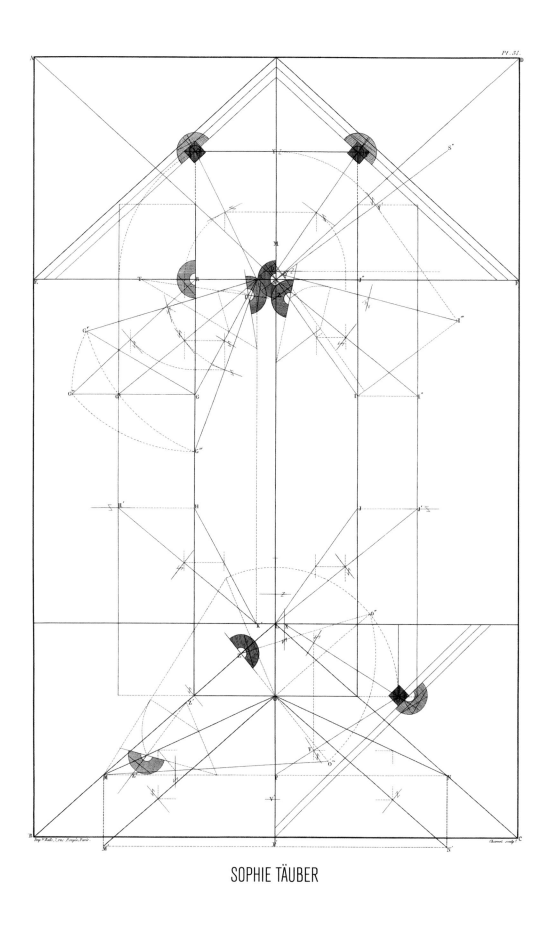

SOPHIE TÄUBER

The Dada Portraits (detail), 2010

Pl. 71.

MARY WIGMAN

The Dada Portraits (detail), 2010

KURT SCHWITTERS

The Dada Portraits (detail), 2010

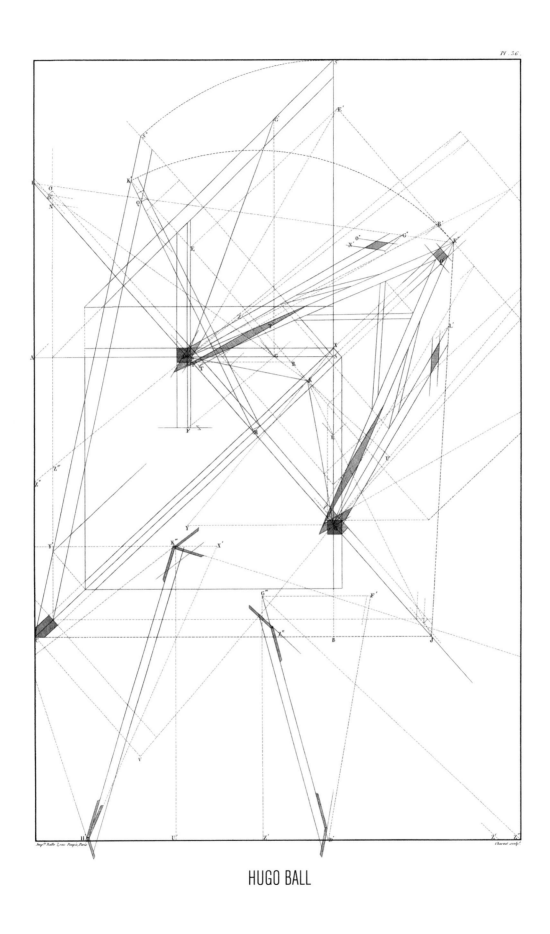

HUGO BALL

The Dada Portraits (detail), 2010

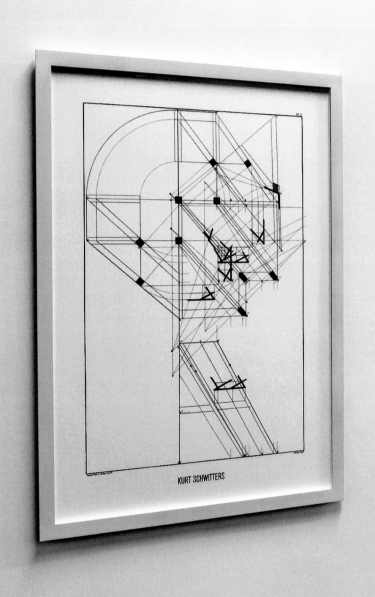

KURT SCHWITTERS

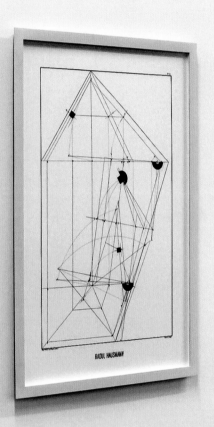

RAOUL HAUSMANN

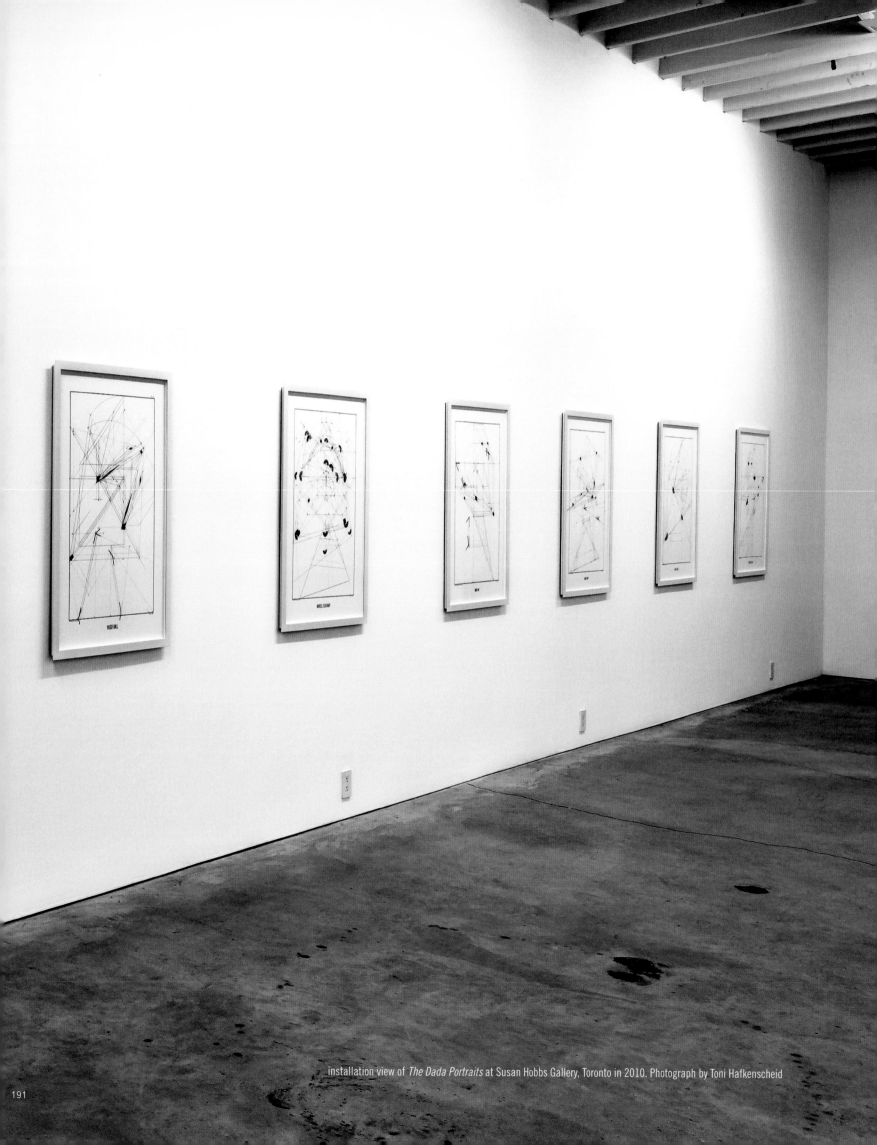

Installation view of *The Dada Portraits* at Susan Hobbs Gallery, Toronto in 2010. Photograph by Toni Hafkenscheid

LIST OF PLATES

All images courtesy Susan Hobbs Gallery, Toronto
and the estate of the artist.

ARNAUD MAGGS

BORN MAY 5, 1926 IN MONTREAL, QUEBEC, CANADA

My work has been based largely on systems of identification, sometimes of my own invention. Along the way I have referenced the history of photography. Nadar, Alphonse Bertillon, Eugène Atget, André Kertész, August Sander and Walker Evans are all photographers I have drawn on in one way or another. I enjoy exploring the filmic aspects of still photography, and the idea of editing work within the camera. I also acknowledge the technical considerations of analog photography, by showing accidents: light leaks, clip scratches, inaccurate positioning of film, multiple exposures, and all manner of things unforeseen. I cherish the procedures and mechanics surrounding film. To me, the print is an object, the end product of an amazing invention. The whole endeavor is magical, magical and mystifying.

SELECTED CHRONOLOGY

1942–44
Designs posters for high school dances as well as the cover of his high school year book

1944–45
Joins the Royal Canadian Air Force. Is sent to Toronto and later, Prince Edward Island

1945
Enrolls in Valentine School of the Arts in Westmount, Québec and quits after one month

1946
Cofounds the Hot Club of Montréal and is elected Chairman

1947
Hired as an apprentice at Bomac Federal Ltd., an engraving house in Montréal

1947
Moves to Toronto and works as a letterer at Brigden's Ltd.

1950
Returns to Montréal and studies typography in a course instructed by Carl Dair, author of the influential book *Design with Type*, published in 1952

1951
Begins working as a freelance designer and attends meetings at the Art Directors Club in Montréal

1952
Moves to New York and establishes his own freelance business designing album covers for Columbia Records and illustrations for popular magazines such as *Seventeen*

1953
Designs album cover for *Jazz at Massey Hall*

1954
Moves back to Toronto and works for Templeton Studios

1957
Decides to work as independent designer from the basement of his home in Don Mills, Ontario

1959
Moves to Milan, Italy to work for Studio Boggeri where he designs for Pirelli and Roche Pharmaceuticals

1963–65
Takes a job in Toronto Art Associates, later becomes Art Director there, exhibits design work at three major graphic design shows in New York

1966
Purchases used Nikon SLR camera and decides to become a commercial photographer, is hired as novice photographer at TDF Artists Ltd., Toronto

1969
Travels to Europe on a Canada Council grant to study the work of various renowned photographers

1970
Returns to Toronto, teaches briefly at the Ontario College of Art

1973
Enrolls in drawing classes at Artists Workshop and studies anatomy

1975
Embarks on a project photographing members of the Toronto art scene and exhibits work for the first time in a group show at the Art Gallery of Ontario

1976
Establishes own studio space in Toronto

1978
Solo exhibition at David Mirvish Gallery, Toronto

1980
Travels to Europe for his solo exhibition at Canadian Cultural Centre in Paris, photographs art students in Düsseldorf, as well as Joseph Beuys, photographs André Kertész in Toronto

1984
Victor Martyn Lynch-Staunton Award for outstanding production

1984–87
First travelling show of Maggs's work organized by the Nickle Arts Museum in Calgary, Maggs designs the exhibition and acts as administrator and archivist for the show

1987
Begins association with Cold City Gallery, Toronto (until 1992)

1988
Artist residency at The Banff Centre, Alberta

1991
Gershon Iskowitz Prize, awarded to mature artists on the verge of creating a significant body of work, returns to Paris to photograph hotel signs

1992
Receives Toronto Arts Award for outstanding contribution to Toronto's art scene

1993
Hotel artist book co-published by Art Metropole, Toronto and Presentation House, Vancouver
Begins association with Susan Hobbs Gallery, Toronto

1999
Retrospective at The Power Plant Contemporary Art Gallery, Toronto

2005
Lifetime Achievement Award from Untitled Art Awards, Toronto

2006
Governor General's Award in Visual and Media Arts for excellence in visual and media arts

2012
Scotiabank Photography Award for distinguished career and exceptional production in photography

SELECTED SOLO EXHIBITIONS

1978
64 Portrait Studies, David Mirvish Gallery, Toronto
Anna Leonowens Gallery, NSCAD, Halifax

1979
Ledoyen Series, YYZ, Toronto

1980
Image Co-op Gallery, Montpelier, Vermont
Canadian Cultural Centre, Paris, France

1981
Downwind Photographs, Mercer Union, Toronto

1982
48 Views Series, Corkin Gallery, Toronto

1983
Turning, Photography Gallery, Harbourfront, Toronto
Joseph Beuys, Optica, Montréal

1984
Photographs 1975-84, Nickle Galleries (formerly Nickle Arts Museum), Calgary; Winnipeg Art Gallery, Winnipeg; and Art Gallery of Hamilton, Hamilton
Photographs 1981-83, Charles H. Scott Gallery, Vancouver

1985
Düsseldorf Photographs, The Isaacs Gallery, Toronto

1988
The Complete Prestige 12" Jazz Catalogue, YYZ, Toronto

1989
Numberworks, Macdonald Stewart Art Centre, Guelph
Joseph Beuys, Stux Gallery, New York

1990
8 Numberworks, Southern Alberta Art Gallery, Lethbridge
7828, Open Studio, Toronto
Joseph Beuys, Neuberger Museum of Art, Purchase, New York
Identification, Saidye Bronfman Centre, Montréal

1991
Köchel Series, Cold City Gallery, Toronto; and Bon Pasteur Historical Chapel, Montréal

1992
Hotel, Presentation House Gallery, Vancouver; and Cold City Gallery, Toronto
Project Room, Mercer Union, Toronto

1993
Art Metropole, Toronto

1994
Travail des enfants dans l'industrie, Susan Hobbs Gallery, Toronto

1996
Notification, Susan Hobbs Gallery, Toronto

1997
Arnaud Maggs: Early Portraits, Edmonton Art Gallery, Edmonton
Répertoire, Susan Hobbs Gallery, Toronto

1999
Arnaud Maggs: Work 1976-1999, The Power Plant Contemporary Art Gallery, Toronto
Susan Hobbs Gallery, Toronto

2000
Arnaud Maggs: Notes Capitales, Canadian Cultural Centre, Paris, France
Susan Hobbs Gallery, Toronto

2001
Susan Hobbs Gallery, Toronto
Lèche-vitrine, Galerie Blanche, Paris

2003
Susan Hobbs Gallery, Toronto

2004
Düsseldorf Photographs, Goethe-Institut, Toronto
Orford String Quartet, Agnes Etherington Art Centre, Kingston

2005
Werner's Nomenclature of Colours, Susan Hobbs Gallery, Toronto
Joseph Beuys, 100 Profile Views, Art Gallery of Hamilton
Christo, Art Gallery of Ontario, Toronto

2006
Nomenclature, The Robert McLaughlin Gallery, Oshawa; McMaster Museum of Art, Hamilton

2007
Nomenclature, Gallery One One One, Winnipeg
Lessons, Susan Hobbs Gallery, Toronto

2008
Nomenclature, Musée d'art contemporain de Montréal, Montréal

2010

The Dada Portraits, Susan Hobbs Gallery, Toronto
Lost and Found, MacLaren Art Centre, Barrie,
Ontario

2012

After Nadar, Susan Hobbs Gallery, Toronto
Arnaud Maggs: Identification, National Gallery of
Canada, Ottawa

2013

Arnaud Maggs, Ryerson Image Centre, Ryerson
University, Toronto

1977

7 Canadian Photographers, National Film Board of
Canada, Ottawa

1978

Sweet Immortality, Edmonton Art Gallery, Edmonton

1979

Photo/Extended Dimensions, Art Gallery of Winnipeg

1980

Three Photographers, Open Space, Victoria

1981

Realism: structure and illusion, Macdonald Stewart Art
Centre, Guelph
Displacements, Glendon Gallery, York University,
Toronto

1982

Persona, Nickle Arts Museum, Calgary

1983

Seeing People, Seeing Space, The Photographers' Gallery,
London, England

1984

Contemporary Canadian Photography, National Media
Museum (formerly the National Museum of
Photography, Film and Television), Bradford, England
Evidence of the Avant-Garde Since 1957, Art Metropole,
Toronto
Allocations, 49th Parallel, New York
Responding to Photography, Art Gallery of Ontario,
Toronto

1985

Contemporary Canadian Photography, National Gallery
of Canada, Ottawa
Identities, Centre National de la Photographie, Paris

1987

Art on Billboards, Olympic Arts Festival, Calgary

1990

Invitational, Cold City Gallery, Toronto
Numbering, Art Gallery of Hamilton, Hamilton
International British Print Biennial, Bradford, England

1991

Photo Based Works, 49th Parallel, New York
Identity, Main/Access Gallery, Winnipeg

1992

Beau, Mois de la Photo, Paris; Canadian Museum of Contemporary Photography, Ottawa; Canada House, London, England

Special Collections: The Photographic Order from Pop to Now, International Center of Photography Midtown, New York; Fondation Deutsch, Lausanne, Switzerland; Mary & Leigh Block Museum of Art, Evanston, Illinois; Arizona State University Art Museum, Tempe; Chrysler Museum of Art, Norfolk, Virginia; Bass Museum of Art, Miami, Florida; The Museums at Stony Brook, Stony Brook, New York; Vancouver Art Gallery, Vancouver; Ansel Adams Center, San Francisco; Sheldon Memorial Art Gallery, Lincoln, Nebraska

1993

Within Memory, Montage '93, Rochester, New York; The Addison Gallery of American Art, Andover, Massachusetts

Observing Traditions: Contemporary Photographs 1975-1993, National Gallery of Canada, Ottawa

1995

20 Years: Art Metropole, Art Gallery of Ontario, Toronto

Obsessions: From Wunderkammer to Cyberspace, Foto Biennale Enschede, Rijksmuseum Twenthe, Enschede, Netherlands

1996

Type Culture, Design Exchange, Toronto

Ten, Cold City Gallery/Mercer Union, Toronto

Reflections of the Soul, Art Gallery of North York, Toronto

Double vie, double vue, Fondation Cartier, Paris

1997

Eros and Thanatos, Art Gallery of Ontario, Toronto

A Little Object, Centre for Freudian Analysis and Research, London, England

Notification, Agnes Etherington Art Centre, Kingston

Survey Results Show …, Oakville Galleries, Oakville

1999

Tongues and Ashes, Kitchener–Waterloo Gallery, Kitchener

Reflections of the Artist, Portraits and Self-Portraits, National Gallery of Canada, Ottawa

2000

Mémoire et archive, Musée d'art contemporain de Montréal, Montréal

Logo City, Blackwood Gallery, Mississauga

2001

Facing History: Portraits from Vancouver, Presentation House, Vancouver

2000 and Counting, part II, National Gallery of Canada, Ottawa

Memoirs: Transcribing Loss, Art Gallery of Greater Victoria, Victoria

Mémoire et archive, Musée d'art contemporain de Montréal, Montréal

The Bigger Picture: Contemporary Photography Reconsidered, Art Gallery of Ontario, Toronto

2002

aluminum, Susan Hobbs Gallery, Toronto

2003

Art in Bloom 2003, MacKenzie Art Gallery, Regina

Confluence: Contemporary Canadian Photography, Canadian Museum of Contemporary Photography, Ottawa

2004

About Face: Photography and the Death of the Portrait, Hayward Gallery, London, England

Facing History: Portraits from Vancouver, Canadian Cultural Centre, Paris

Identities: Canadian Portraits, McMichael Canadian Art Collection, Kleinburg

Je t'envisage: La disparition du portrait, Musée de l'Elysée, Lausanne, Switzerland

2005

Impulse Archaeology, Museum of Contemporary Canadian Art (MOCCA), Toronto

Facing History: Portraits from Vancouver, Wharf, Centre d'art contemporain de Basse-normandie, Hérouville Saint-Clair, France; Presentation House, Vancouver

The Cold City Years, The Power Plant, Toronto

2008

Momentum, Susan Hobbs Gallery, Toronto

2009

Beautiful Fictions: Photography at the AGO, Art Gallery of Ontario, Toronto

A Field Guide to Observing Art, McMaster Museum of Art, Hamilton

For Emily, MacKenzie Art Gallery, Regina

Snapshot: Selections from the WAG's Photography Collection, Winnipeg Art Gallery, Winnipeg

Traffic: Conceptual Art in Canada 1965 to 1980, Vancouver Art Gallery, Vancouver

2010

F/STOP: 4th International Festival of Photography,
Centre for Contemporary Photography, Leipzig
Traffic: Conceptual Art in Canada 1965 to 1980,
University of Toronto Art Centre, Toronto
Art at Work: Corporate Collecting Practices Today, Art
Gallery of Mississauga, Mississauga
*Beyond Likeness: Contemporary Works from the Portrait
Gallery of Canada*, Art Gallery of Calgary, Calgary

2011

The Most She Weighed / The Least She Weighed, Susan
Hobbs Gallery, Toronto
Traffic: Conceptual Art in Canada 1965 to 1980,
Dalhousie Art Gallery, Halifax; Art Gallery of Alberta,
Edmonton
*Beyond Likeness: Contemporary Works from the
Portrait Gallery of Canad*a. Beaverbrook Art Gallery,
Fredericton, New Brunswick
Animal, Museum London, London, Ontario;
Kenderdine Art Gallery, Saskatoon; The Robert
McLaughlin Gallery (RMG), Oshawa; Dalhousie Art
Gallery, Halifax

2012

Exposure, Susan Hobbs Gallery, Toronto
Again and Again…Repetitive Actions and Serial Formats,
Vancouver Art Gallery, Vancouver
Like-Minded, Plug In ICA, Winnipeg
"Photography Collected Us": The Malcomson Collection,
University of Toronto Art Centre, Toronto

SELECTED EXHIBITION CATALOGUES

1978

Clark, Douglas. *Sweet Immortality*. Edmonton:
Edmonton Art Gallery

1979

Allen, Karyn Elizabeth. *Photo-Extended Dimensions*.
Winnipeg: Winnipeg Art Gallery

1980

Macwilliam, David. *Arnaud Maggs*. Paris: Centre
Culturel Canadien

1981

Nasby, David. *Realism: Structure & Illusion*. Guelph:
Macdonald Stewart Art Centre
Walsh, George. *Contemporary Photographers*. London,
England: St. James Press

1982

Allen, Karyn Elizabeth. *Persona*. Calgary: Nickle Arts
Museum
Craven, George M. *Object & Image*. New Jersey:
Prentice Hall

1984

Allen, Karyn Elizabeth. *Arnaud Maggs Photographs
1975-84*. Calgary: Nickle Arts Museum
Davies, Sue. *Seeing People / Seeing Space*. London,
England: The Photographers' Gallery
Ewing, William E. *Allocations*. New York: 49th Parallel
Lindberg, E. Theodore. *Arnaud Maggs, An Exhibition
of Selected Works 1981-83*. Vancouver: The Charles H.
Scott Gallery, Emily Carr College of Art and Design
Sutnik, Maia-Mari. *Responding to Photography*. Toronto:
Art Gallery of Ontario

1985

Frizot, Michael; July, Serge; Pheline, Christian;
Sagne, Jean. *Identités*. Paris: Centre National de la
Photographie

1989

Jenkner, Ingrid. *Arnaud Maggs Numberworks*. Guelph:
Macdonald Stewart Art Centre

1990

Holubizky, Ihor. *Numbering*. Hamilton: Art Gallery of
Hamilton

1992

Langford, Martha. *BEAU*. Ottawa: Canadian Museum of Contemporary Photography

Fischer, Barbara. *DECALOG*. Toronto: YYZ Books

Stainback, Charles A.. *Special Collections: The Photographic Order from Pop to Now*. New York: International Center of Photography

1993

Ferguson, Bruce. *Hotel*. Toronto/Vancouver: Art Metropole/Presentation House

Sheldon, James M. *Within Memory*. Andover, MA: Addison Gallery of American Art

1996

Roegiers, Patrick. *double vie, double vue*. Paris: Fondation Cartier pour l'art contemporain

1998

Monk, Philip. *Picturing the Toronto Art Community*. Toronto: The Power Plant

1999

Monk, Philip; Sutnik, Maia-Mari. *Arnaud Maggs: Works 1976-1999*. Toronto: The Power Plant

2000

Bedard, Catherine and Keziere, Russell. *Arnaud Maggs: Notes Capitales*. Paris: Canadian Cultural Centre

Fischer, Barbara. *logocity*. Toronto: Blackwood Gallery, Mississauga, Ontario

2002

Love, Karen. ed. *Facing History: Portraits from Vancouver*. Vancouver: Presentation House/Arsenal Pulp Press

2003

Hanna, Martha. *Confluence*. Ottawa: Canadian Museum of Contemporary Photography

2004

Love, Karen. *Facing History: Portraits from Vancouver*. Paris: Centre Culturel Canadien

The Bigger Picture: Portraits from Ottawa. Ottawa: Ottawa Art Gallery

2005

Bean, Robert. ed. *Image and Inscription*. Toronto: Gallery 44 Centre for Contemporary Photography/ YYZ Books

2006

Langford, Martha. *Arnaud Maggs: Nomenclature*. Oshawa: Robert McLaughlin Gallery

Love, Karen. *The Governor General's Award in Visual and Media Arts*. Ottawa: The Canada Council

2009

Knechtel, John. *Water*. Cambridge, MA: MIT Press

Portis, Ben. *Lost and Found* (exhibition brochure). Barrie, Ontario: MacLaren Art Centre

Priest, Margaret in *The Gershon Iskowitz Prize: 1986 to 2006*, Laurel MacMillan, ed. Toronto: The Gershon Iskowitz Foundation

2010

Davis, Geraldine; Freeman, Robert. *Art At Work: Corporate Collecting Practices Today*. Mississauga, Ontario: Art Gallery of Mississauga

2011

Ghaznavi, Corinna; McKay, Sally; York, Alissa. *Animal*. London, Ontario: Museum London

Hansen, Michael, *2010-2011 Season: ArtSync*. Toronto, Ontario

2012

Stainback, Charles A.; Drouin-Brisebois, Josée and Vogl, Rhiannon. *Arnaud Maggs: Identification*. Ottawa: The National Gallery of Canada

2013

Sutnik, Maia-Mari; Hackett, Sophie and Popescu, Doina. *Arnaud Maggs*. Göttingen, Germany: Steidl; Toronto, Ontario: Scotiabank (Scotiabank Photography Award 2012)

ACKNOWLEDGEMENTS

There's a Buddhist saying that goes like this: We are here through the kindness of others. I feel embraced by the kindness of others.

I'd like to thank Christian Marclay (points straight ahead in the direction of *The Clock*) and I'd like to thank Benny's Bistro (points to the right). I'd like to thank Alexander McQueen (points up with left hand) and a special prayer for Levon Helm, who went up to Heaven earlier this month (points up with right hand). I'd like to thank Martha Langford, Martha Hanna, Martha Fleming, Martha Wainwright, Rufus Wainwright, Loudon Wainwright, Robert Enright, Michael Enright, Michael Mitchell, Michael Haddad, Ann Thomas, St. Thomas Aquinas, David Angelo, Ben Portis, Ben Webster, Robin Redbreast, Ed Burtynsky, Miles Collyer, Miles Davis, Sammy Davis, Sammy Cushion, Nancy Hushion, Nancy Cardwell, Shanitha Kachan, Open Kitchen, Heather Cook, Lawrence Cook, Jesse Cook, Gerry Sheff, Julia Mustard, Art Pepper, Chick Rice, Clara Tice, Hanna Hoch, J. S. Bach, Charles Cutts, Christopher Cutts, Jane Zeidler, Georgia Scherman, Fiona Christie, June Christie, Dinah Christie, Dinah Washington, Diana Nemiroff, Daina Augaitis, Doina Popescu, David Ross, David Dorenbaum, David Rabinovitch, David Mirvish, David Maggs, François Rochon, Frances Bacon, Canadian bacon, Caitlan Maggs, Kate Zeidler, Kate Brown, Kate Reid, Canada Council, Ontario Arts Council, Toronto Arts Council, Beth Leon, Alexander Graham Bell, Robert Fones, Telus, William Tell, William Ewing, Barr Gilmore, Claire Dawson, Claire de Lune, Lilly Koltun, Lyne Lapointe, Matthew Teitelbaum, Mark Lewis, Mark Allen, Jim Allen, Sheila Murray, Murray Whyte, Gabor Szilasi, Elizabeth Porebski, Elizabeth Smith, Jay Smith, Elizabeth Dorion, Dennis Dorion, Feist, Hugo Ball, Hugo Boss, Reesa Greenberg, Elke Town, Harold Town, Katherine Knight, Bruce Kuwabara, Noam Chomsky, Noah Tremblay, Daniel Tremblay, Linda Jansma, Lorenzo Maggs, Diego Lorenzo, Diego Rivera, Susan Hobbs, Suzanne Duchamp, Max Ernst, Max Dean, Marc Mayer, Sophie Hackett, Clea Forkert, American folk art, Amanda Sebris, Maia-Mari Sutnik, Mary Walsh, Mary Wigman, Marie-Justine Snyder, Marcia Connolly, Carol Rapp, The Clichettes, AA Bronson, AA Johnson, Eva Major-Marothy, Samuel Goldwyn, A. Gold and Son, Jack Diamond, Jeanne Parkin, Laurence Silver, Phil Silver, Phil Markowitz, Phil Nimmons, Cynthia Markowitz, Peggy Gale, Richard Storms, Michael Snow, Malcolm Rains, Claude Rain, Toby Maggs, Narsing Maggs, Adoración Maggs, Santiago Pina, Fidel Peña, Ydessa Hendeles, Our Virgin of Guadalupe, Katyuska Doleatto, Duke Ellington, Paul Reddick, Donovan Tremblay, Jane Nokes, Geoffrey James, James Brown, Red Grooms, Brian Groombridge, Rachel Verbin, Marwan Osseiran, Man Ray, Hans Arp, TIW, RIC, Morton Rapp, Laura Rapp, Laura Jones, Norah Jones, Glen Cumming, Mike Robinson, Snookums, Jessica Tandy, Jessica Bradley, Olga Korper, Victoria Jackman, Nancy McCain, Nancy Sinatra, Jo-Ann Kane, Citizen Kane, Andrea Kunard, Peter Porebski, Rebecca Duclos, Bob Sirman, Pamela Meredith, Josée Drouin-Brisebois, Deborah Duffy, Deborah Harry, Vicky Henry, Karen Love, Glen Bloom, Love in Bloom. Spring Hurlbut.

ARNAUD MAGGS
THE GREAT HALL, NATIONAL GALLERY OF CANADA
MAY 3, 2012

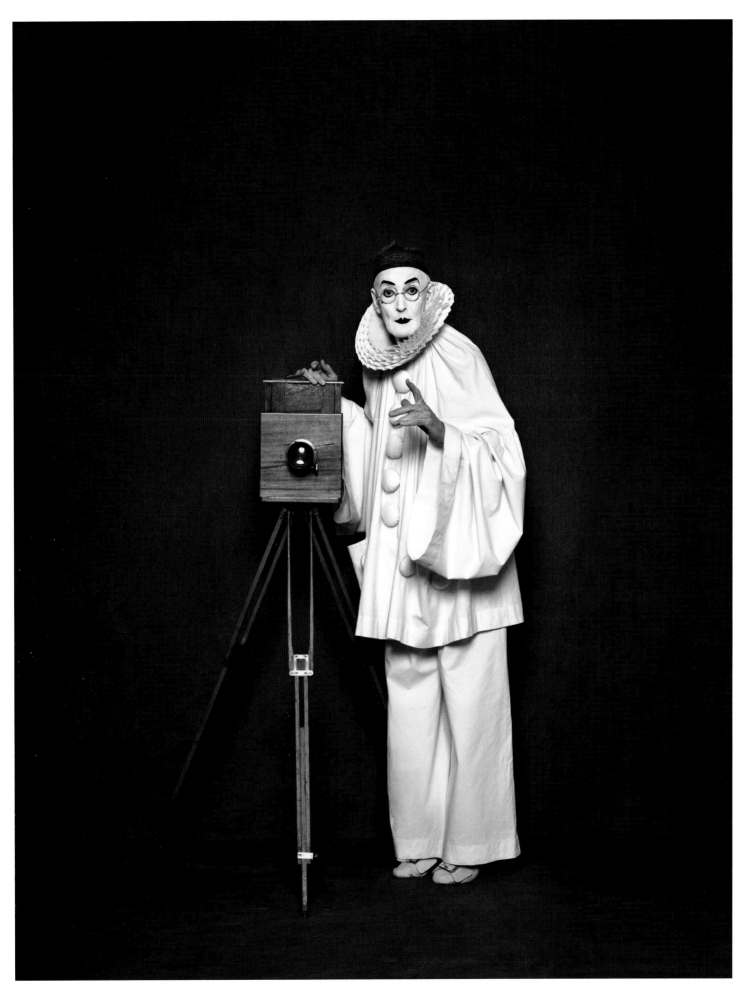

After Nadar: Pierrot the Photographer, 2012

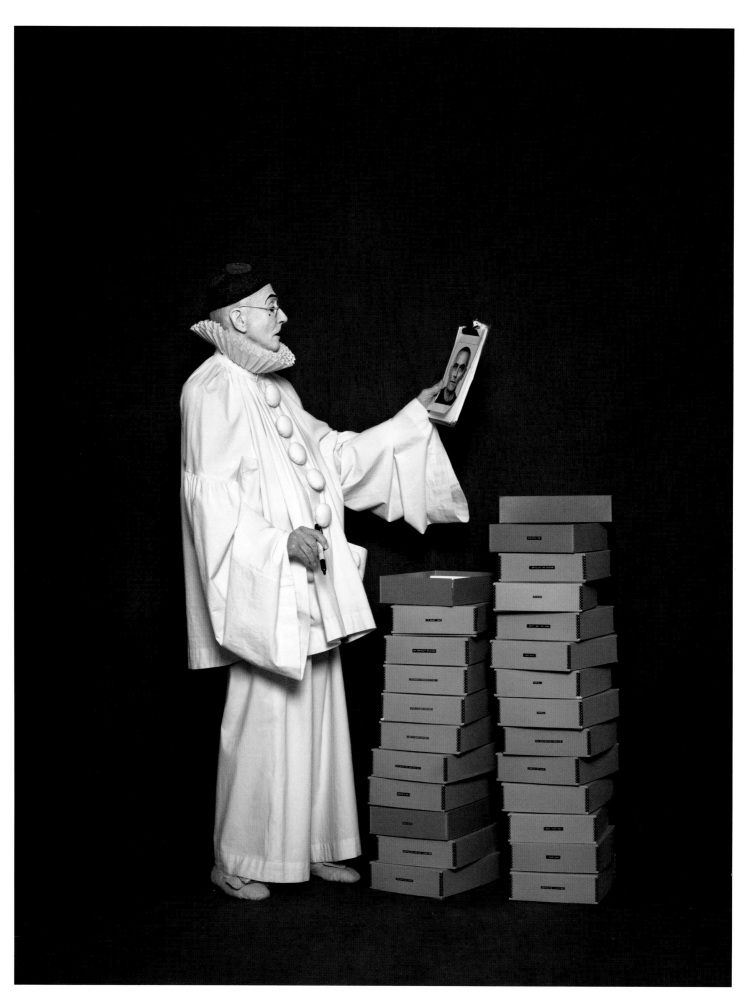

After Nadar: Pierrot the Archivist, 2012

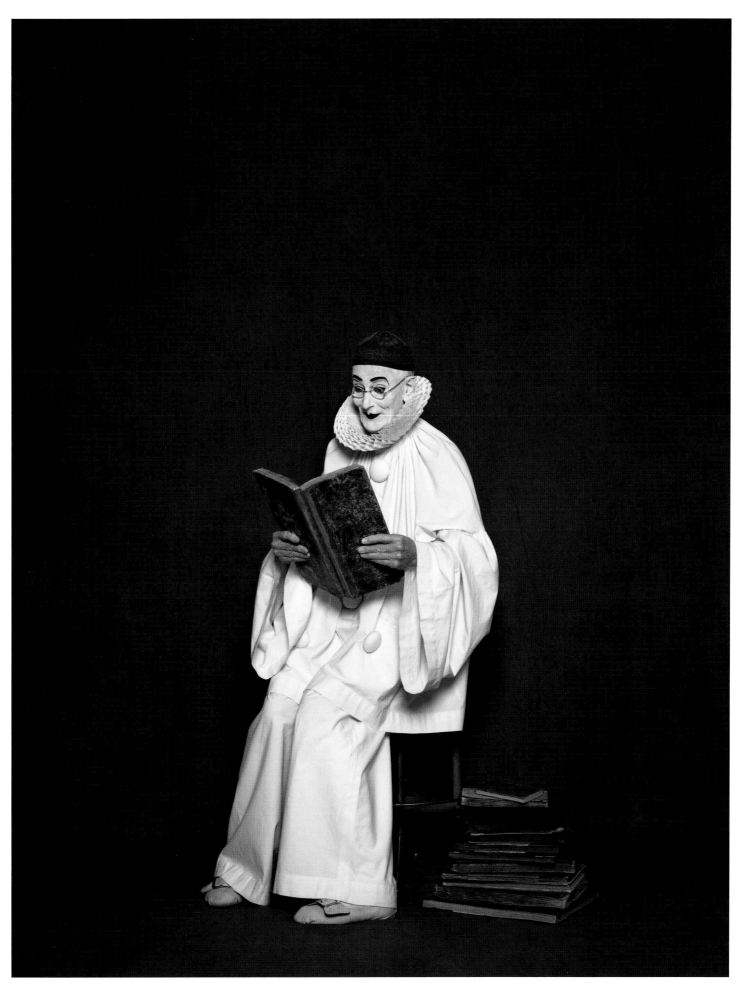

After Nadar: Pierrot the Storyteller, 2012

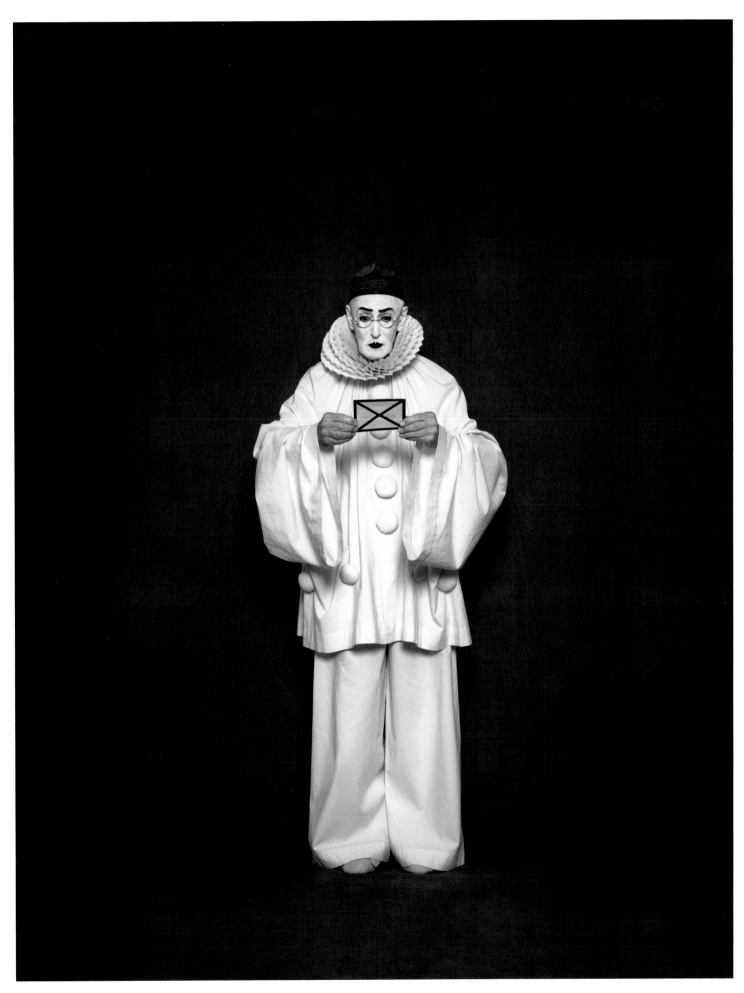

After Nadar: Pierrot receives a Letter, 2012

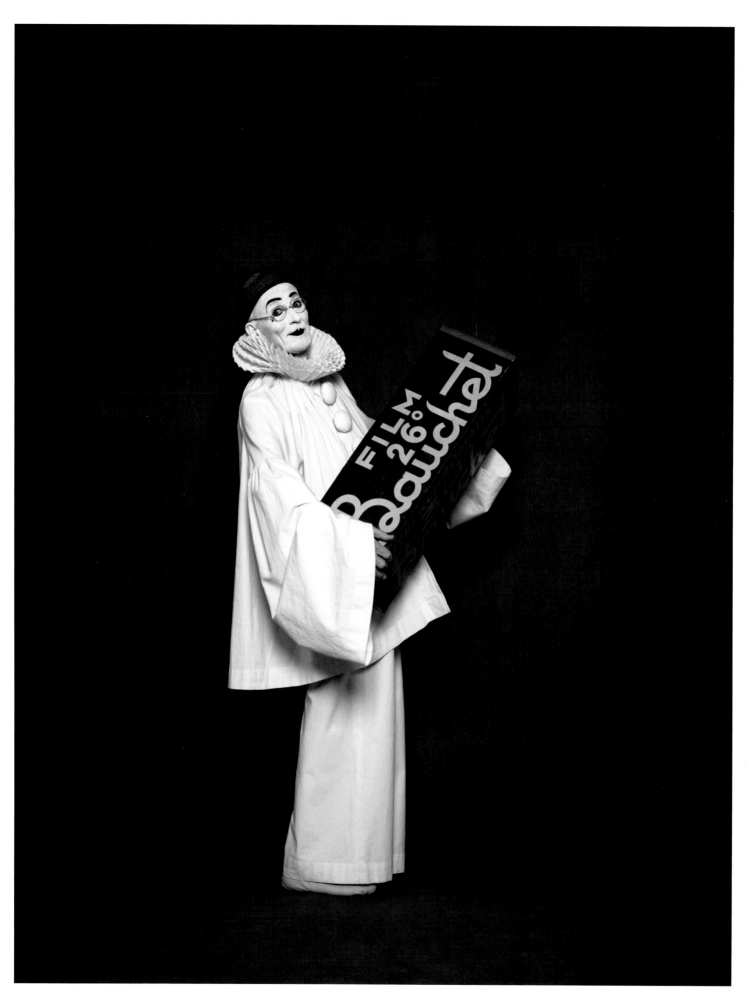

After Nadar: Pierrot and Bauchet, 2012

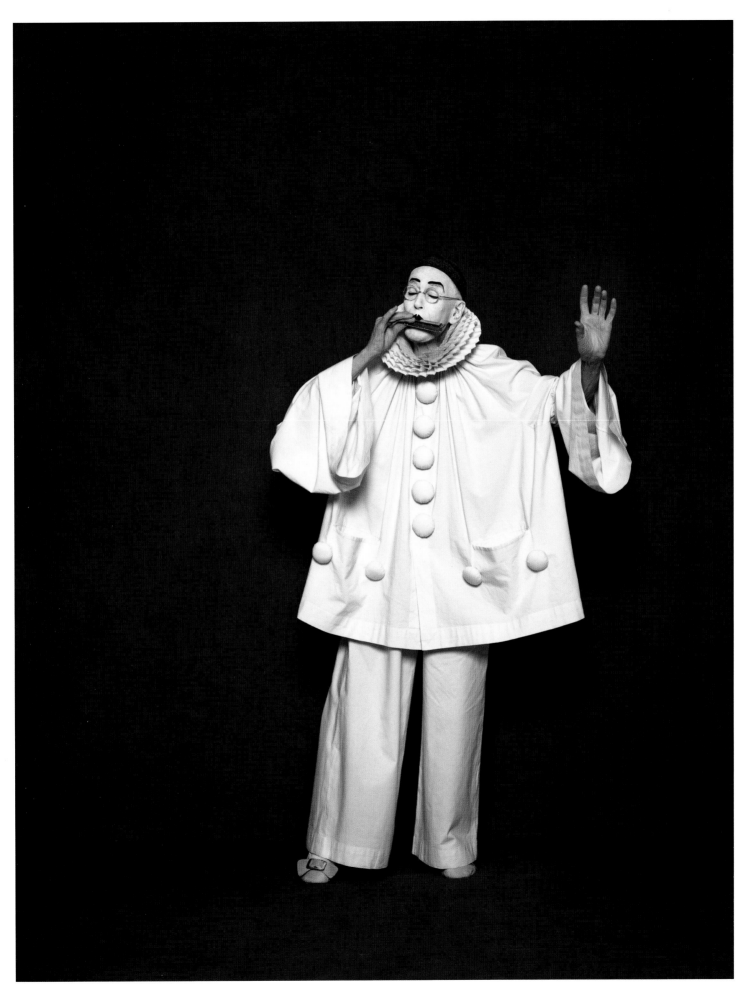

After Nadar: Pierrot the Musician, 2012

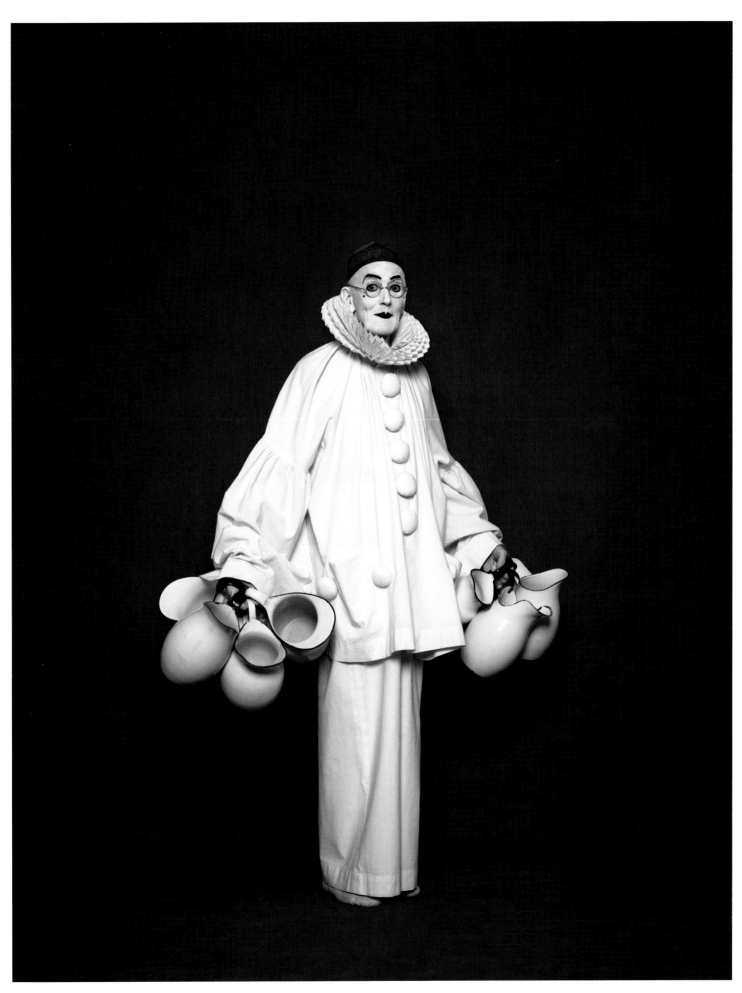

After Nadar: Pierrot the Collector, 2012

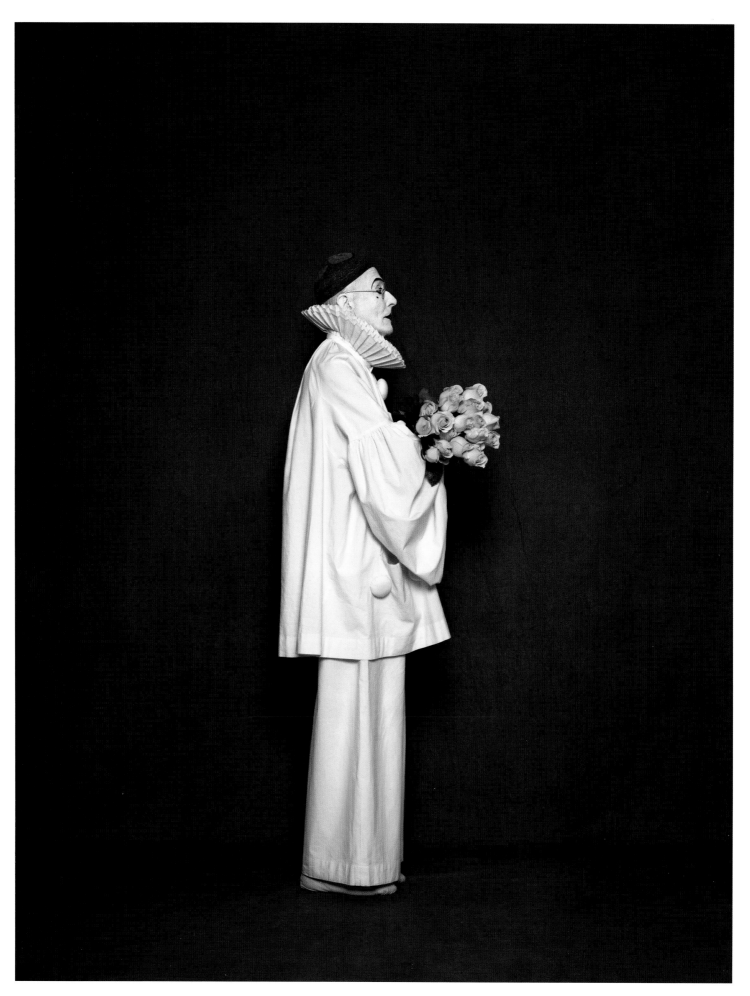

After Nadar: Pierrot in Love, 2012

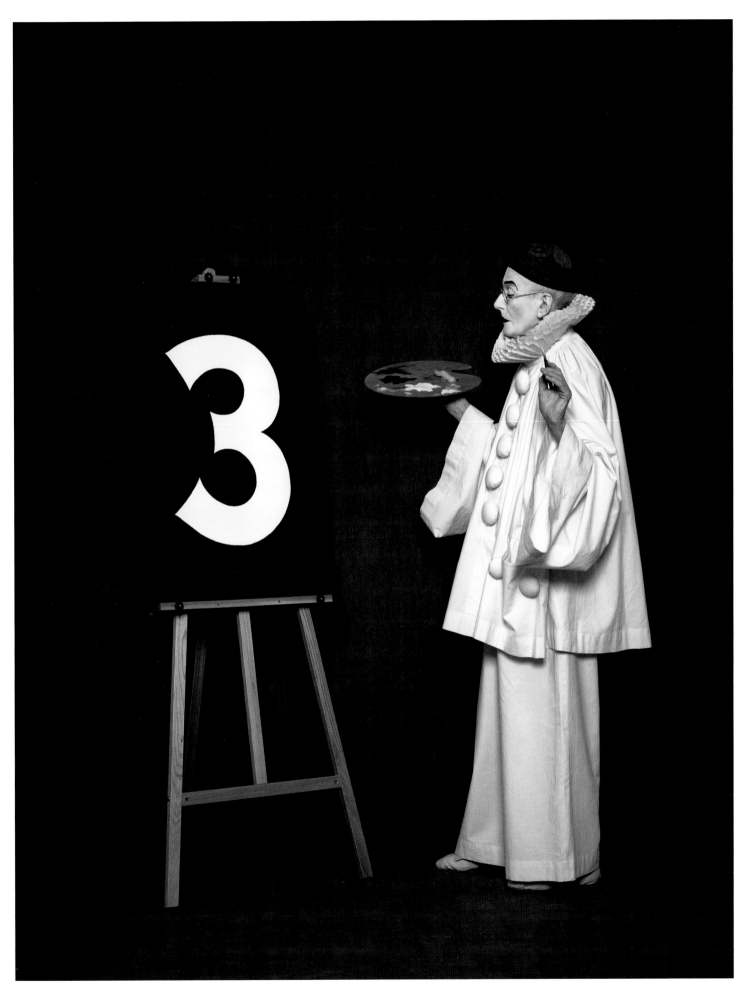

After Nadar: Pierrot the Painter, 2012